The
Italian Renaissance
of Machines

The Bernard Berenson Lectures
on the Italian Renaissance

SPONSORED BY VILLA I TATTI

THE HARVARD UNIVERSITY CENTER FOR

ITALIAN RENAISSANCE STUDIES

FLORENCE, ITALY

The

Italian Renaissance

of Machines

PAOLO GALLUZZI

TRANSLATED BY
JONATHAN MANDELBAUM

Harvard University Press

Cambridge, Massachusetts
London, England
2020

First printing

Library of Congress Cataloging-in-Publication Data
Names: Galluzzi, Paolo, author.
Title: The Italian Renaissance of machines / Paolo Galluzzi.
Description: Cambridge, Massachusetts : Harvard University Press, 2020. |
 Includes bibliographical references and index.
Identifiers: LCCN 2019014445 | ISBN 9780674984394 (alk. paper)
Subjects: LCSH: Mechanical engineering—Italy—History—15th century. |
 Mechanical engineering—Italy—History—16th century. | Engineering and the
 humanities—Italy—History—15th century. | Engineering and the humanities—Italy—
 History—16th century. | Art and technology—Italy—History—15th century. |
 Art and technology—Italy—History—16th century. | Renaissance—Italy.
Classification: LCC TJ79 .G35 2020 | DDC 621.80945/09024—dc23 LC record available
 at https://lccn.loc.gov/2019014445

Contents

Preface

CONVENTIONAL VISIONS OF THE RENAISSANCE usually grant little space to the protagonists of what may be defined as the "Renaissance of machines," overshadowed by the Renaissance of arts and letters. Yet, from the first decades of the fourteenth century, Italy was the stage of a revival of interest in technical issues, of original discussions on the very concept of machine, and of the development of new graphic conventions for effectively representing its structure, components, and functions.

To understand the rapid change in the cultural and social setting in which technical players operated, we need only compare the image of the medieval technicians with the reputation that the most skilled artist-engineers acquired during the fifteenth century. With very few exceptions, the former remained anonymous, even those who were protagonists of remarkable achievements: the construction of Gothic cathedrals; the creation of innovative systems of production; the design of new machines and instruments; and the radical changes in hydraulic, military, and agricultural techniques introduced by what is known as the "medieval technological revolution."

By contrast, the artist-engineer at the height of the fifteenth century was a prominent figure, sought after by the most powerful patrons, generously remunerated, and often exhibited as an ornament in courts. There was fierce competition to secure the services of the most-renowned engineers, feted not only by popes, princes, and republics in the Italian peninsula but also by leading European rulers and even by powerful sultans. Many engineers, including Aristotele Fioravanti, Francesco di Giorgio, Fra Giocondo, Giuliano da Sangallo, and Leonardo, undertook tiring journeys to work on projects commissioned by patrons in Italy and beyond the Alps: the design and building of churches and

of palaces for royalty and the powerful nobility; the construction of fortifications and the production of weapons; the design of efficient aqueducts, of bridges, navigable canals, and dikes; the invention of special effects for stage performances and courtly festivities—in addition, of course, to the execution of paintings, sculptures, and decorative artifacts.

In an age that witnessed continuous wars, the formation of the principal seignories, the robust expansion of trade and industrial production, and intense urbanization, the contribution of these practitioners—with their multiple skills refined in that laboratory of artistic and technological innovation that was the Renaissance workshop—became ever more important.

This process had two closely related effects. First, the artist-engineer enjoyed growing social prestige, which soon came to resemble the honors bestowed by sovereigns in the classical age upon the most eminent engineers, such as Dinocrates, protégé of Alexander the Great, and Apollodorus of Damascus, admired by the Emperor Trajan. In turn, this greater visibility stimulated the artist-engineers to embark on an ambitious process of literary qualification to earn the recognition enjoyed by the humanists who graced the courts with their elegant Latin orations and poetry, discussions on Aristotelian natural philosophy and logic, and commentaries on the ancient Latin and Greek texts. Many Renaissance artist-engineers made enormous efforts to turn themselves from uncultured, literarily "mute," and purely operative technicians into authors of well-organized texts based on classical models and replete with quotations from ancient sources.

The figure of the engineer-author had been substantially absent from Western culture since the age of Vitruvius and Hero of Alexandria. The emergence of these new players in the literary arena was marked by distinctive features that had an impact on the overall development of Renaissance culture. The artist-engineers' writings rarely display a coherently organized structure—in the vast majority of cases they appear as ambitious but sketchily outlined and ultimately unfinished works. Moreover, none of the many literary efforts of Italian engineers in the fifteenth century was ever disseminated in print, but their texts circulated extensively and were

widely read—as attested by the considerable number of copies and derivative versions surviving in libraries and archives across the world.

The fortune enjoyed by this literary genre and its authors was due not only to the novelty of the topics discussed and the interest aroused, in an age of veneration for classical culture, by the revival of Vitruvius's illustration of mechanical devices in Book X of his *De architectura*. It depended above all on the fact that these works displayed a new dimension of the very concept of "text," as verbal descriptions now engaged in a constructive dialogue with a vast apparatus of evocative visual representations.

The most original contribution of these new authors was indeed the systematic recourse to images and the prominent role assigned to them. Taccola, Francesco di Giorgio, and later—even more eloquently—Leonardo da Vinci all emphasized the limits of purely verbal descriptions, incapable of making technical systems understandable without the decisive support of images. Thanks to his mastery of drawing, only the artist-engineer could deal competently with subjects pertaining to architecture and machines, as well as to anatomy, hydraulics, and geology.

This generation of technicians contraposed a new concept of learning, characterized by observation, know-how, and visual expression, to traditional knowledge, based on eloquence, rhetoric, and listening. Leonardo's definition of himself as an "unlettered man" should be viewed not as paradoxical praise of ignorance of bookish culture but as a resolute statement of the need to combine the reading of texts with the careful observation of phenomena and to describe works of art and nature not with words alone but above all with drawings. Aware of the vital contribution that he could make thanks to his technical and drawing skills, the artist-engineer engaged in a dialogue of equals with the humanists, thus paving the way for the long-lasting affirmation and vast dissemination of the *machinae pictae*, the portraits of machines, to which the lavishly illustrated and extremely popular volumes of the authors of the *Theaters of machines* also effectively contributed.

It should be kept in mind that, on entering the literary scene, the Renaissance artist-engineers did not rely on drawing and technical skills alone. They also strived to assimilate the achievements of classical technical and scientific culture, often traveling to Rome in an attempt to

penetrate the secrets of the great Roman civilization through direct inspection of the surviving material evidence. In their antiquarian curiosity we recognize the same veneration displayed by the humanists for classical authors. This intellectual motivation is eloquently illustrated by their search for "intermediaries" who could help them overcome their ignorance of classical languages and lack of mathematical competence. It is not fortuitous that, throughout the fifteenth and most of the sixteenth century, a reciprocally self-interested convergence developed between these new technicians and the most eminent humanists: Filippo Brunelleschi and Paolo dal Pozzo Toscanelli; Taccola and Mariano Sozzini; Francesco di Giorgio and Ottaviano Ubaldini; Leonardo da Vinci, on the one hand, and Luca Pacioli and Giorgio Valla, on the other. Fra Giovanni Giocondo, who combined engineering and humanist skills, was to remain an exceptional figure.

Later on, a new generation of humanists—the so-called restorers of ancient mathematics and mechanics—came to the fore. They claimed that successful practical applications required not only skill in draftsmanship and practical experience but also the mastery of geometry and the perfect knowledge of the universal principles of mechanics. In the refined works of the restorers of ancient mechanics, including Galileo—who drew inspiration from their lessons—the realistic representation of machines was replaced by geometrical diagrams emphasizing the abstract rules that preside over the workings of all mechanical devices. The priority of theory over practice also entailed a clear social distinction between engineers cognizant of the general laws of mechanics and practitioners unversed in mathematics.

I FOCUSED ON this fascinating scenario in the *Berenson Lectures,* which I delivered at Villa I Tatti between October and December 2014.

The present volume is divided into three chapters reflecting the main topics addressed on that occasion: the explosion of intense activity in pictorial visualization of machines and technical systems thanks to the innovative contribution of Sienese engineers; the revolution in graphic conventions and the new concept and goals of the representation of machines introduced by Leonardo da Vinci; and the progressive affirmation, from the second half of the sixteenth century, thanks to the

restorers of ancient mechanics and to Galileo, of an entirely new method of interpreting and depicting machines—no longer in realistic portraits, but reduced to the immaterial figures of Euclidean geometry.

I AM MOST GRATEFUL to Lino Pertile, who, as director of Villa I Tatti, invited me to give the 2014 *Berenson Lectures,* warmly welcoming my proposal to devote them to the visual representation and conceptual interpretation of machines in the Italian Renaissance. I should also like to express my deep appreciation to Alina Payne, current director of the prestigious American institution in Florence, for having encouraged and supported the transformation of the three *Lectures* into a richly illustrated volume.

I wish to thank Jonathan Mandelbaum for his competent translation of the unpublished manuscript from Italian and the staff of the Museo Galileo, particularly Giulia Fiorenzoli, Elisa Bonaiuti, and Laura Manetti for their valuable help in the final revision of the text.

THE FIRST TWO CHAPTERS of this volume focus on personalities and issues that I examined in earlier publications, all in Italian. I have revisited them here from a different angle, updated the bibliography, and added new reflections. Some of the pages devoted to Francesco di Giorgio in the second part of Chapter 1, for instance, contain analyses that I first developed in the introduction to the exhibition on Sienese machines in 1991 (Galluzzi 1991).

In Chapter 2, I present some of the conclusions of my earlier essays (see especially Galluzzi 1988, 1996a, 2003, 2006 ed., and 2015) with bibliographical updates, additions, and revisions.

Lastly, the opening section of Chapter 3 deals with topics discussed in Galluzzi 2005.

The

Italian Renaissance

of Machines

The Sienese Machines

Before Taccola

The production of drawings of machines and technical devices intensified from the first half of the thirteenth century onward. This process began with significant but isolated examples—such as the *Notebook* (ca. 1230) by Villard de Honnecourt from Picardy, who depicted a small sample of devices in use on medieval construction sites.[1] It was revived, a century later, by Guido da Vigevano, author of the *Texaurus* (1335), a text featuring a large apparatus of visual representations of military contrivances inspired by late Roman sources.[2]

The trend accelerated between the late fourteenth and early fifteenth centuries; within a few decades, the modest portfolio of "intentional" drawings of machines inherited from the Classical Age was transformed into a vast and varied archive of images.[3] These images had a strong impact owing to the wide circulation of an impressive number of copies and, later, to the diffusion across Europe of the bestselling genre of the "Theaters of machines" in which they were reproduced.

While it is certain that ancient authors of engineering and mechanics texts used images to illustrate the devices and technical systems described in their treatises, we know almost nothing about the channels through which these sources were transmitted over time.

However, classical technical texts almost always circulated through copies without the iconographic apparatus originally designed by their authors. The most conspicuous example is offered by Vitruvius's *De architectura*. The protagonists of the mid-fifteenth-century revival of a keen

interest in his celebrated treatise on architecture faced the daunting challenge of restoring the genuine meaning of a text transmitted through manuscripts that were not only severely corrupted but also completely devoid of illustrations.

Other ancient authors of treatises on machines and mechanical systems met with a different fate. Their endeavors are documented by a handful of manuscripts accompanied by an often substantial corpus of illustrations. Although very old, these manuscripts were compiled many centuries after the original texts were written. The oldest surviving illustrated copies of Greek and Hellenistic treatises on machines date from the ninth century, and we have no knowledge of the adaptations and transformations they underwent during the many centuries from their original compilation. This raises the issue of the authenticity of their illustrations. Are these drawings of machines faithful copies of those produced by the original authors? Or are they interpolations and/or inclusions added centuries later in order to make the obscure textual descriptions of machines intelligible?[4]

In any event, the exiguous number of illustrated manuscripts on technical subjects dating before the end of the first millennium CE, their wide dispersion, and their reappearance on the scene of Western culture only around the mid-fifteenth century suggest that in the decades between the late fourteenth and early fifteenth centuries—which saw the rebirth of the long forgotten genre of the illustrated technical treatise—these documents and their iconographic apparatus were unknown.[5]

This must be kept in mind when attempting to bring into focus the points of reference and the motivations that inspired the work of Mariano di Iacopo, called Taccola (Siena 1382b–ca. 1453), who, for many reasons, should be regarded as the first effective promoter of a movement for the cultural and social recognition of technical knowledge and practice that was soon to gain widespread and lasting momentum.[6]

TO FULLY GRASP THE RADICAL CHANGE introduced by the Sienese author and his original approach to those ancient and admired technical traditions, we need to concentrate on the careers, manuscript production, and professional skills of the authors of the most significant technical treatises that appeared shortly before Taccola or in his time.

Among Taccola's predecessors, a prominent role should be assigned to Konrad Kyeser (Eichstätt 1366–after 1405), a physician by training but a soldier by profession, who in the first years of the Quattrocento authored a treatise entitled *Bellifortis,* dedicated to Rupert, Elector Palatine.[7] As the title indicates, the *Bellifortis* is primarily devoted to military techniques and displays some of the earliest representations of firearms. The finest among the many manuscript codices of the *Bellifortis* contain images, some of them water-colored, featuring war scenes set in roughly sketched landscapes and architectures peopled by soldiers and horsemen brandishing threatening weapons. The dialogue between Latin text and illustrations appears balanced and fully integrated, but the quality of the images, which are not by Kyeser, is uneven. The artist was not always able to effectively confer a plausible sense of depth on the devices. The attack and defense machines often seem askew, disproportioned, and clumsy. Like the works of later authors, the *Bellifortis* emphasizes the role of technicians as advisors to the most powerful warlords while constantly expressing admiration for ancient technical knowledge.

Despite the prevalence of war devices, Kyeser's treatise also contains images of nonmilitary subjects, often expressed with joyful vitality. One vivid example is the highly animated scene of Philo of Byzantium's bath with separate compartments for men and women (Figure 1).[8]

A generation later, Giovanni Fontana (1395–after 1454) of Padua compiled a richly illustrated text extolling the wonderful performance of ancient and modern machines.[9] The title, *Bellicorum instrumentorum liber,* should not mislead us. Military devices represent a modest share of the images of machines contained in the single surviving manuscript copy, which is not in Fontana's hand. The choice of the title presumably reflected a desire to please the patron to whom Fontana intended to offer the treatise. The unnamed dedicatee was without doubt a man of war, for many years incorrectly identified as the great commander—Piedmontese by birth but Venetian by adoption—Francesco da Busone, better known as the Carmagnola.[10]

Like Kyeser, Fontana was a physician by training. His works display a far more explicit commitment than Kyeser's to retrieving, explaining, and promoting ancient knowledge on machines. In style and motivation, Fontana's work is comparable to that of the humanists who, during the

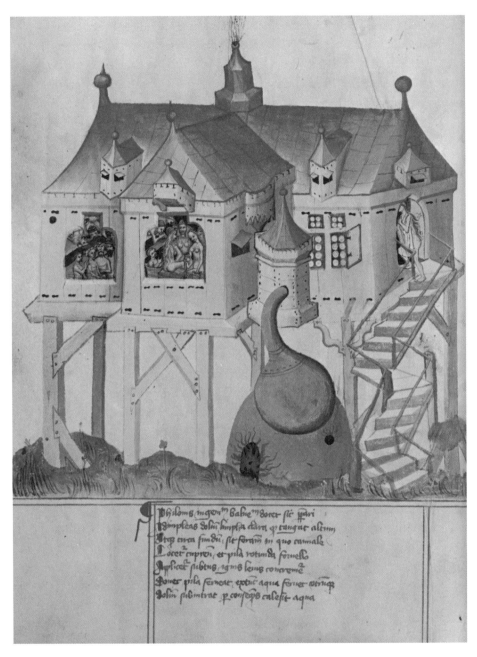

FIG. 1 Konrad Kyeser: Philo's bath.

same decades, were assiduously reviving long-forgotten texts that provided precious information on the technical knowledge of the ancients. Fontana is interested not only in Greek authors—Aristotle, Plato, Philo of Byzantium, and Hero—but also in Roman, medieval, and Arab authors. He exerts himself in emending these texts and, above all, in interpreting and elucidating through visual renderings the devices described in them.

Fontana was not an artist, nor did he execute the many drawings illustrating his treatise. However, he engaged in a close dialogue with Giovanni Bellini on issues regarding linear perspective.[11] His familiarity with eminent artistic personalities and circles explains the often high quality of the illustrations by an unknown artist, as well as the adoption of innovative graphic conventions. These include foreshortening, transparent views, plan and elevation views, and, in addition to the overall image of the device, a separate visualization of its key components (Figure 2).[12]

Alongside these learned figures, other contemporary actors in Italy played an equally important, albeit different, role in the cultural and social promotion of technical skills. They did not write treatises, nor did they leave notes or sketches from which to reconstruct their processes of innovation and discovery. Unlike Kyeser, Fontana, and—as we shall see shortly—Taccola, evidence of their remarkable professional gifts is provided by their daring construction works and by the testimony of contemporaries awestruck by the innovative character of their achievements.

Filippo Brunelleschi (Florence 1377–1446) comes most readily to mind as the most emblematic representative of this different category of promoters of the culture of machines.[13] His architectural heritage displays his extraordinary talent more forcefully than any treatise. "Pippo," as he was nicknamed, did not disclose any drawings of his ambitious building projects and brilliant technical solutions: civilian and military architectural structures; water regulation systems; machines for the construction site, for creating special effects at festive events or on theater stages; and vehicles for transporting heavy loads on land and water.

A generation later, another engineer, Aristotele Fioravanti (Bologna 1415–Moscow [?] 1486) followed the tradition of carefully concealing the technical procedures that enabled him to realize a series of exceptional projects that were to make a deep and lasting impression on contemporary and later engineers.[14] As with Brunelleschi, there are no surviving

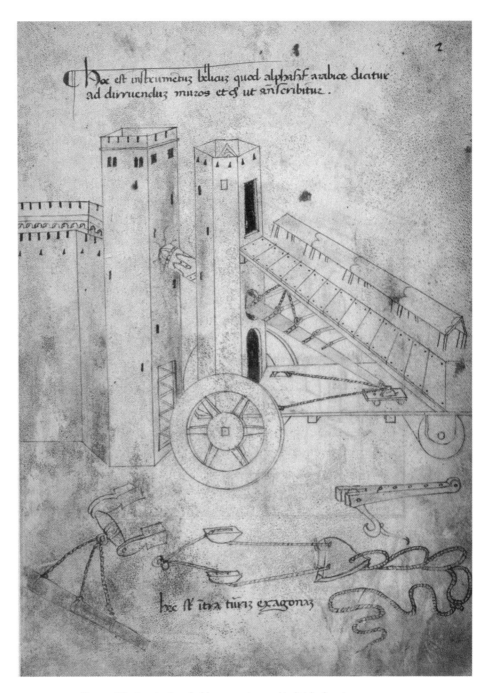

FIG. 2 Giovanni Fontana's siege ladder: overview and individual parts.

autograph texts, drawings, or sketches by Aristotele illustrating the ingenious machines and mechanical systems that he designed and implemented. Yet his work had a universal impact. Sought after by the highest civil and religious authorities of the Italian peninsula, Fioravanti became famous not only across Europe but also on the southern shores of the Mediterranean. Today we would describe his success as "global"—the result of his reputation as the master who moved towers without damaging them, who miraculously consolidated precarious architectural structures, and planned complex river regulation works. This fame turned him into a constant wanderer among the courts of Italy's most powerful rulers, who competed for his services. His nomadic life ended in a lengthy stay in Moscow, where he received important commissions directly from the tsar. As with Brunelleschi, Fioravanti's inventions were divulged through textual and figurative descriptions by contemporary and later engineers.

The Rediscovery of Taccola's Manuscripts

A native of Siena, where he spent his entire life, Taccola studied to become a notary without ever practicing the profession. Surviving documents attest to his work in wood sculpture, miniatures, and drawing in the artistic circles of Iacopo della Quercia, Domenico di Bartolo, and Domenico dei Cori. He was appointed by the Sienese government to the senior administrative positions of Camerarius of the Domus Sapientiae (General Secretary of the University College) and Viario (Superintendent of roads). Taccola authored two large treatises: *De ingeneis*,[15] in four books, and *De machinis*,[16] in ten books. The autograph manuscripts of these works are preserved in Munich and Florence, forming a total of some 580 pages packed with texts, sketches, and drawings.

After his death, Taccola vanished from the collective memory until the early nineteenth century, when Giovan Battista Venturi—a learned physicist from Reggio Emilia, who also played an important role in the rediscovery of Leonardo's manuscripts—fixed his competent gaze on Taccola's last compilation, the *De machinis*.[17] In Paris, Venturi was able to examine the parchment manuscript, richly illustrated with polychrome figures, containing the copy taken from Taccola's autograph by Paolo Santini.[18] Through channels unknown to us, perhaps when Taccola was

still alive or shortly after his death, this splendidly illuminated manu-
script found its way to Sultan Mehmed II's fine collection of manuscripts
in Constantinople, from where it was taken to Paris in 1687 by the French
ambassador Pierre de Girardin.[19]

After capturing Venturi's attention, the precious manuscript at-
tracted that of the French emperor Napoleon III, who described its con-
tents in the four-volume history of artillery compiled between 1847 and
1871 in collaboration with colonel Ildephonse Favé.[20]

Neither Venturi nor Napoleon III was aware of Taccola's identity.
While De machinis found its way back into circulation in the 1820s through
these curious channels, it was only at the end of the nineteenth century
that Taccola's other work, De ingeneis, and its author's identity came to
light. Marcelin Berthelot[21] and Theodor Beck[22] were the first to describe
the contents of the autograph manuscript, preserved in Munich, which
contains the first two books of De ingeneis. At this point the Sienese engi-
neer was finally recognized also as the author of De machinis.

After these manifestations of interest, a veil of silence descended over
Taccola until the mid-twentieth century, when Lynn Thorndike, the em-
inent historian of magic and experimental thought, drew attention again
to his works. In an article in 1955, Thorndike described in detail not only
the first two books of De ingeneis but also the other surviving codex in
Taccola's hand, Ms. Palatino 766 of the Biblioteca Nazionale Centrale in
Florence, containing the third and fourth books.[23]

Thorndike's article—followed, a few years later, by Bertrand Gille's
seminal book on Leonardo and the Renaissance engineers[24]—inaugurated
a long season of in-depth studies and refined editions of Taccola's man-
uscripts that have restored an intellectual physiognomy and a voice to the
Sienese author.

When Gille's monograph appeared, scholars had long reached sub-
stantial consensus on the stages that marked the process of social recog-
nition of practitioners at the dawn of the modern age. In their interpre-
tation, the intense growth of urbanization imposed the construction of
massive architectural structures for civil, religious, and military pur-
poses; of roads and waterway networks to transport merchandise; and the
design of innovative systems to supply water to populous communities,
to power watermills, and to exploit mineral resources. These challenges
could only be faced by talented practitioners, who thus were in great

demand in the major seignories and republics of northern and central Italy in the first half of the fifteenth century, triggering a process of social and cultural promotion of technical skills that culminated in the unrivalled contribution and global success of Leonardo da Vinci.

The rediscovery of Taccola's manuscripts, compiled many years before the birth of the genius from Vinci, forced scholars to reconsider this narrative. Mariano's works, together with Francesco di Giorgio's *machinatio*, strongly inspired by his Sienese predecessor, made it abundantly clear that it was no longer possible to write the history of the evolution of technical knowledge in fifteenth-century Italy focusing only on episodes and players in Florence and Milan, and to a lesser extent in Venice and Rome. Siena and its engineers had not been taken into consideration, despite the fact that major scholarly contributions had for some time provided solid documentary evidence of the level of excellence reached in many fields by the technicians active in the small town of central Tuscany. Suffice it to mention the monumental work by Bargagli Petrucci of 1906 on the construction of the extraordinary network of *bottini,* the underground aqueduct in Siena, between the thirteenth and fourteenth centuries.[25]

The earthquake produced by the rediscovery of Taccola's manuscripts and the evidence of their strong influence on Francesco di Giorgio's *Treatise on architecture and machines* triggered a process of revision of the traditional interpretation of the evolution of technical knowledge. Historians were confronted with the emergence of a tradition—that of Sienese machines—that had enjoyed a vigorous and lasting success, as attested by the impressive number of manuscripts and printed copies that scholars were unearthing in libraries and archives across Europe.[26]

It is no exaggeration to speak of an earthquake. With Taccola's manuscripts, a massive number of sketches and drawings resurfaced, often accompanied by descriptive texts, illustrating a wide variety of machines and technical systems used in all fields of human activity. By comparison, the sources on which historians had previously relied in their attempts to reconstruct the development of techniques from antiquity to Leonardo seemed disproportionately meager and fragmented. Moreover, they consisted primarily of literary accounts, contracts, and payments, while "intentional" visual representations of technical devices were extremely rare.

The more than 2,000 drawings and sketches in Taccola's *De ingeneis* and *De machinis* proved a true Eldorado for scholars. These documents

were an exciting invitation to observe from a new perspective the machines and mechanical systems illustrated by better-known authors, such as Francesco di Giorgio, and to reconsider the question of the sources for Leonardo's sublime inventions.

In 1972, in the introduction to the first intellectual biography of Taccola, Frank Prager and Gustina Scaglia recognized that his manuscripts imposed a reexamination of the stages and the actors of the process of innovation that characterized the fifteenth century. His works, they emphasized, add

> a new dimension to Taccola's image and a new series of facts
> to the history of Quattrocento art. New problems also arise
> from Taccola's recorded works, for example, whether his
> machines will explain some of the mechanical work of his
> predecessors and followers and whether his drawings will
> allow sharper dating of other artistic works.[27]

Indeed, Taccola's manuscripts shed new light not only on the progress of technical knowledge and practices but also on important aspects of artistic expression in the first half of the fifteenth century—a period in which the prominent role of Sienese art had long been recognized.

Unsurprisingly, given the dual nature—technical and figurative—of his work, two experts joined forces to restore an identity to Taccola, to cast light on the artistic environment in which his remarkable graphic talent was nurtured, and to interpret and contextualize the Sienese machines: a historian of architecture and art, Gustina Scaglia, who had earlier displayed interest in Francesco di Giorgio; and Frank Prager, a noted historian of ancient, medieval, and early modern technology. The two distinguished American scholars collaborated in the preparation of a complete edition of the first two books of *De ingeneis,* which was published in 1984, accompanied by a facsimile of the autograph manuscript.[28] Previously, in 1971, Gustina Scaglia had edited the text of the autograph manuscript of *De machinis,* also with a complete facsimile reproduction.[29] Two years earlier, in 1969, James Beck—again a historian of art, not of technology—had inaugurated the season of the publications and facsimile reproductions of Taccola's autograph manuscripts with his edition of Ms. Palatino 766 of the Biblioteca Nazionale Centrale in Florence, containing

the third and fourth books of *De ingeneis*.[30] In just over thirty years, therefore, the entire corpus of Taccola's works became available to scholars.[31]

The keen interest of historians of art and architecture in manuscripts entitled *De ingeneis* and *De machinis* may have been the consequence of a certain disappointment on the part of the historians of technology who first examined those sources in the hope of finding sensational intuitions or discoveries that had paved the way for Leonardo. Failing to come across evidence of pioneering technical anticipations, their interest faded.

The publication of Prager and Scaglia's biography of Taccola and of his manuscripts was followed by a long period of stagnation. By contrast, research intensified on the conspicuous role played by machines in Francesco di Giorgio's *Treatise*, even though his devices continued to attract far less attention than his studies on civil, religious, and military buildings. Suffice it to mention that, while a critical edition of his *Treatise* on architecture has been available for some time, thanks to the efforts of historians of architecture and art,[32] the splendid *Opusculum de architectura*[33]—which, despite its title, consists almost exclusively of drawings of machines— still remains unpublished. Moreover, a beautiful facsimile of his *Codicetto* (filled with drawings and texts on machines) was published, but without transcription of the texts, critical apparatus, or commentary.[34]

Francesco di Giorgio, who had early access to Taccola's autograph manuscripts, was the main agent for the transmission of his older fellow citizen's literary heritage.[35] Francesco copied the entire corpus of texts and drawings of *De ingeneis* into his *Codicetto Vaticano*, which provides the earliest documentary evidence of his interest in machines and technical subjects.[36]

The *Codicetto* and, shortly thereafter, the *Opusculum de architectura* mark the start of a dissemination of texts and—above all—images derived from Taccola that, for scope and persistence, has few equivalents. Ladislao Reti[37] and then Frank Prager, Gustina Scaglia,[38] and other scholars reconstructed the vast diffusion of the Taccola corpus, particularly its figurative dimension, well beyond the Christian world, as attested by dozens of manuscripts and—from the late sixteenth century onward—by many richly illustrated printed books.[39]

Francesco suffered the same fate as Taccola. The presentation, in his *Treatise*, of an exhaustive analysis of the theory and practice of architecture

together with a detailed illustration of mechanical devices had an enormous impact on the architectural and technical production throughout the sixteenth century and beyond. Yet his name was never mentioned. He achieved great visibility thanks to his many architectural projects and his art works, but until the mid-nineteenth century his activity as an inventor and designer of civil and military machines was overlooked. This neglect is eloquently confirmed in the biography of the Sienese architect that Vasari added in the second edition of his *Lives of the most excellent painters, sculptors and architects.* Emphasizing Francesco di Giorgio's talent as an artist, Vasari made only one fleeting reference to his technical skills, in particular to his interest in "war machines and instruments of the ancients."[40]

The Sienese Archimedes: A "Humanist of Machines"

After the publication of Taccola's manuscripts, scholars have endeavored to bring into focus the readership for whom he conceived those works and to reconstruct the cultural and social motivations that led him to compile and extensively illustrate a technological corpus of unprecedented dimensions.

Attention has been paid, in particular, to the contribution that Taccola's manuscripts offer to the understanding of the models and social mechanisms of Renaissance patronage,[41] and to explaining why Taccola, abandoning the strict discretion that prevailed among engineers of earlier generations and among many of his contemporaries, openly showcased his "inventions." Scholars have also discussed—and continue to discuss—Taccola's role in the emergence of an awareness of the need for effective systems of public protection of what we would today define as "intellectual property."[42] Careful analyses have also been devoted to the graphic methods and conventions that he used to depict machines and technical systems.[43] From this standpoint, his drawings mark a major shift from the medieval figurative language of machines—hard to decipher for our eyes trained in perspective—to the adoption of strategies to render even the most complex devices intuitively understandable.

Considerable uncertainty persists as to the motives that inspired Taccola to compile manuscripts replete with drawings and sketches. It has been rightly emphasized that *De ingeneis* and *De machinis* do not belong to the genre of workshop notebooks of medieval and Renaissance

artists and practitioners. Nor can they be regarded as instruction manuals for workers in charge of the construction of machines and instruments. Taccola's use of Latin suffices to demonstrate the untenability of this assumption. On the other hand, the ordinary nature of his devices, along with the naïve freshness of his military stratagems, rules out the possibility that his manuscripts record the results of original researches conducted by Taccola himself.

In recent decades, scholars have gradually come to recognize the need to introduce specifications and distinctions in the vast galaxy of fifteenth- and sixteenth-century manuscripts containing textual descriptions and drawings of machines that have been traditionally viewed as a homogeneous block falling under the collective heading of "manuscripts of Renaissance engineers." The first crucial distinction to be made is that between architecture and machines. Among the protagonists of the renaissance of machines in the first half of the fifteenth century, there is no sign of the interest in theoretical architectural issues or in civil, religious, and military constructions that was to characterize the work of artist-engineers of later generations. Stimulated by the work of Leon Battista Alberti and, above all, by the rediscovery of Vitruvius, the intrinsic connection between architecture and machines was affirmed later in the century by Francesco di Giorgio and became the standard model in the sixteenth century.

A further distinction to be introduced is that between texts prepared for presentation to patrons and notebooks recording original ideas and solutions developed through personal experience and to be hidden from indiscreet eyes.

There is substantial consensus among scholars that Taccola's manuscripts belong to the category of technical works intended for eminent patrons—a genre that boasted distinguished precedents in classical antiquity—such as the works of Vegetius, Vitruvius, and Frontinus, to name but a few. However, the attribution of Taccola's manuscripts to this category raises some thorny questions. To begin with, neither *De ingeneis* nor *De machinis* left their author's study during his lifetime. He may well have intended to write richly illustrated manuscripts for an illustrious patron, but, during their compilation or after their completion, that intention faded to the point of being abandoned.

Let us examine the autograph manuscript of the first two books of *De ingeneis* preserved in Munich. The author's original plan seems clear:

many folios feature a large drawing in a central position below or above which Taccola wrote, in a neat hand on evenly spaced lines, Latin texts with no amendments, which often open with an illuminated capital letter. This refined layout characterizes a significant number of sheets of the first book of *De ingeneis*. At a certain point, however, for reasons unknown, Taccola gave up the idea of preparing an elegant dedication copy. The lack of any explicit reference in the manuscript to an intended recipient is therefore not surprising. The initial orderly method of compilation gave way to a scrapbook of fragmentary notes and sketches with no logical or thematic order. The spaces around the accurate illustrations in the center of the page were filled with memoranda, small rapidly executed drawings, and lists of references to other sheets of the manuscript dealing with similar topics.

Books III and IV of *De ingeneis*, preserved in Florence, tell a different story. This important document displays a far more orderly and careful organization, in which we discern the author's intention of preparing a product worthy of a powerful patron.[44] Thus it comes as no surprise that the manuscript opens with a solemn Latin dedication to Emperor Sigismund of Hungary most probably composed during the future Holy Roman Emperor's long sojourn in Siena in 1432, when he was accompanied by a retinue of five hundred horsemen and one thousand horses; for the Tuscan city, Sigismund proved both a powerful protector and an expensive guest.[45]

To enhance his tribute, Taccola adorned his text with a carefully executed portrait of the emperor (Figure 3).[46] It shows Sigismund, protected by elegant armor, looking up to the heavens, from where he receives the order—from the Lord, no less!—to defend the beloved people of Siena. Defend them from what and from whom? The portrait provides an unequivocal answer. While paying devout attention to the divine order, Sigismund is already poised to obey it. His left foot forcefully crushes the tail of a lion, a clear allusion to the Marzocco (a seated lion bearing a shield adorned with a lily), symbol of Florence in ceaseless combat with Siena and particularly threatening at the time.

Taccola's Florence manuscript contains other explicit references to the imperial patron: the drawing of the Sienese she-wolf, accompanied by a text extolling her loyalty to the Empire;[47] an evocative portrait of Saint Dorothy (Figure 4),[48] widely worshiped in Hungary, along with the

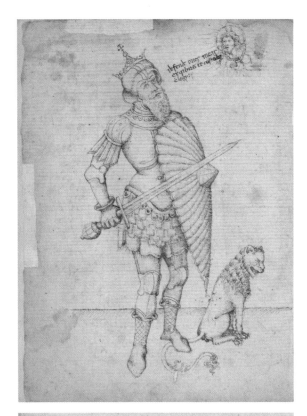

FIG. 3 Taccola: portrait of Emperor Sigismund.

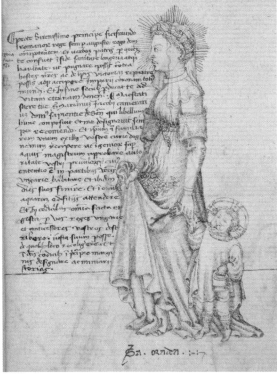

FIG. 4 Taccola: ideal portrait of St. Dorothy.

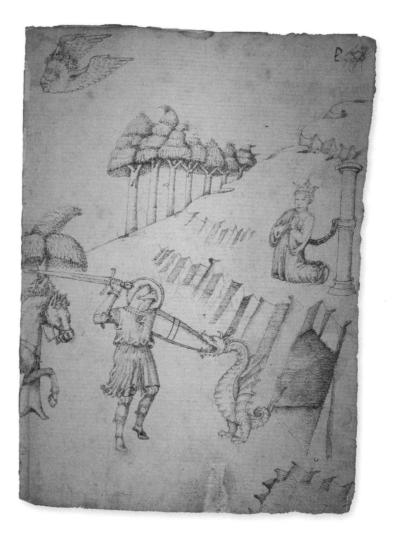

FIG. 5 Taccola: Saint George slaying the dragon.

author's offer to make his military skills available to the emperor, whose role as the defender of Christianity from the infidels is alluded to, at the end of the manuscript, by Saint George slaying the dragon (Figure 5).[49]

While this elegant manuscript qualifies unquestionably as a dedication copy, we should not overlook a few distinct anomalies. The first regards the dedication text, curiously "confined" to the top margin of the first page, almost entirely taken up by a drawing that illustrates the method for measuring the height of a tower with a sextant (Figure 6): a scene totally unrelated to the laudatory dedication.[50] It is truly perplexing that a text to which Taccola attached critical importance, given the patron's exceptional status, was placed in a position of such marginal visibility.

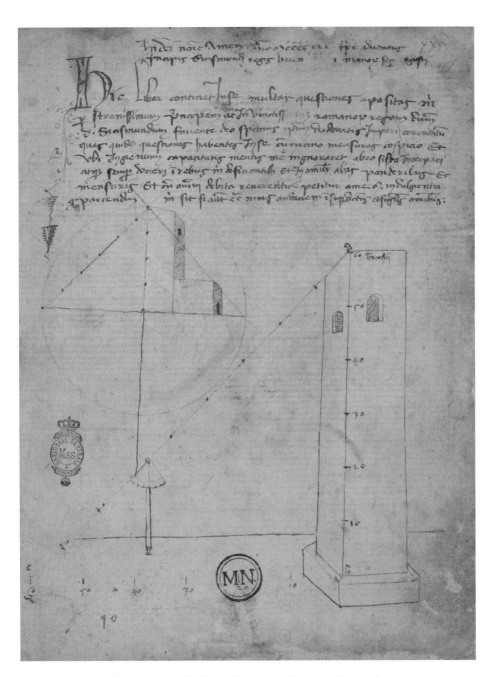

FIG. 6 Sheet from *De ingeneis* III–IV with Taccola's dedication to Sigismund.

No less perplexing is the fact that, in the immediately following folio, Taccola jotted down the title of the manuscript ("Beginning of the third book on uncommon devices and machines")[51] in minuscule characters above a large drawing illustrating a method for leveling with a plumb line. The curious position of the title speaks in favor of his decision to dedicate the work to Sigismund only after completion of the manuscript.

The title highlights a further inconsistency. How could Taccola consider dedicating to the emperor a manuscript whose very title *(Liber Tertius)* obviously indicated that it was but a section of a larger work? The frequent references in the Florence manuscript to folios in the first two books of *De ingeneis* make it even clearer that it was not a complete work. How could Taccola have imagined that these anomalies would have escaped the notice of the emperor and his counselors?

Furthermore, the first page of the Palatine manuscript, with its cramped dedication, displays the autograph Roman numeral XXVII, another explicit sign of the manuscript's being a segment of a larger work and of Taccola's embarrassing mix-up.

THESE CONSIDERATIONS SUGGEST THAT the Florence manuscript was compiled at an earlier date as an expansion and continuation of the topics discussed in the first two books of *De ingeneis*. When the emperor made his appearance, Taccola, in the hope of reaping personal benefits, decided to personalize the document by hastily and clumsily adding the dedication, the portrait, and celebratory illustrations. In any event—and unsurprisingly—Taccola did not offer the work to his potential patron but kept it in his possession until his death.

Taccola's other autograph manuscript, *De machinis,* does offer the appearance of a finished work. Its careful layout, consistent graphics, and texts almost entirely free of corrections and afterthoughts perfectly match the requirements of a manuscript conceived as a dedication copy. However, we observe once again—particularly in the initial pages—the insertion at a later date of memoranda,[52] and references to pages with numbers much higher than those present in the codex.[53]

The opening text of *De machinis* contains no clues as to the identity of the patron to whom Taccola may have intended to present it.[54] There

can be no doubt, however, that the text was not produced for Sigismund. It was drafted after 1441, at least four years after the emperor's death (December 1437). Taccola offers his purportedly innovative military solutions to Christendom, threatened not only by external enemies, but weakened, above all, by internecine struggles among Christian sovereigns. In his denunciation, we perceive the echo of the continuous wars—particularly between Milan and Venice—in which Christian principalities and republics depleted their strength instead of uniting forces against the Turk.

He also inveighs against those "evil Christians" who seek by every means to usurp the legitimate power of princes and republics instead of dedicating themselves to good works and the salvation of souls. The target of this tirade is clearly the Church, which spared no effort in attempting to bring civilian authority under its control.

In another passage of *De machinis,* Taccola excoriates both the expansionist policy of the Duchy of Milan and the secular ambitions of the Church: "Two fundamental conditions are required to subjugate Italy; first, to be always in harmony with the Supreme Pontiff and, second, to take full control of Milan."[55]

In the opening text of *De machinis,* Taccola calls on an authority *super partes* to put an end to these dramatic divisions of the Christian world, which, just a few years later, while he was still alive, led to the fall of Constantinople and to the end of the Eastern Roman Empire. It is hard to determine whether he had a specific person in mind or whether he was simply expressing a deeply felt desire. He repeatedly praises the virtues of a figure whom he never identifies but whom he defines as *Dux bataliarum* (the Lord of War). The portrait that emerges is that of a wise and brave military commander, who, mastering the most sophisticated war strategies, confronts and defeats the enemies of Christendom.

We cannot exclude the possibility that Taccola envisaged dedicating *De machinis* to Sigismund's successor, his son-in-law Albert II, who in those years was engaged on multiple fronts: the Turks in Hungary; the opposition of the local nobility; and the Hussite rebellion in Bohemia supported by the Polish princes. It is worth recalling that the reign of Albert II witnessed what came to be known as the "second Western schism," which

resulted in the election, at the Council of Basel in 1439, of the Antipope Felix V, in civilian life Amadeus VIII of Savoy. Taccola may also have considered Albert II's successor, Frederick III of Habsburg, crowned emperor in Rome in 1440, as a possible dedicatee. Frederick's life was no easier than that of his predecessor, locked as he was in a bitter conflict with his brother Albert VI, intent on overthrowing him.

Irrespective of the identity of the dedicatee, *De machinis,* like *De ingeneis,* remained in Taccola's possession and, after his death, followed an itinerary whose stages are impossible to trace until its reappearance in the late 1950s.

A curious, indeed paradoxical, fact deserves mention. One splendidly illuminated copy of *De machinis,* in all likelihood produced from the autograph manuscript when Taccola was still alive, met with a fate that its author could never have imagined.[56] While intended by Mariano to offer Christendom the support of his military engineering skills against the Turks, it ended up in the hands of its archenemy, Sultan Mehmed II. The author of this cynical recycling operation naturally took care to conceal the author's name and, above all, to cover with conspicuous dark watercolor brushstrokes the passages of the opening text in which Taccola exhorted Christians to join forces against the infidels (Figure 7)![57]

It has been said that Taccola's manuscripts should be read bearing in mind that they were addressed to two different kinds of readers: the patron and the practitioner.[58] It has also been argued that the ambiguity of his graphic and textual language is the consequence of his effort to make his work understandable to a powerful, nonspecialist patron and, at the same time, to draw and describe machines in sufficient detail to allow craftsmen to construct them.

I have already pointed out the evidence suggesting that Taccola's prime motive in compiling *De ingeneis* and *De machinis* was not to present the manuscripts to a patron. As for the practitioner, it is my belief that he was extraneous to the horizon and objectives of the Sienese engineer and that civil and military contractors might even have been puzzled by his drawings and Latin texts. Not only would they have failed to find in them any feasible technical innovations but they would probably have been unable even to comprehend their meaning and goals.

FIG. 7 Taccola's dedication blacked out in the Paris copy of *De machinis*.

If Taccola's manuscripts cannot be assigned either to the genre of presentational works for authoritative patrons or to the category of workshop notebooks, what drove him to expend so much energy in compiling them? Clearly he shared the same intellectual tensions and motivations that animated the humanist movement. His works show his ambition to restore dignity, social visibility, and authority to technical literature. He strove for recognition as the author of a new, or rather renewed, literary genre that drew inspiration from the most successful technical works of the ancient world. The attempts—albeit largely imaginary and, in any event, all aborted—to dedicate the fruits of his labor to powerful patrons also reflect his desire to emulate the literary production of the most illustrious contemporary humanists, with many of whom he was on friendly terms.[59]

Inspired by humanistic ideals, Taccola committed himself to reviving ancient technical knowledge, relying not so much on refined textual philology as on the expressive and evocative power of images. Like many artist-engineers of later generations, he attached greater importance to the restoration and promotion of classical achievements through their translation into clear drawings than to extolling the most innovative solutions developed by himself and his contemporaries. It was not by chance that Taccola was dubbed "the Archimedes of Siena."[60] This nickname not only emphasized the ingeniousness of the technical devices illustrated in his works but emblematically expressed his admiration for the genius and the civic virtues of Archimedes, who placed his outstanding technical and scientific skills at the service of his city when threatened by the overwhelming forces of the Roman fleet under the command of the Consul Marcellus. Taccola must have felt himself to be in a similar position when he solemnly offered the improbable military stratagems described in his manuscripts to the authorities of his city and to the emperor engaged in defending Christendom from the infidels.

De ingeneis and *De machinis* marked the revival, after centuries of silence, of the ancient literary tradition of praise for the Prince as the man responsible for the development of society, supreme military leader and promoter of the most ingenious inventors and builders of machines. This tradition had been established by authors who had narrated the memo-

rable civil and military enterprises of Alexander the Great, Julius Caesar, and Augustus.

That Taccola's pride was flattered above all by the prospect of being regarded and appreciated as the resurrector of the civil and military virtues of ancient engineers is confirmed by the memorandum, dated 1441, in the second book of *De ingeneis:* "Antonius Catalanus, priest of Tortosa, on the 15th of August, saw these drawings and also the roll containing [the drawings of] ancient machines and weapons, done by me, Marianus Jabobi of Siena."[61]

It has to be stressed that here Taccola emphasized not so much his own inventions as his graphic interpretations of "ancient machines and weapons." These were the achievements that filled him with pride.

In Taccola and in his contemporary Giovanni Fontana we glimpse the first signs of the emergence of a new cultural movement: that of the "humanists of machines." Shortly thereafter, this movement was promoted by a number of authoritative players, starting with Robertus Valturius, continuing with Fra Giocondo, Francesco di Giorgio, and Cesare Cesariano, and culminating with Leonardo. Thanks to their efforts, the commitment of the humanists to reviving classical culture opened up to the hitherto neglected world of machines.

Like Giovanni Fontana, Taccola had no knowledge of Vitruvius's *De architectura,* which, after centuries of oblivion, began to circulate again in the decades when they were compiling their works. The rediscovery of the Roman author's masterpiece would soon give fresh momentum to the revival of ancient technical knowledge. The laborious emendations of the manuscripts of *De architectura,* as well as its subsequent publication and wide circulation, reveal the same tension that was at work in Taccola's treatises. As we shall underline later, technicians and artists, joining forces with humanists, played a key role in the efforts to decipher the corrupted text of Vitruvius's work, preserved in a number of codices none of which contained images. In facing this delicate challenge, they employed the same powerful tool of graphic representation, of whose strategic function Taccola had offered pioneering examples.

His ambition to emulate the great classical writers, distinguishing himself from compilers of workshop notebooks, is evident in Taccola's

use of Latin and in his frequent references to interests and topics alien to the world of practitioners. Albeit in haphazard order, his manuscripts contain statements on the principles and general laws of nature, chiefly derived from the Aristotelian tradition (such as *horror vacui* and the theory of the four elements), reflections on the theoretical foundations of astrology,[62] fables and anecdotes conveying moral messages, visual citations from Scripture, maxims on human nature, and references to the human body as the perfect miniature image of the structure and articulation of the universe (Figure 8).[63]

Although *De ingeneis* and *De machinis* clearly display Taccola's ambition to be recognized as an author, this does not mean that he lacked technical skills, or that he failed to carefully observe the work of technicians, especially those operating in and around Siena: builders and decorators of civil and religious monuments; workmen of the underground aqueduct; technicians in charge of optimizing the performance of waterwheels; officers defending the coasts of the Sienese Maremma from corsairs; and, naturally, experts in military strategy.

His familiarity with the world of practitioners is confirmed by the frequent insertion in his Latin prose of vernacular terms and expressions, which sound like a live recording of their voices. In Books I–II of *De ingeneis,* for example, he notes that the popular expression for a hollow screw *(vitis vacua)* is *feminella* or *bussula* (female screw or nut).[64] In another folio he specifies that saddlebags in the vernacular are called *bisacce di quorio* (twin flaps of leather), and that lead projectiles are referred to as *pallotte* (pellets).[65] An even more vivid presence of the language of craftsmen is to be found in the text describing a system for drawing water from a well by means of two pails operated by a capstan: "in the vulgar tongue"—he writes—"this device is called a *manico di paiuolo*" (the handle of a copper pot traditionally hung over the fire).[66]

Although his dialogue with technicians is attested by a handful of references to the workings of machines and instruments that he personally witnessed, in his textual descriptions and visual renderings he often drew inspiration from classical and medieval literary sources on ambitious technical achievements in places that he had never visited.

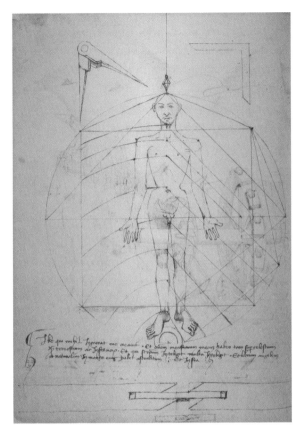

FIG. 8 Taccola: man as microcosm.

The "Interview" with Brunelleschi

As we have pointed out, practitioners offered their innovative solutions to public and private clients while making every effort to shield their inventions from prying eyes or agreeing to public disclosure only after obtaining exclusive rights to their use.

However, as shown by the fate of Brunelleschi's machinery for the construction of the dome of the Florence Cathedral, it was almost impossible to prevent inventions, once put into practice, from being copied and divulged. Although the great Florentine builder left no drawings of those machines, once installed on the highly visible construction site, where they would remain for decades, they were attentively scrutinized,

portrayed, and publicized, naturally with no reference to their inventor. It is well known that contemporary artist-engineers and those of successive generations recorded in their notebooks views of Brunelleschi's ingenious devices to lift and move weights. These sketches give us a fairly precise idea of the appearance and functioning of those machines, which are mentioned, but without detailed textual or graphic descriptions, in the documents preserved in the archive of the Opera di Santa Maria del Fiore.[67] Information on Brunelleschi's machines was disseminated not only through the drawings by Bonaccorso Ghiberti, Giuliano da Sangallo, and Leonardo but also through those of Taccola. Brunelleschi and Taccola met in Siena probably in the early 1440s. It was on that occasion that the Florentine architect disclosed his innovative technical solutions in a direct discussion of which his Sienese colleague recorded a detailed transcript in a series of sheets of Book I–II of *De ingeneis.*

Taccola's account of his "interview" with Brunelleschi is an exceptional document that has attracted the attention of scholars.[68] It gives us a vivid image of the dialogue between a leading architect and engineer—who had spared no effort, with varying degrees of success, to defend his rights as inventor—and an author who had spent the best years of his life promoting the wonderful achievements of ancient engineers and their most significant contemporary developments. What emerges is a lively portrait of Brunelleschi and his resolute character, along with his perception—now toward the end of his life—of a career crowned by great successes but also marked by disappointments and failures.

Taccola wrote out a fair copy in a neat hand of the stenographic notes that he had jotted down during his chat with Brunelleschi. The text, enclosed in a precise pencil frame, appears on a page previously used to outline a hypothetical reconstruction of the Roman inverted-siphon aqueduct in Toledo (Figure 9)[69]—a problem in the archeology of hydraulic technology that fascinated the Sienese author, who was to return to it in other sections of his manuscripts.

The account of the interview is divided into two parts, drafted at different times. In the first, Taccola wrote in Latin; in the second, he reported Brunelleschi's words in the vernacular, giving us the impression of a live recording of his voice.[70]

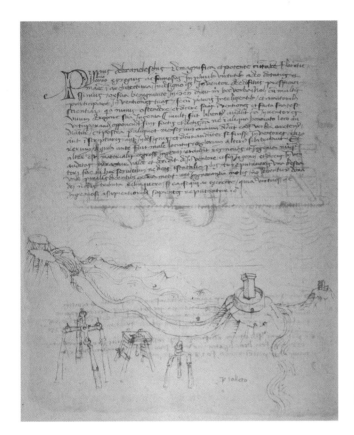

FIG. 9 First page of Taccola's
interview with Brunelleschi.

Taccola opens with a brief biographical and professional profile of
his interlocutor, for whom he displays the deepest veneration: "Pippo
Brunelleschi of the great and mighty city of Florence, a singularly hon-
ored man, famous in several arts, gifted by God especially in architecture,
a most learned inventor in the design of construction machines, was kind
enough to speak to me in Siena, using these words."[71]

Brunelleschi must have bitterly complained about the negligence of
the authorities in charge of awarding contracts in controlling their proper
implementation and in protecting inventors from piracy. Taccola, in turn,
informed his Florentine colleague about his efforts to produce trans-
parent graphic and textual illustrations of his most innovative devices
for civil and military use. Brunelleschi's reaction to this open attitude was
peremptory:

There are many who like to listen in order to find fault with
the inventors and to oppose their work and speech, so that
they will no longer be heard in honorable places, but after
some months or a year they use the same [the inventor's]
words, in speech, or writing, or design. They boldly call
themselves the inventors of the things that they first con-
demned, and attribute the glory of another to themselves.[72]

Brunelleschi's tirade against denigrators who became plagiarists re-
flects the resentment of a highly innovative technician forced to wage a
tough battle against unscrupulous rivals and incompetent decision-
makers. It is well known that his career was indeed marked by fierce
competition with other talented engineers and by conflicts with the
Florentine authorities.

Direct traces of Brunelleschi's lively complaints surface here and
there in the Latin transcript of the interview. Taccola faithfully records
Filippo's vernacular expressions, "tu reputaveris una bestia" (you will
be esteemed a beast),[73] or transliterates into Latin popular expres-
sions without any equivalent in the classic idiom—it is a grave error,
Brunelleschi stated, to reveal one's inventions "coram capocchis" (i.e.,
to blockheads).[74]

His outburst reflects the delicate situation in which the new profes-
sional figure of the inventor found himself, especially in the democratic
systems of city-states, such as Florence and Siena, which saw a significant
growth of industrial production and progress in technical innovation
from the late thirteenth century on. The main players of this new season,
characterized by ambitious construction projects, bold river regulation
works, and radical transformations in defensive and offensive military
strategies and techniques, were penalized by the absence of codified
norms for protecting intellectual property and by the limits of a system
that restricted decision-making powers to political levels, even in strictly
technical matters.

Brunelleschi's strong advice not to divulge one's inventions must have
led Taccola to reflect on the risks involved in his practice of disclosing
technical proposals. In fact, he repeatedly warns the reader that the

FIG. 10 Allusive portrait of Brunelleschi with "sewn" mouth (detail).

graphic and textual information provided will not suffice for the material construction of the devices because: "not everything in these drawings is said expressly." Elsewhere, he emphasizes that the most innovative solutions, even when illustrated in apparently explicit drawings, remain concealed in the inventor's mind: "It is impossible to assign reasons to each and every thing, because the invention resides more in the mind and intellect of the architect than in drawings and writings."[75]

Brunelleschi's recommendations to adopt discretion also inspired Taccola's talent as creator of images laden with symbolic meanings. An eloquent example is offered by the second part of the interview with Brunelleschi, which opens with a vivid sketch of a small head with the mouth "sewn up" (Figure 10).[76]

In the first two books of *De ingeneis* we find other telling examples of Taccola's imaginative graphic solutions and of his confidence in the inability of plagiarists to penetrate the mind of the inventor. A full-page drawing shows a man astride a water buffalo with reins attached to its horns and nose (Figure 11).[77] The rider has a small bag fastened to his chest, indicating the secrets that he protects from inquisitive eyes. From the thigh down, his right leg is portrayed as a fish. The text helps us to decipher the meaning of this curious image: "I keep to myself what I know to make, so that you may not fancy to be able to do anything without me, the silver-bearing mullet."[78]

Taccola's message is clear—his innovative ideas, mute as a fish, remain impenetrable. It is not by chance that the man rides not a horse but a

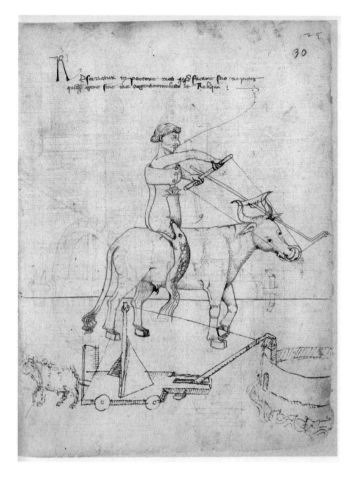

FIG. 11 Taccola: symbolic image of the virtue of discretion.

water buffalo, whose capacity to stay underwater for a long time was repeatedly underlined by Taccola.

We should note the serious misunderstanding of the text quoted above by the editors of the Munich manuscript of *De ingeneis,* Frank Prager, Gustina Scaglia, and Ulrich Montag, who translated the Sienese author's "sine me argentino muletto" as "without me, the silver-bearing ass."[79] Taccola does not refer here to a mule carrying a load of silver, but to a fish, precisely to a silver *cefalo,* or *muggine* (*muletus* in late Latin, from which the English *mullet*), an underwater creature that symbolizes the precautions taken by the inventor to guard his secrets.

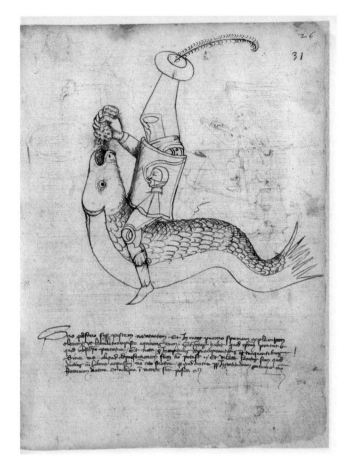

FIG. 12 Taccola: symbolic image of the inventor "mute as a fish."

The mullet and the water buffalo clearly evoke the territory familiar to the author of *De ingeneis*. Both abounded in the swamps of the Maremma, most of which was then under Sienese rule. Prager and Scaglia have consistently confused water buffalo, frequently portrayed by Taccola, with oxen, leading to misinterpretation of many of his texts and images.

In the drawing on the following page, Taccola imaginatively reiterates his confidence that the fruits of the ingenuity of the inventor are inaccessible.[80] A man protected by heavy armor straddles a huge fish with a sponge in its mouth (Figure 12). The sponge contains oil, a meta-

phor for the precious invention that remains hidden underwater. The fish, Taccola explains, carries both the invention and its author, who is completely concealed by the armor to stress once more the impenetrability of his ideas.

The text beside the drawing spells out the meaning of this curious image: "My speech has been veiled. What I have acquired during a rather long time with labor shall not be known at once. I say what I say because of the ingratitude of some people, and not of all men. The rest reposes in my mind."[81]

To further emphasize this concept, Taccola draws on the rider's shield an emblem that alludes once again to the metaphor of concealing secrets underwater—a diver drawing air from above the surface through a tube.

TACCOLA'S LIVELY PORTRAIT OF Brunelleschi also helps to illuminate the personality, concerns, and priorities of the Sienese interviewer. The second section of the interview, written in the vernacular, shows that he was determined to exploit Brunelleschi's expertise above all as to the most efficient methods for laying solid foundations in water. He literally quotes Brunelleschi's statements on this issue: "Note that there are two things wherein the river itself causes difficulty when you want to build the palisade for a mill [i.e., create millponds to feed waterwheels], or to construct bridges."[82] This part of the interview is actually recorded on a sheet at the center of a sequence of pages filled with drawings and texts illustrating methods for laying underwater foundations for bridges, piers, and buildings using waterproof palisades or caissons.[83] Taccola had reflected at length on these problems as shown by a memorandum dated December 6, 1427, in which he claims to have developed four innovative solutions for easily laying solid underwater foundations: "we completed four inventions and finished their test."[84]

As Mariano reports, the first two inventions concerned methods for placing bridge foundations without having to temporarily divert the river, and for facilitating the construction of piers in a port. Thanks to the other two inventions, he was confident that he could make a mill function on a flat stretch of water, and build bridges or walls in water using waterproof caissons.[85]

Filippo must have expressed some reservations about these solutions, as implied by his recommendations not to become enamored with ideas conceived only in the mind or merely outlined in a drawing. He invited his colleague to consider the many factors involved when tackling an actual construction project:

> when building river works . . . first see whether forests are nearby, offering places to provide timber . . . , stones for the walls and for making lime, as well as gravel or sand for the masonry. If these things are not close by, he who will contract for such a construction or who undertakes it will become poor if he was rich.

As a final exhortation Filippo warns against undertaking the work and bearing the related costs in exchange for a fixed remuneration: if you decide to take on the work—he recommends—do it with the money of those who have commissioned it.[86]

We find here further testimony of the distance between the practitioner, who takes into account every phase and infrastructural requirement of the construction process down to the last detail—and the designer of solutions who, however brilliant, remains in the abstract dimension of drawings and texts.

The third book of *De ingeneis* offers other clues about the topics at the heart of Taccola's conversation with Brunelleschi. The Sienese author outlined two different versions of a lifting device (Figure 13) undoubtedly described to him by the architect who had designed and used it on the construction site of the dome of the Florence cathedral:[87] the three-speed reversible hoist that attracted the attention of leading artist-engineers of later generations. Taccola's image is important because it is the earliest visual representation of that ingenious apparatus, preceding by nearly half a century those of Bonaccorso Ghiberti, Leonardo (Figure 14),[88] and Giuliano da Sangallo. His drawing is not based on direct observation of the machine, which at the time was still in operation; nor is it derived from an illustration that Brunelleschi might have shown him. Based on the verbal description provided by his interlocutor, Taccola produces a schematic and simplified

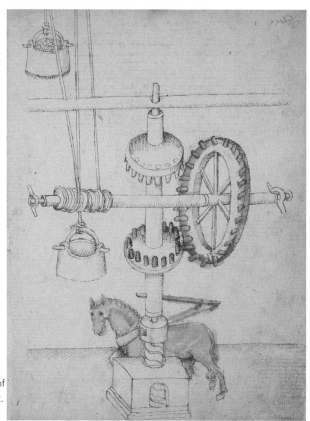

FIG. 13 Taccola: interpretation of Brunelleschi's three-speed hoist.

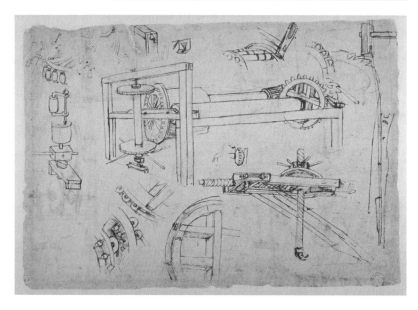

FIG. 14 Leonardo da Vinci: drawing of Brunelleschi's three-speed hoist.

representation of the hoist as operating at a single speed (as against the three speeds of Filippo's machine) and driven by a horse rather than by the pair of oxen used on the construction site. Moreover, the hoist lacks the safety mechanism to avoid the dangerous reverse rotation of the shaft and the bronze roller bearings to reduce attrition—two ingenious solutions that Leonardo, struck by their highly innovative design, later analyzed in detail.

The text appended by Taccola to his visual reconstruction shows that Brunelleschi had laid particular stress on the fact that the machine worked in a continuous loop, thus saving the considerable amount of time lost in unhitching the animals and hitching them again in the opposite direction: "And the horse that operates the wheel always moves forward, and never turns backward, but keeps moving clockwise."

Saving time was one of the main drivers behind Brunelleschi's quest for innovation. The ingenious machines designed for the construction of the dome of the Florence cathedral had enabled him to erect it in a very brief span of time, considering its size and complexity. The reversible three-speed hoist, in particular, was an invention that emblematically addressed this priority—so much so as to qualify it as an iconic expression of the emergence of a new entrepreneurial spirit.

Taccola was struck by Brunelleschi's emphasis on time saving. In *De machinis* he repeatedly pointed out that innovative machines shorten construction processes. Annotating a drawing of a winch that lowers one load while raising another, he stresses that "time is never lost."[89] Elsewhere, discussing a system for drawing water from a well, he comments: "time is not lost, but gained."[90]

Taccola's manuscripts preserve other traces of his conversation with Brunelleschi. The dialogue was intense, lengthy, and frank. Fully trusting Taccola's loyalty, Filippo opened his heart to his Sienese admirer. He described to him, for example, his solution for expediting the construction of particularly complex monumental works—a problem acutely felt in cities such as Florence and Siena, engaged in large-scale architectural projects requiring the transportation of heavy blocks of stone or marble from distant quarries.

Evidence for this is provided by a series of drawings in which Taccola incorporated information from Filippo on his invention of the *badalone*,

a giant cargo ship to transport marble slabs from the Carrara quarries down the Tuscan coast, up the river Arno, and finally overland, without transfer of load, to the Duomo construction site in Florence. In 1421, Brunelleschi requested—and obtained—from the Florentine Republic an exclusive three-year patent for the invention of his novel means of transportation. This is the first known patent ever granted. While highly promising—above all for the considerable savings in shipping costs— the *badalone* ultimately proved a failure. In 1427, the Opera del Duomo authorities commissioned Brunelleschi to transport 100,000 pounds of white marble from the Carrara quarries by sea, river, and road to Florence on this multipurpose ship. The *badalone* encountered major problems because of the Arno's high water and ran aground on the riverbank near Empoli. The heavy cargo therefore had to be unloaded and carried to Florence on smaller craft or by land. That was the *badalone*'s last run.[91]

In spite of receiving succinct and purely verbal information on the *badalone,* Taccola had fully grasped Brunelleschi's objective and his solutions to achieve it, namely, to ensure continuous conveyance of the heavy marble blocks from Carrara to their final destination. Mariano's drawings in the third book of *De ingeneis* illustrate in sequences the phases of the operation (Figure 15):[92] a column over ten meters tall is extracted (with details of the excavation instruments) from the quarry, wrapped to protect it during handling, lowered by winches onto a fourteen-wheel platform, and transported to the seashore. From there, it is set afloat and pulled by rowboats to the ship that will tow it to the mouth of the Arno river. After navigating up river as far as Empoli, the floating platform becomes a land vehicle again and transports the load to the construction site.

The text appended to the double-page image confirms that Taccola was trying to visualize the method described verbally by Brunelleschi: "it is impossible to assign reasons to each and every thing because the invention resides more in the mind and intellect of the architect than in drawings and writings," and also, he adds, because "many accidents occur [during construction] that neither the architect nor the workers had envisaged."[93]

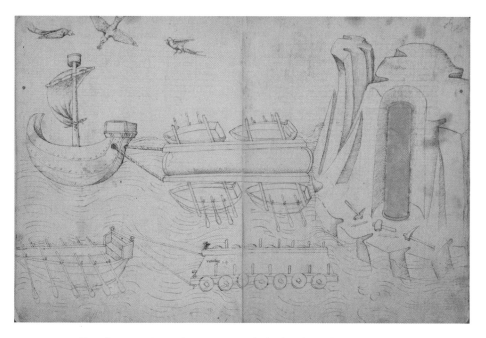

FIG. 15 Taccola: excavation and transportation by land and sea of a marble column.

The repeated references to the *architector*—which Taccola was not, nor claimed to be—as the protagonist of this brilliant enterprise is further evidence that he was inspired by Filippo's words, as is the concluding detailed description of the innate and acquired qualities of an *architector* worthy of the name, which delineates a portrait of Brunelleschi's virtues as seen by Taccola:

> It is necessary that the architect be experienced, knowledgeable,
> that he treasures former experiences, that he has read
> many books and is prepared to face unexpected setbacks;
> he needs one quality above all others: if the architect is
> not endowed from birth with subtle and penetrating inge-
> niousness, he will always be of modest value; but, if he has
> received talent from nature, he will be able, through learning
> and experience, to exercise his profession at the highest
> level.[94]

In the pages of *De machinis* illustrating solutions for diverting rivers, we glimpse another reflection of Taccola's conversation with Brunelleschi. In 1430, the Florentine Republic commissioned Filippo to divert the Serchio river in order to flood Lucca, under siege by the Florentine army, which was unable to overcome the enemy's resistance. The complex operation ended in disaster.[95] While Lucca was unharmed, the waters flooded the Florentine camp, which had to be swiftly evacuated. The episode is mentioned by Machiavelli in the *Historie fiorentine*.[96] Although Brunelleschi's project was a failure in strategic terms, the diversion of the Serchio river was a success from a technical standpoint. It is not surprising, therefore, that, despite missing the target, the operation caused quite a sensation, as also shown by a number of drawings in *De machinis* in which Taccola describes the most effective methods to divert rivers[97] to flood enemy cities (Figure 16). A note appended to one of these drawings clearly refers to Brunelleschi's unfortunate enterprise on the Serchio: "Flooding cities, castles and cultivated fields should not be permitted in war, to avoid killing innocent people. So this practice must not be praised, but rather considered an infamous act."[98]

Mariano's admiration for Brunelleschi's daring project is stifled by the scruples of a loyal Sienese citizen, who could not forget that Filippo had designed the diversion of the Serchio to flood Lucca, Siena's ally in the struggle to contain Florentine expansionism. Taccola referred again to the strife between the neighboring republics in a bitter note at the end of the third book of *De ingeneis,* completed in January 1432, "when the Sienese and the Florentines were at war."[99]

The discussion between Taccola and Brunelleschi was not an exchange of information on technical issues between professionals wishing to share their experiences. It was not a dialogue of peers. It is no accident that this exceptional document has been traditionally labeled as an "interview of Brunelleschi," for Taccola played the role of the person who asks questions and passively records the answers. Moreover, while Brunelleschi described, albeit schematically and only verbally, some of his inventions, Taccola does not appear to have reciprocated by showing him the technical solutions illustrated in his own manuscripts.

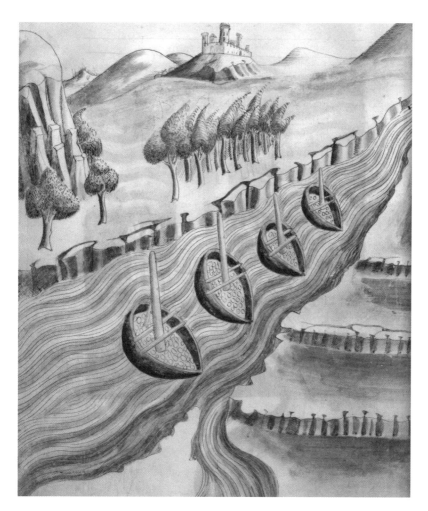

FIG. 16 After Taccola: damming a river by means of stone-laden boats.

It bears repeating that Taccola is a promoter on the literary and social levels of the image and culture of machines. He does not aspire to be regarded as an inventor. He records Filippo's words with veneration not so much because they outline solutions capable of improving his own technical expertise but rather as testimonies of some of the boldest projects undertaken by a giant of his time that could withstand comparison with those of the celebrated engineers of antiquity.

The Machine as Instrument for Liberation
from Toil and Icon of Power

One would search Taccola's manuscripts in vain for a definition, even an indirect one, of the machine as a general concept. This confirms that Taccola did not have access to Vitruvius's *De architectura,* whose definition of *machina,* at the beginning of *Liber X,* was to serve as a constant reference for the architect-engineers of later generations.

Taccola assigned a twofold meaning to the Latin term *ingenium,* which he generally uses to denote machines, technical instruments, hydraulic systems, and even military stratagems: *ingenium* is both the machine and the mental process through which it has been devised. Graphic representation plays an important part in the invention process; it conveys, first, a purely mental concept, which is then transformed into an image that allows the invention to be understood, memorized, and communicated.

The programmatic ambiguity of *ingenium* is stated explicitly in *De machinis.* Next to a drawing of a winch, Taccola inserted a note, set apart from the descriptive text for greater visibility: "A small engine [*ingenium*] easily raises a great weight."[100]

The determination to emphasize the mental matrix of the machine appears evident on a page with a large illustration of a lifting device at the center. Under its caption, Taccola inscribed the following words with a bold stroke of the pen: "Ingenuity [*ingenium*] is worth more than the strength of buffaloes."[101]

As many of these illustrations indicate, when using *ingenium* to refer to a specific device, Taccola did not view it as an end in itself but rather as a means to produce tangible benefits—above all, that of freeing men from toil or at least of greatly reducing it. In *De ingeneis,* Taccola presents a full-page picture of a floating watermill on two boats firmly anchored to the banks of a river (Figure 17).[102] The water current rotates the three vertical wheels, which, through a combination of toothed wheels and sprockets, transmit the energy to the mill's grindstone, which therefore turns continuously without human intervention. The miller, emancipated from toil by this automatic technical system, is fast asleep. The image is so eloquent that Taccola does not feel the need to add a descriptive

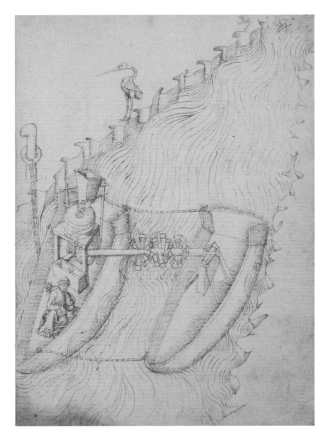

FIG. 17 Taccola: miller dozing on floating flour mill.

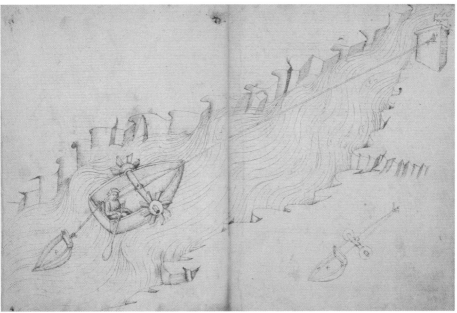

FIG. 18 Taccola: boatman relaxing on boat moving upstream.

text—a rare occurrence in the manuscript containing the third and fourth books of *De ingeneis.*

The same ideal is expressed in another double-page drawing again without text (Figure 18). Taccola depicts a boat with a paddlewheel on either side.[103] To stress the fact that the paddlewheels propel the boat upstream without the use of oars, the boatman is portrayed in a relaxed attitude, delicately holding an oar whose sole function is to serve as a rudder.

Another eloquent example of the advantages of automation is provided by a page of *De machinis.*[104] In an unrealistic setting, a lady, without any apparent effort, operates a suction pump to draw water from a well (Figure 19). I know of no other fifteenth-century image of a woman operating a mechanical device. Taccola's message is clear: thanks to machines, even a woman—shown in elegant attire to emphasize her noble status—can perform operations that would otherwise require the force of a man.

Many of Taccola's drawings are pervaded by the utopian vision that, thanks to machines, man can emulate the operations of nature, even to the point of countering its regular course. He expresses this expectation in his drawings of giant siphons that, exploiting nature's presumed *horror vacui,* raise water to outstanding heights.[105] The diversion of rivers,[106] and the solutions that enable a man to float and to breathe under water (Figure 20)[107] or to keep a candle burning under a bell jar immersed in water,[108] reflect the same confidence in the limitless potential of machines and mechanical ingenuity.

Taccola also conceives of the machine as an emblematic icon of power. This vision emerges in the drawings and texts describing the qualities of the *Dux bataliarum* (the Lord of War), author of the most ingenious inventions and designer of refined military stratagems. The high-tech horseman depicted in *De machinis* (Figure 21) offers a vivid example of the symbolic value assigned by Taccola to the most advanced technical solutions in warfare.[109] Like his mount, the horseman, armed with a gun, wears heavy armor. The metal ring and shaft with which he maneuvers the firearm are fastened to the saddle, which holds the can of gunpowder. The exclusive nature of this integrated human-equine mechanical arrangement is emphasized by the crown over the rider's helmet, as if to display his high rank.

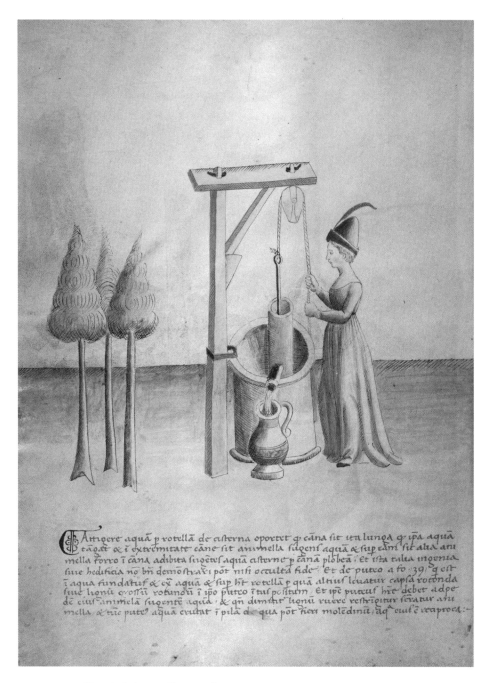

Attigere aquã p rotellã de asterna oportet q̃ cãna sit ita lunga q̃ ipa aquã
tãgāt & ĩ extremitate cãne sit animella sugens aquã & sup eãm sit alia ani
mella porro ĩ cãna adibita sugēts aquã asterne p cãnã plobeã. Et ista talia ingenia
sine hedificia nõ bn demõstrari pot nisi occultã fide. Et de puteo a fo 391 q̃ est
ĩ aqua fundatus & ex aquã & sup hr rotellã p quã altius levatur capsa rotonda
sine lionũ grossũ rotundũ ĩ ipo puteo ĩtus positum. Et ipe puteus hr̃ debet adpe
de eius animellã sugentũ aquã, & q̃n dimittr̃ lionũ ruere restringitur seratur ani
mella & sic puteus aquã evitat ĩ pila de quã pot fieri moledinũ, aq̃ eius ē reaproca:∹

FIG. 19 Taccola: lady operating a suction pump.

FIG. 20 Taccola: a diver helps to raise a column from the seabed.

Taccola conveys a similar message in another drawing (Figure 22) of the *eques scopetarius* (horseman with a gun),[110] which shows an ironic streak coupled with his awareness that these complex contrivances were unlikely to function: next to the Lord of War in armor, he wrote the invocation, taken from soldier's jargon, "you, the devil, help us. Amen."[111]

For Taccola, the machine is a space for unrestricted creativity, to be expressed chiefly through drawings. His manuscripts show no sign of any serious interest in the physical construction of the devices described. Moreover, except for the emphatic statement, dated December 6, 1427, of having completed four innovative solutions, Taccola never describes himself as the inventor of the machines he illustrates.

Taccola the Artist: The Dialogue between Text and Images

In recent decades, scholars have carefully analyzed the methods used by fifteenth-century authors to represent buildings and machines in order

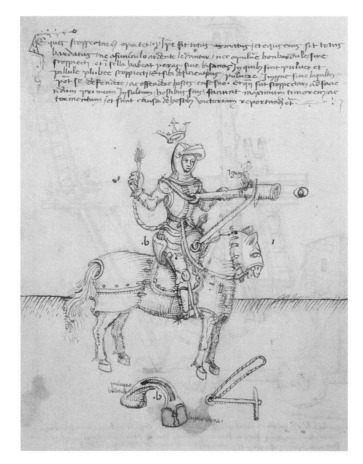

FIG. 21 Taccola:
eques scopetarius.

to reconstruct the process that, in less than a century, led to the defini-
tion of graphic conventions that were to remain substantially unchanged
until today.[112]

The advent of linear perspective marked a crucial step in this pro-
cess. As is well known, in the field of drawings of machines and me-
chanical systems, the earliest examples of a mature use of perspective are
found in Francesco di Giorgio's *Treatise of architecture and machines* and
in Leonardo's manuscripts. Taccola's works date from a period when
linear perspective was coming into its own. It is worth recalling that, in
the same years when the Sienese author was compiling *De ingeneis,* Ma-
saccio adopted for the very first time a rigorous perspectival construction

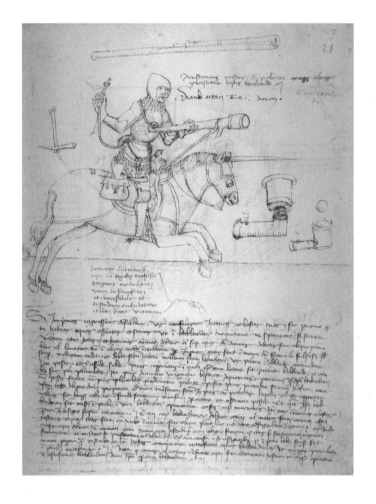

FIG. 22 Taccola: weaponry carried by *eques scopetarius*.

in the fresco of the Trinity in the basilica of Santa Maria Novella in Florence.

The new method for representing spatial depth on two-dimensional surfaces was not immediately accepted by the Sienese artistic circles in which Taccola was trained. It is not surprising, therefore, that his manuscripts offer no instances of a rigorous application of the rules of linear perspective. His lack of familiarity with this new frontier of artistic representation is also confirmed by the account of his conversation with Brunelleschi, which contains no allusions to the famous perspective experiment of the Florentine architect and to the revolution that it was triggering in drawing, painting, and architecture.

This does not mean that Taccola was incapable of drawing in perspective. Many of his illustrations show his awareness that figures and objects must be shortened as they recede from the foreground. However, what we observe in his notebooks is an instinctive and spontaneous perspective, not a geometrically constructed one.[113] His devices often seem lopsided and disproportioned, their parts connected in a confusing and distorted manner,[114] to the point of making it hard to understand their structure and functioning. This is not due to Mariano's limited skill in depicting the distribution of machine parts in three-dimensional space. On the contrary, his lopsided and clumsy machines were a significant improvement compared with traditional figurative techniques. Villard de Honnecourt and Guido da Vigevano, for example, had moved even further away from a realistic representation of technical objects and architectural structures; in addition to distorting their parts, they had usually tilted vertical planes so as to display the internal structure (Figure 23).[115]

Taccola distorts machines for the same reason as Villard and Guido tilted vertical planes—to achieve maximum economy of execution. Like his predecessors, he depicts even the more complex devices in a single drawing. This made it difficult to clearly display their internal parts. To overcome these limitations, he shows the machines as they appeared when observed from different elevations and viewpoints, by bending them, so to speak, as if they were made of rubber. His manuscripts offer many examples of this multifocal approach. He uses it to illustrate how toothed wheels move pinions and vice versa,[116] and the working of treadmills,[117] waterwheels (Figure 24),[118] hoisting devices, and bell-lifting machines.[119]

The iconography of machines—like that of architecture and anatomy—would undergo a radical change a few decades later, when the principle of "one machine, one drawing" was abandoned. As we shall see, Leonardo was the prime mover of this revolution, which paved the way for the lasting adoption of linear perspective in the visual representation of machines, living beings, buildings, and landscapes.[120]

It should also be emphasized that in the scenes where Taccola depicts humans, animals, and landscapes in addition to machines, he does not concern himself with respecting the relative proportions between those various iconographic elements. His priority is to showcase the detail to

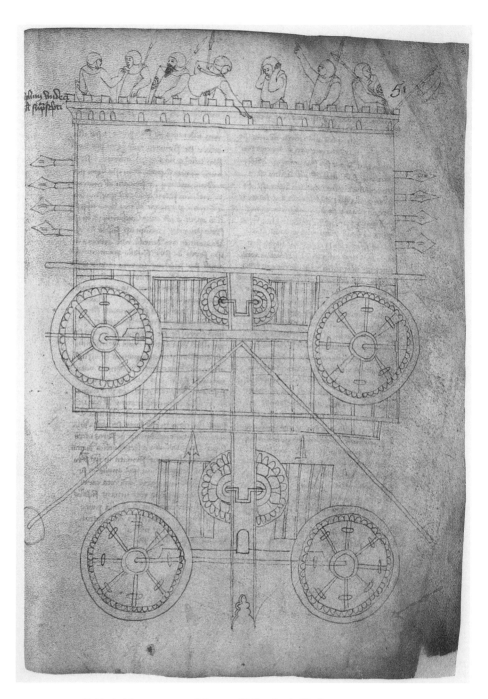

FIG. 23 Guido da Vigevano: assault tower with its wheels tilted.

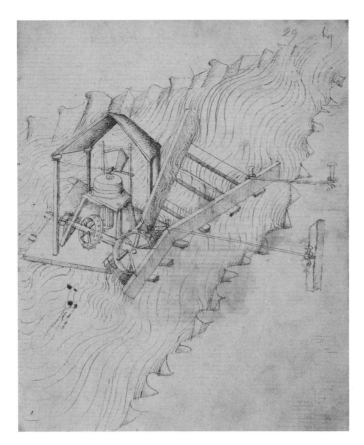

FIG. 24 Taccola:
floating mill.

which he wants to draw attention. Witness the absurd disproportion, in a drawing in the third book of *De ingeneis,* between the man operating the camshaft pump and the landscape and the building that houses the mill,[121] or that between the large assault boat with a protective shield and the minuscule tree houses—just big enough to accommodate dwarves—from which the inhabitants are hurling stones (Figure 25).[122]

The lack of measured perspective, the consistent neglect of plausible proportions, and the repetitive schematic rendering of landscapes, city skylines, and fortresses confer a poetic touch on the pages of Taccola's manuscripts. This effect is strengthened by the recurring presence of plants and animals often portrayed more realistically than machines. In an essay published in 2003, a New York artist, Lawrence Fane, confessed

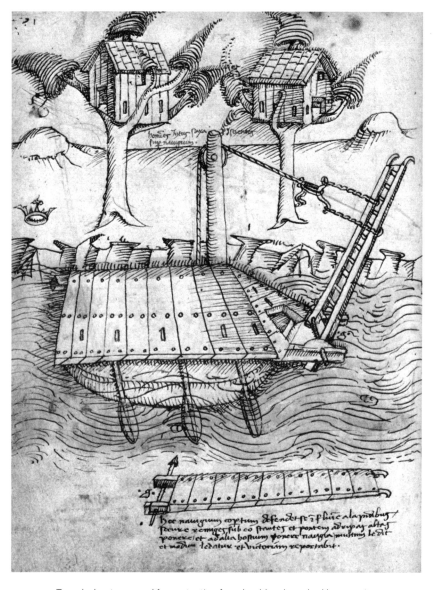

FIG. 25 Taccola: boat armored for protection from boulders launched by enemies barricaded in tree houses.

his fascination with Taccola's technical universe.[123] It is a pity that scholars have overlooked his essay, because it contains penetrating observations on the emotions produced by Taccola's images. Fane describes the feelings of "good humor" and "light-heartedness" generated by the fairy-tale atmosphere of the Sienese's improbable military stratagems. He defines Taccola's world as a private, subjective dimension that emanates a pleasurable aura.

Fane was so inspired that he visited Florence and Munich to compare the facsimile reproductions with the original manuscripts. After carefully inspecting them with the trained eye of the professional artist, he meticulously noted and described Taccola's writing and drawing techniques and the various functions he assigned to each: the variable pressure of the hand on the quill; the uneven level of oxidation depending on the quantity of ink laid on the paper; and, above all, an intentional figurative strategy, based on the combined use of pencil, pen and ink, and watercolor.[124] A close observation of Taccola's original sheets reveals that he used pencil for the preparatory sketches, which he then reworked with pen and ink to add shadows, thus creating a three-dimensional effect. He hatched curved lines with watercolors to give body to the flow of water in rivers and to columns of smoke, to leaping flames, and to gusts of wind. He also used watercolors to illuminate the initial capital letters of texts.

In *De ingeneis* and *De machinis,* text too plays an important role. Blocks of text, often drawn out to the point of prolixity, are carefully calligraphed in a refined, although sometimes uncertain, Latin prose. When the connection between text and image does not appear intuitive in the overall organization of the page, Taccola sketches a *manicula* (small hand) to link them.[125]

The text-image relationship in the first two books of *De ingeneis* is substantially balanced. Taccola generally drew the image before adding the text, which is often redundant. While perfectly aware that the originality of his contribution resided mainly in the apparatus of images, Mariano knew that to be recognized as an author he had to express his ideas in literary form as well.

Although Taccola never abandoned the text-image synergy, the evolution of his work shows a tendency to give ever more prominence to drawings and sketches. This shift is clear in the third and fourth books

of *De ingeneis,* where images entirely occupy two facing pages, their textual description being confined to the following page. This is telling evidence of the autonomy acquired by drawings, thanks to the development of a graphic language so expressive as to make verbal descriptions superfluous.

In Mariano's later work, *De machinis,* the text engages once again in a direct dialogue with the drawing. However, long sequences of pages contain images without text and Taccola reiterates that verbal descriptions of the devices are not necessary, as the information conveyed in the drawing suffices to clarify their purposes and functioning.[126]

In one case, however, describing a suction pump, he states that the construction details of this machine cannot be illustrated even by the most accurate drawing. The only way to fully understand its structure and working is to see it in operation: "Be it noted that this device cannot be given by drawings; you have to see it at work with your own eyes."[127]

Nevertheless he soon reasserts his confidence in the superior eloquence of drawing, providing in the following pages visual illustrations of a series of hydraulic devices without text, because—he comments—they are self-explanatory.[128]

Taccola vaunts graphic language in many texts in which, to justify the conciseness of his verbal descriptions, he argues that images convey all necessary information: "as can be seen in the drawing,"[129] and, again, "as shown by the drawing."[130] Elsewhere, he contrasts the power of images with the limitations of textual language. Referring to a winch, he states that not every detail of the machine can be described with words, but "competent technicians will see in the drawing what needs to be made."[131]

Such confidence in images was well placed. An eloquent example is provided by a page of *De ingeneis* showing a hydraulic device with no textual description (Figure 26).[132] We are helped to identify this technical system by the building on the left bank of the millrace, beside which we observe a few sheep in a pen. The sheep are an obvious reference to wool, and, in fact, the unnamed device is a fulling mill powered by a vertical waterwheel operating a camshaft that alternately raises the mallets that hit the wet wool soaking in the two caissons.

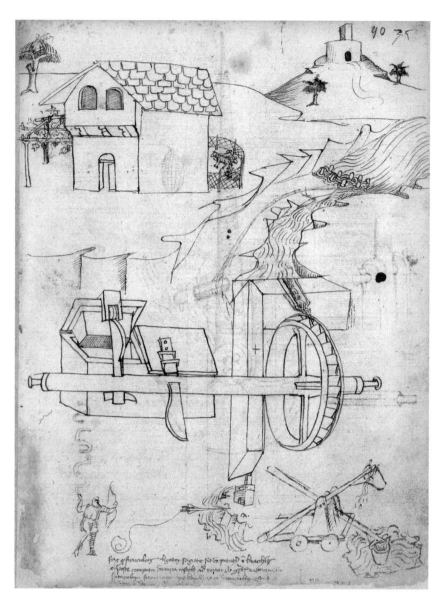

FIG. 26 Taccola: hydraulic fulling mill.

FIG. 27 Taccola: tide flour mill.

FIG. 28 Taccola: weary workman operating a winch (detail).

Another equally effective example of the autonomy of graphic language is offered by a drawing of a vertical waterwheel (Figure 27).[133] Some apparently negligible but revealing details enable us to understand that the device is a tide mill: the bag of grain on the back of the mule, which, prodded by its master, heads toward the mill, and, above all, the seashells on the water's edge.

Taccola also exhibits considerable artistic skills in his drawings of human figures, of animals, and of landscapes that enliven many images of machines and technical installations in his manuscripts. Moreover, he shows great talent in depicting the moods and emotions of people and animals: thoughtfulness,[134] pride and nobility,[135] fatigue and prostration (Figure 28),[136] boldness and aggressiveness.[137]

He adds a personal touch to landscapes, which portray nature in perpetual motion: trees bending in the wind (Figure 29),[138] rippling water,[139] and leaping flames.[140] He masterfully depicts living beings in dynamic attitudes: men running and shooting darts (Figure 30),[141] or walking up and down stairs,[142] horses and water buffaloes galloping (Figure 31),[143] fish darting through the water (Figure 32),[144] and birds soaring joyfully through the sky.[145]

Taccola excels particularly in stenographic sketches. This specialization is hardly surprising, given that the only document attesting his work as an artist is a payment for the preparation of twenty-two gargoyles (gorgolle) (wood sculptures of animal heads) for the choir of the Duomo in Siena.[146] Unfortunately, those sculptures are lost, but we can guess what they looked like from the two-dimensional gargoyles of animals used as page markers (Figure 33) in De ingeneis,[147] and from the amusing expression of the faces sketched as initial capital letters of many blocks of text.

The most spontaneous of his manuscripts—that containing the first two books of De ingeneis—provides the finest examples of a figurative vein that reaches its highest expression in the dense sequence of stenographic sketches that animate its pages. The attitudes of the humans and animals, outlined with rapid strokes of the pen,[148] suggest cinematic sequences of which the image represents a still frame (Figure 34).[149] One would search in vain for comparable examples in the manuscripts of Kyeser or of Giovanni Fontana, or even in the later Treatise of Francesco di Giorgio.

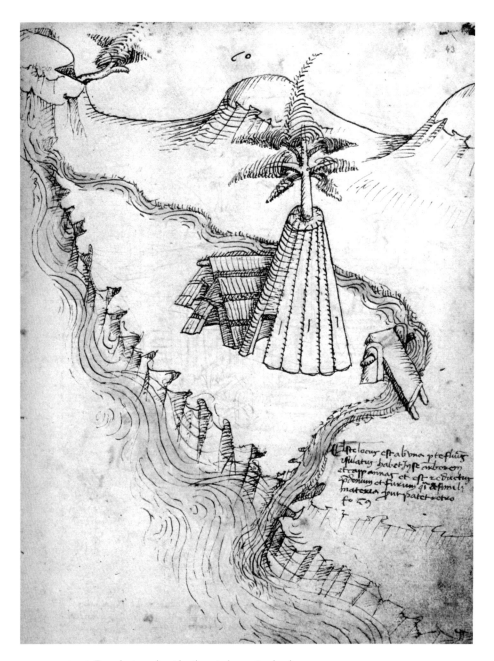

FIG. 29 Taccola: trees bent by the wind on a riverbank.

FIG. 30 (left) Taccola: archer and man launching incendiary projectiles.

FIG. 31 (below) Taccola: armored fire-carrying water buffalo.

FIG. 32 Taccola: fish farm with canal linking it to the sea.

FIG. 33 Fox holding captured bird, used by Taccola as bookmark (detail).

The stenographic sketch is Mariano's preferred graphic language, and he practices it spontaneously (Figure 35),[150] rivalling the celebrated stenographic sketches with which Leonardo portrays the attitudes of men and animals,[151] the motions of the elements, and lively action scenes.

Taccola's instinctive tendency to portray machines in natural settings (Figure 36) had no precedents in technical drawing—and almost no sequel.[152] Later authors, starting with Francesco di Giorgio and continuing with Leonardo, almost always depicted machines in splendid isolation; the human figure rarely appeared in their drawings, while landscape elements were confined to a schematic indication of the energy generated by water or wind.

Taccola's devices, by contrast, are deeply anthropized and naturalized. They have not yet achieved the full autonomy from living beings and the landscape that would soon characterize the visual representations of machines.

Innovative Technologies for the Sienese Territory

Despite frequent references in his manuscripts to technical installations in localities and territories far from Siena (such as Genoa, Venice, Rome—but never Florence—the Po and Tiber rivers and Mount Etna), Taccola probably never left his native city. At most, he visited areas under Sienese control, particularly the coasts and marshlands of the Maremma. Consequently, many of the solutions recorded in his manuscripts (particularly in the numerous pages describing systems and machines for supplying water and using hydraulic energy to power mill wheels) reflect the demands of those territories.

In their search for solutions to the chronic water shortage in the city, Sienese technicians had acquired high competence in water control and conveyance. Between 1200 and 1400 an underground aqueduct over twenty-five kilometers long had been built. Known as the *bottini,* it was one of the most impressive achievements of Sienese civilization.[153] Taccola was not directly involved in the construction of the underground network, but thanks to his friendship with Iacopo della Quercia—who was in charge of the aqueduct's maintenance—and to his strong interest in technical systems and processes, he was familiar with this vital

FIG. 34 Taccola: ostrich chasing away enemy cavalry (detail).

FIG. 35 Taccola: stenographic sketch of scythed chariot in action (detail).

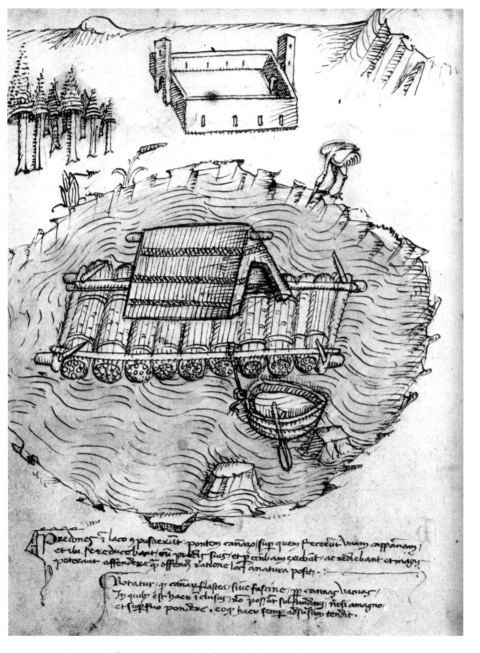

Predones z̄ laco q̄ puuexerūt pontem cañazoʃ ʃup queʃ ſtetexūt vnam cappānam,
et ibi. ſexeducebant̄ oū ſoxdeʃ, ſuiſ, et ꝑ cm̄bam exedāt, ac xedebant et magʃ
poteant̄ offendexe q̄ offendꝪ ratione loci a natuxa poſiti.

Notatur, q̄ cāñaʃ flaſteʃ, ſiue faſaine, ꝑ cānaʃ vaciaʃ,
In quibᵛ eſt hacꝛ icluſiuʃ, ſeo poſſūt ſultundaxy ñiſi a magno,
et ʃuꝑfluo pondexe, coq̄ hacꝛ ſemꝙ adſuſum tendit.

FIG. 36 Taccola: floating house made of wooden beams and canes.

infrastructure. It is only natural therefore that his manuscripts provide visual records of the instruments used to excavate the network's galleries and the methods employed to ensure a constant gradient for the supply canals (Figure 37).[154]

Taccola's drawings reveal his abiding ambition to find the technical solution that would guarantee an endless supply of water for the life and productivity of the Sienese community. He imagines installing improbably sized siphons among rocky cliffs or bold canal-bridges[155] to carry water from the source to a mill wheel or to a fishery. The emphasis on siphons reflects his search for solutions to complement the gravity-driven water supply system of Siena's underground aqueduct. To lift water, he also resorts to the Archimedean screw, which he sometimes depicts in a vertical position, revealing his ignorance of the fact that it works properly when set at a slight angle.[156]

The same motives—inspired by daring visions, evocations of the epic enterprises of antiquity, and the search for practical applications—fuel the ideal reconstruction of the Roman aqueduct of Toledo, represented by Taccola as a fortified city atop a hill, just like Siena.[157] The comparison between contemporary Siena and ancient Toledo perfectly expresses the blend of antiquarian curiosity and the quest for innovative applications of use to his community that characterizes Mariano's involvement in the world and culture of machines.

The physical characteristics and the requirements of the Sienese environment are perceived in many other of Taccola's drawings, particularly in those that demonstrate his distinct preference for water buffaloes over oxen and horses.[158] The water buffaloes evoke the marshlands of the Maremma plain, as do the systems for draining ponds and lagoons to reclaim the wetlands, the shallow-draft boats and the amphibious carts drawn by water buffaloes wearing mud-proof boots (Figure 38).[159]

The same holds true for the emphasis on hull-piercing devices to be placed—as Mariano specifies—in swamps *(in paludibus)*,[160] a transparent reference to the Sienese efforts to defend the lagoon-port of Talamone from corsairs, and the images illustrating the corsairs' methods for fortifying their lairs on the small islands dotting the marshes of the Maremma.[161]

Furthermore, the presence, among the few mills illustrated by Taccola, of an unusual mercury-driven system[162] was in all likelihood

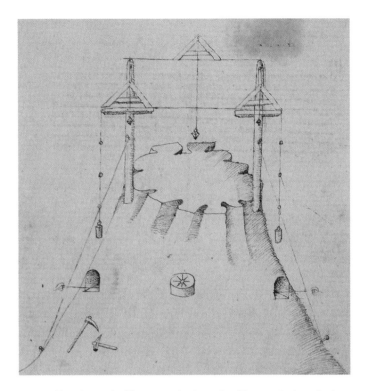

FIG. 37 Taccola: method for excavating tunnels with a constant gradient.

inspired by the large deposits of the heavy metal in the mines of the Amiata mountain under Sienese rule.

The amusing and obsessively repeated fishing scenes reflect another matter of importance for the Sienese community that captured Taccola's imagination. The plentiful catches obtained thanks to complex technical equipment[163] clearly refer to fish farms (Figure 39),[164] which abounded in the territory of the Republic and left many traces in local place names. This series of drawings was probably inspired by the ambitious plan for a large fishery-lake in the Maremma to free Siena from the need to import at great expense massive quantities of fish from Lake Trasimeno. To solve this problem, the Sienese authorities decided to create a large reservoir on the Bruna river near Giuncarico. Work began in 1468, that is, at least a decade after Taccola's death. However, evidence that the project was designed much earlier is contained in a document

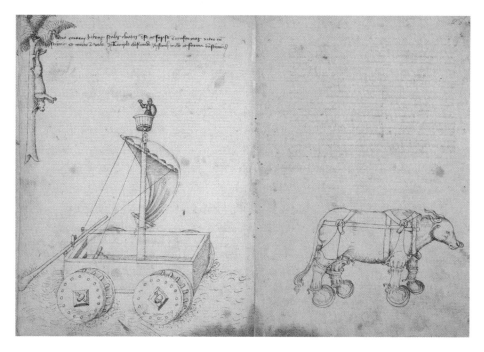

FIG. 38 Taccola: amphibious carriage with sail mast drawn by a water buffalo.

dated December 1334, to which historians have only recently given the attention it deserves despite its having been published in 1935.[165] The document contains the report submitted to the Government of the Nine of the Old State of Siena by a technician who had made an on-site survey. In his opinion, it would have been possible and relatively easy to create "in the plain between Giuncarico and Colonna, at little expense, a lake from which the city would obtain all kinds of fish in abundance, and the inhabitants of the area would enjoy not only fish, but many species of water birds and their eggs."[166]

Thus, it is reasonable to assume that Taccola was aware of the project and that the many fishing scenes in his manuscripts—as well as the drawing of a river dam in a valley with a spillway fitted with a mobile sluice gate—reflect his excitement at the extraordinary benefits promised by its implementation.[167]

Mariano also depicts night fishing by lamplight (Figure 40),[168] and methods for the exploration of sea- and riverbeds from a boat (Figure 41)

to retrieve sunken treasures by the light of a candle burning inside a diving bell.[169] His fascination for underwater illumination is confirmed by his drawing of a waterproof lamp flanked by a sponge (Figure 42).[170] A note appended to the drawing explains its singular presence: a sponge soaked in warm vinegar and placed inside the lamp prevents the candle flame from being rapidly extinguished by smoke.

This curious method for keeping the candle lit underwater reappears in a later manuscript, probably by Iacopo Cozzarelli, a student and close collaborator of Francesco di Giorgio, which records copies of drawings by Taccola and Francesco. The drawing, without text (Figure 43), shows a diver who, breathing through a bellows and holding in his hand a glass lantern containing a lit candle and a sponge, explores the seabed—clearly a visual citation of Taccola's above-mentioned solution.[171]

It should be noted that the methods for night fishing by lamplight had been illustrated by Kyeser in the *Bellifortis,* which may have been Taccola's source: "If you place a lit candle in a pond at night, the fish will gather around the light. . . . So many fish will come that you can catch as many as you want with your hands."[172]

Kyeser had actually provided in his treatise many recipes for making candles that burned underwater, recipes that are reminiscent of Marcus Graecus's *Liber ignium,* a text almost fully transcribed by Taccola in *De ingeneis.*[173]

Mariano also conceived solutions to allow humans to breathe underwater.[174] His bizarre drawings of divers and their equipment attracted the attention of Francesco di Giorgio, who, in the final pages of the manuscript containing the first two books of *De ingeneis,*[175] copied Taccola's texts (with a faithful but not literal translation in the vernacular) and images. Francesco sketched Taccola's windmill (*De ingeneis* II, f. 87r), a floating mill (IV, f. 66r), and a siphon powering a mill wheel. He also reproduced, albeit schematically and without descriptive text, the drawing in which Taccola visualizes Brunelleschi's system for transporting marble blocks from the Apuan Alps to Florence by sea and by land.

Francesco focused in particular on the image in the third book of *De ingeneis* (f. 18r), in which Taccola illustrated the method for retrieving a column from the seabed.[176] While closely following Taccola's text,

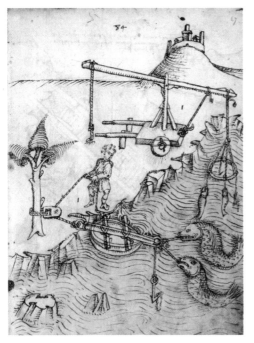

FIG. 39 Taccola: high-tech fisherman.

FIG. 40 Taccola: night fishing with lamps.

FIG. 41 Taccola: retrieving valuables by means of an underwater bell with candle.

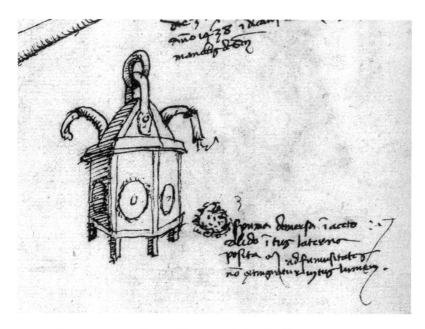

FIG. 42 Taccola: waterproof lamp with a sponge inside (detail).

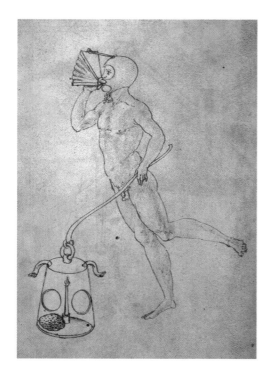

FIG. 43 Anonymous: diver with bellows for breathing and lantern with sponge and lit candle.

Francesco introduced a series of remarks—absent from the source—on how to assemble the diver's suit. He also voiced a reservation. In Taccola's drawing, the end of the breathing tube, which protrudes from the helmet fitted with "glass eyes," is held above the water's surface by means of a float. Francesco argues that this arrangement would not work—the diver would breathe the same air repeatedly with lethal consequences. He stresses that the diver must use not one, but two tubes, inhaling fresh air from one and exhaling through the other.

One may wonder whether Francesco's correction was inspired by the passage of the *Bellifortis* in which Kyeser had emphasized that a diver, to survive underwater for a long time, should wear a helmet fitted with two tubes connected to the surface. In the text appended to his illustration of two differently equipped divers, the German author explained that to avoid dire consequences, divers should exhale before inhaling fresh air.[177]

Star Wars

Taccola gives free rein to his creativity when devising stratagems for his imaginary patron, the Lord of War. He develops an array of strategies to overcome the enemy: by corrupting his officers; wreaking damage with bombards and blowguns; launching incendiary projectiles, fetid excrement, and rotten fish; forcing surrender through famine and thirst; and digging tunnels to explode mines under fortresses.[178] He provides a highly detailed description of the "thirst" stratagem: the Lord of War should have his army followed by a flock of sheep or a herd of oxen deprived of water for a long time. The thirsty animals introduced into the enemy castle will consume the entire water supply, forcing the besieged army to surrender.[179]

No less fanciful is the "cat stratagem" to vanquish the diehard foe barricaded in the fortress.[180] The method is simple. The felines are soaked in alcohol, long fuses are tied to their tails and lit. As the image shows (Figure 44), these living torches, once in the fortress, burn it to the ground. Taccola notes that, if no cats are available, the same effect can be obtained with fire-bearing mice, also portrayed in the drawing.

FIG. 44 Taccola: incendiary cats and mice destroy a fortress.

The tactics that he recommends for war at sea are equally outlandish. An enemy ship is attacked by a vessel armed with a counterweighted hull-smashing system (a pile of stones at the stern prevents it from capsizing).[181] When the device is triggered, it strikes a massive blow to the enemy ship (Figure 45), whose sailors might, however, reduce its

FIG. 45 Taccola: stratagem for sinking an enemy ship.

destructive effect by cutting off its tip. In that event, a second maneuver is performed; a container filled with gunpowder fitted with a short fuse so as to explode on contact with the deck of the enemy ship is launched. The flames and the blast cause facial injuries to the sailors. If these strategies are not effective in forcing surrender, there is a final move: clay pots filled with liquid soap or lard are flung at the enemy vessel; the pots smash on impact, the slippery liquid spreads all over the deck, and "the sailors slip and fall to the ground."[182] Note the direct dialogue here between the text, describing the operations in sequence, and the drawing, which provides a perfectly coordinated visual account.

Another creative stratagem, depicted in detail in its dynamic sequence (Figure 46),[183] is introduced by Taccola with a harsh judgment on the nature of men, trapped by their voracity "like birds and fishes by bait."[184] The ploy relies precisely on this human weakness. If the enemy, with superior forces, threatens your army's camp, you must protect it by erecting a stockade (Taccola stresses that it must be easy to climb over) amassing a large amount of food and wine inside it. Then, feigning terror at enemy's advance, you must hastily abandon the camp, leaving the provisions behind. On entering the camp, the enemy troops will find

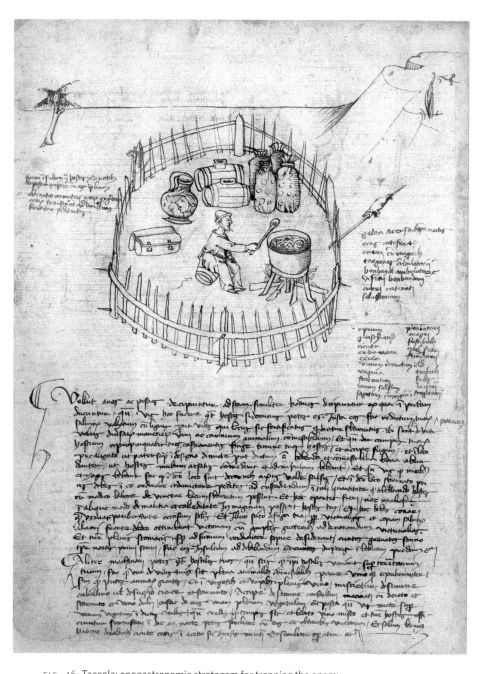

FIG. 46 Taccola: enogastronomic stratagem for trapping the enemy.

all that God-given bounty and gorge themselves to excess. Taccola even suggests adding plenty of salt to the food, causing the enemy to drink in abundance:

> To make them drink even more, let there be sides of roasted
> meat, very salty.[185]

Extenuated by the food and wine, the enemy will fall fast asleep, making it easy to return and defeat them.

The temptations of the flesh inspire another stratagem in which we discern a typical custom of the military life of the time—the widespread abuse of young boys by officers.[186] Taccola recommends administering small doses of poison to the victims with their food for fifteen days. The progressive poisoning will make the adolescents' breath and sweat toxic, thus contaminating the pedophile officers to death.

The innumerable stratagems described in Taccola's manuscripts exude a gentle spirit, untainted by the acrid smell of the battlefield or by dismay or horror for the dead and wounded. In the hundreds of drawings and sketches of infantrymen, horsemen, or sailors at war, we never see mutilation or bloodshed. War is depicted as a chivalrous tournament, a game of chess in which players move pawns that can be "taken," but only in the imagination.

It is hard to believe that Taccola trusted that these texts and drawings would arouse the interest and appreciation of military professionals and the Lord of War for their strategic value. Perhaps he reckoned that his imaginary Lord would be flattered to be credited with the capacity to devise such subtle and unusual solutions. This was certainly one of Taccola's goals. He repeatedly emphasized that not only courage and strength but also guile and wits are key qualities for a great commander. Not by chance, he cited as exemplary models two heroes of the ancient literary tradition: Ulysses, symbol of guile, and Achilles, of strength: "Here [in war] vigor and sense are, for the work of the lance, of equal weight. Herakles fights with vigor, Ulysses with sense."[187]

Perhaps he thought instead that his imaginary patron would be amused by these stories and their lively illustrations. The Lord of War would have smiled when reading how to trick the army besieging a fortress by evacuating it at night with one's horses hoofed back to front (Figure 47).[188]

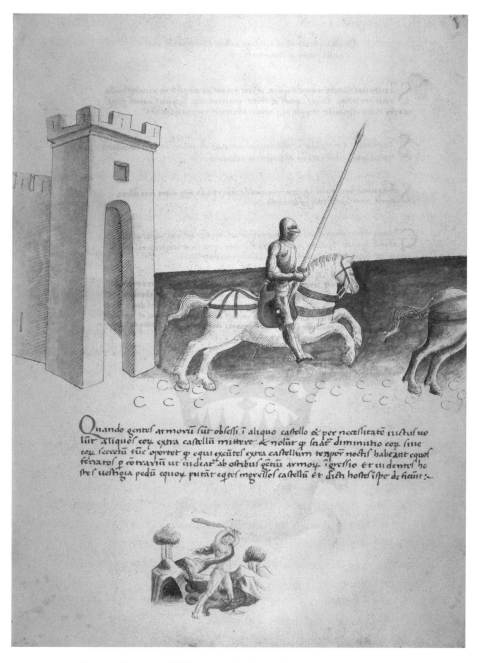

Quando gentes armorū sūt obsessi ī aliquo castello & per necessitatē tūctus uolūt aliquos eoy extra castellū mittere & nolūt qt sciāt diminutio eoy sue eoy secretū tūc oportet qt equi excūtes extra castellum tenpoy noctis habeant equos fenatos p cōtrariū ut iudeat ab ostibus gētiū armoy īgressio et iudentl hostes uestigia pedū equioy putāt eqtes mgrestles castellū et dicti hostes ispe de hāut:~

FIG. 47 Taccola: stratagem with horses hoofed back to front.

At daylight, the enemy, seeing the hoofprints on the ground, would conclude that reinforcements had arrived during the night and would lift the siege. He would have been entertained by the ingenious solution to abandon a fortress unbeknownst to the enemy. It was as simple as tying a dog to a bell (Figure 48), placing food and water at such a distance that the animal would be forced to pull on the rope to reach them, causing the bell to ring.[189]

One might be tempted to label Taccola's military stratagems as PlayStation wars, except that, unlike those fierce virtual battles, the ones depicted by Mariano are delicate, gentle, almost poetic engagements. He expressed that poetry through fresh, instinctive graphic representations, replete with ingenious expedients to enhance telling details: the reversed hoofprints of the horses; the spit with the roast piglet protruding from the stockade as bait for the enemy;[190] the crates filled with rotten fish, fetid excrement, and sleeping draft launched into the besieged fortress, infecting the occupants and making them drowsy;[191] the attack launched against the enemy when the wind drives dust into their eyes, illustrated by a stenographic vignette;[192] and, lastly, the turgid male organs of the armored, fire-carrying great danes—highlighted as if to emphasize their virile aggressiveness (Figure 49)—attacking and routing the enemy cavalry.[193]

AS MANY OTHER EXAMPLES SHOW, warfare offers Taccola a dimension where his imagination can roam free without being shackled to physical reality.

Through a quirk of fate, when his manuscripts reappeared on the European cultural scene in the early nineteenth century, they aroused curiosity primarily as documents illustrating the state of the art in military technology and war strategy at the beginning of the modern age. I am convinced that Taccola himself would have been astonished. At the end of the fourth book of De ingeneis, in offering his services to Emperor Sigismund, he emphasized his skill as illustrator of finely illuminated manuscripts to celebrate the deeds of the emperor and his lineage, and his expertise in hydraulics.[194] Despite addressing a warrior sovereign, he made no mention of his competence in the design of weapons, or of offensive or defensive strategies.

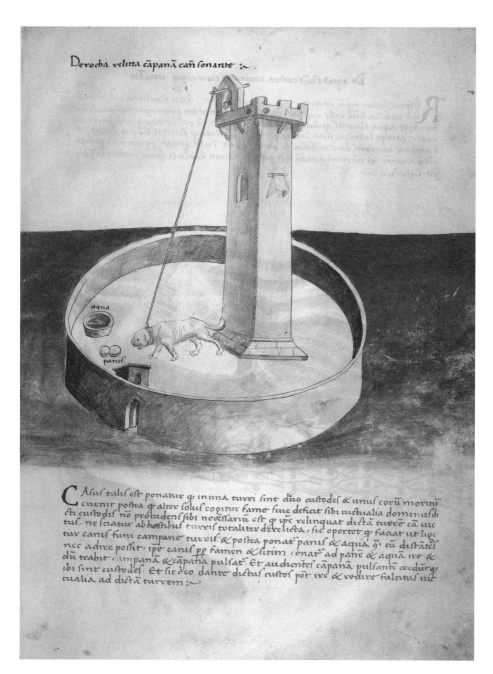

Derocha relitta cāpanā can sonante

Casus talis est ponatur ꝗ in una turri sint duo custodes & unus corū moritur cuenit postea ꝗ alter solus cogitur fame siue deficit sibi uictualia dominus dictus custodis no prouidens sibi necessariū est ꝗ ipe relinquat dictā turrē cā uictus, ne sciatur ab hostibus turreis totaliter derelicta, sic oportet ꝗ faciat ut liget canis funi campane turris & postea ponat panis & aquā ꝗ eū distātes nec adiue possit, ipe canis ꝓ famen & sitim conat ad pane & aquā ire & dū trahit campanā & cāpana pulsat. Et audientes cāpanā pulsātā accedūt ꝗ ibi sint custodes. Et sic deo dante dictus custos pot ire & redire fulcitus uictualia ad dictā turrem :~

FIG. 48 Taccola: stratagem with a dog ringing a bell.

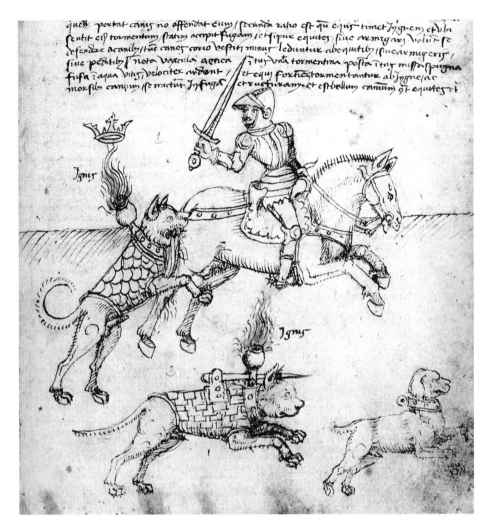

FIG. 49 Taccola: armored fire-bearing great danes exhibiting their male "attributes."

Taccola's Legacy

As mentioned earlier,[195] in the final pages of the autograph manuscript of Taccola's first two books of *De ingeneis,* Michelini Tocci—now over half a century ago—recognized a series of autograph notes and drawings (Figure 50) by Francesco di Giorgio (Siena 1432–1501). These pages express, better than any other document, the continuity of the Sienese technical tradition. They are, as it were, a snapshot of the moment when

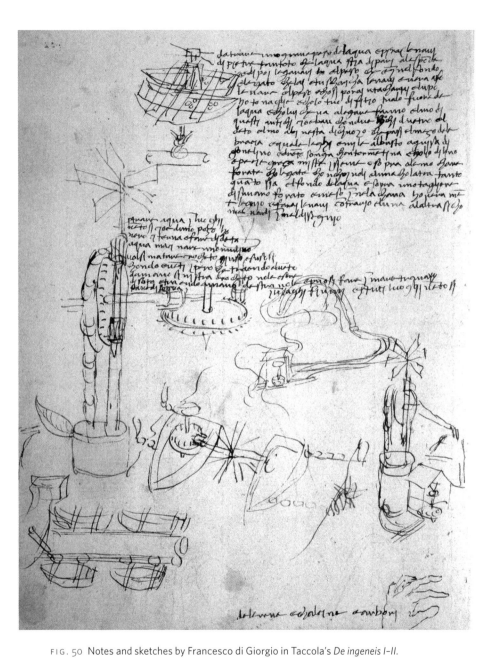

FIG. 50 Notes and sketches by Francesco di Giorgio in Taccola's *De ingeneis I–II*.

Mariano di Iacopo handed the baton to Francesco di Giorgio. Having possibly become the owner—at least temporarily—of Taccola's manuscript now in Munich, Francesco felt authorized to record on it his own notes and drawings. From these, we infer that he had also had access to the manuscript containing the third and fourth books of De ingeneis, the source for some of his texts and sketches concerning devices not illustrated in the first two books. Indeed, neither the sketch of Taccola's interpretation of Brunelleschi's method for transporting columns on water and land,[196] nor the pontoon formed by two boats loaded with stones to raise a column from the seabed with the help of a diver,[197] nor the floating mill, which Francesco depicts with rough sketches,[198] are present in the Munich manuscript.

We therefore glimpse the young Francesco engaged in a close reading of Taccola's texts, which probably remained in the Domus Sapientiae in Siena after the author's death. As with all Francesco's surviving manuscript works, these notes and sketches are impossible to date with precision.[199] In all likelihood, they should be assigned to the start of his successful career as an engineer, but we cannot exclude that they were compiled during a period of apprenticeship under his elderly Sienese predecessor, although we lack evidence for this.

In any event, the earliest surviving documents on Francesco's activity show that his career as a technician began with a careful assessment of Mariano di Iacopo's legacy. The most eloquent evidence is offered by the so-called Codicetto, a minuscule notebook that Francesco crammed with notes and sketches.[200] The Codicetto cannot be dated precisely but is generally regarded as Francesco's earliest manuscript. He presumably started to compile it in the first half of the 1460s, although he kept adding notes and drawings at least until the mid-1470s.[201]

Together with the Opusculum de architectura, the Codicetto is the only surviving manuscript entirely in Francesco's hand. It contains notes and drawings for his personal use, most of them hastily jotted down in haphazard order. It has the appearance of a modest pocket notebook, despite the fact that it is on vellum, too luxurious a material for such practical purposes (but the membrane was recycled), and that it has an elegant wooden board binding (in all likelihood made when the manuscript came into the Urbino Ducal Library).

With respect to Francesco's autograph annotations in Taccola's manuscript of Books I–II of *De ingeneis,* the *Codicetto* displays some similarities and a few significant novelties. The annotations are vernacular paraphrases of Mariano's Latin texts, often fairly loose and sometimes supplemented by personal comments. The drawings are clearly inspired by Taccola's models, but Francesco frequently adds or omits details, occasionally introducing significant changes. What we observe in the *Codicetto* is a process of transcription-assimilation-innovation characteristic of the transmission of knowledge in fifteenth-century artistic workshops: training through observation, imitation of the Master's work, and attempts at new solutions and improvements with no scruples about adopting the ideas and procedures of others, even on the part of artists such as Francesco, who will later vehemently denounce plagiarists.[202] Indeed, Francesco, who became Taccola's greatest popularizer, never so much as mentioned his name.

Beyond the evidence of Francesco's attentive transcription and assimilation of Taccola's work, other important documents throw light on his training and early career.[203] Contrary to a longstanding belief, Francesco's father, Giorgio di Martino, was not a humble poulterer but a civil servant.[204] It is possible, therefore, that Francesco's training in the Sienese artistic workshops was facilitated by his father's public position, which also enabled him to make contact with prominent local authorities and win major public contracts—such as the appointment in 1469 as manager of Siena's underground aqueducts *(Operaio dei Bottini)* in partnership with Paolo d'Andrea.[205] In this connection, it is worth stressing that the Sienese artistic workshops were traditionally engaged in a variety of activities: drawing and painting, sculpture, manuscript illumination, hydraulic engineering, and foundry work—from gold-working to bronze sculpture, from bell-making to the manufacture of cutting weapons and firearms. The little we know of Francesco's early work reflects this variety of professional skills, which was to characterize his entire career.

In 1478 Francesco participated in the Colle Val d'Elsa war,[206] in which Siena was a member of a coalition against Florence that included Pope Sixtus IV, Alfonso of Aragon, Duke of Calabria (present on the battlefield), and Federico da Montefeltro, Duke of Urbino, whose troops were led by his son Antonio. We lack information on Francesco's role in a

conflict that, during the siege of Castellina, would have pitted him against another brilliant engineer, Giuliano da Sangallo, on the side of the Florentine army. The conflict marked Francesco's debut as a military architect, launching him into an extremely successful career, thanks above all to the protection of the two warrior-lords, Federico da Montefeltro and Alfonso of Aragon, both keen collectors of rare and finely illuminated manuscripts.

By the late 1470s, Francesco had settled in Urbino, where he was involved—to an extent that remains unclear—in the preparation of the bas-relief frieze on the art of war above the bench of the wing façade of the Ducal Palace.[207] More than any other document, this undertaking, conceived and commissioned by Federico da Montefeltro, attests to the strong interest in ancient machines and the symbolic value attached to their public display on the part of the learned Duke.

The affectionate familiarity of Federico and the stimulating environment of a court in which refined humanists were engaged in the recovery and interpretation of ancient texts helped Francesco to perfect his skills. The Duke soon appointed him ambassador to the Sienese Republic. Although Federico's esteem and trust greatly enhanced Francesco's reputation among his fellow citizens, it also provoked envy.[208]

Francesco Di Giorgio "Author"

The change of environment and relations also had an impact on Francesco's literary output if—as seems plausible—the small nucleus of notes and sketches on military architecture in the Vatican *Codicetto* date from his first stay in Urbino. The *Codicetto* reflects his professional growth as a designer of technical devices. Alongside the large corpus of solutions derived from Taccola, we observe the first attempts to formulate original ideas.[209] From the central pages of the small manuscript onward, Francesco starts to insert drawings of machines not documented in *De ingeneis* and *De machinis* into the sequence of drawings and notes based on Taccola's manuscripts. These carefully drafted drawings, without annotations, focus on four basic types of contrivances: machines for moving and lifting obelisks and columns (Figure 51);[210] devices for raising water; mills; and wagons with complex transmission systems (Figure 52).[211]

FIG. 51 Francesco di Giorgio: column-raising machine.

FIG. 52 Francesco di Giorgio: wagons with complex gears propelled by manpower.

Francesco offers no information on the abrupt shift from the faithful reproductions of Mariano's drawings and texts to the presentation of innovative projects. Moreover, these "new" machines display a far more complex and advanced design than those of Taccola. They feature complex gear mechanisms, often incorporating worm screws and metal racks,[212] and variously assembled to transmit motion produced by different sources at any desired velocity. As we know of no earlier models of comparable mechanical complexity, we may assume that these designs are Francesco's original contribution.

The large collection of drawings of machines to lift and move columns and obelisks appears particularly intriguing, if only because such devices were so seldom used on worksites. Francesco's almost maniacal focus on these machines may be connected to an early visit to Rome, for which, however, we lack documentary evidence. It is likely that Francesco's interest in these gigantic contraptions was stimulated by the legendary feats of the Bolognese engineer Aristotele Fioravanti, who, as previously noted, moved and straightened towers in several Italian towns. Fioravanti was repeatedly consulted by Popes Nicholas V and Paul II about the feasibility of moving Julius Caesar's obelisk to Saint Peter's Square.[213] The project was abandoned because of its extreme complexity, despite Fioravanti's claim that he would be perfectly able to execute it. The presence of a hauling device *(tirare)* for moving a tower (Figure 53) in the series of machines for hoisting or moving columns and obelisks depicted in his *Opusculum de architectura* seems to attest Francesco's ambition to match the achievements of his celebrated Bolognese colleague.[214]

On the other hand, we cannot rule out that these drawings represent a refined exercise in the archeology of machines. Francesco may have conceived them as "divinations" of the methods used by Roman engineers to hoist monolithic columns without damaging them—or to transport obelisks from the Nile valley and erect them in the imperial city. They would thus provide evidence of the same blend of antiquarian curiosity and spirit of innovation that we noted in Mariano's work—a combination that would also characterize the production of several architect-engineers of the fifteenth and sixteenth centuries.

The technical proposals contained in the *Codicetto* turn up in the manuscript of the so-called Anonymous Sienese Engineer,[215] which also

FIG. 53 Francesco di Giorgio: method for moving a tower without damaging it.

includes borrowings from Roberto Valturius's *De re military*,[216] a partial Italian translation of the treatise on pneumatics by Philo of Byzantium, and devices and technical solutions not found in Francesco's production, such as the drawings of the flying man (Figure 54)[217] and the parachute (Figure 55),[218] so often reproduced for their pre-Leonardian overtones. In the London manuscript, in addition to Taccola's virtually complete technological corpus (with the texts paraphrased in Italian in a manner inconsistent with the *Codicetto*), we observe the insertion of the nucleus of "new" devices that first appeared in Francesco's *Codicetto*, although with the puzzling absence of the series of pumps.

The Anonymous Engineer mentions "Maestro Francesco da Siena" three times[219] and reveals his familiarity with the Sienese territory in the drawing of the hydraulic saw, which he claims to have seen in operation at the abbey of San Salvatore on Mount Amiata.[220] All available evidence indicates that the author frequented Francesco's workshop, where he had the chance to examine the *Codicetto* and also, possibly, Taccola's first two books of *De ingeneis*. Gustina Scaglia attributed[221] to the refined draftsman Guidoccio Cozzarelli the drawings found in a splendidly illustrated manuscript[222] in the Biblioteca Nazionale Centrale of Florence, which displays the same combination of Taccola's legacy with Francesco's new machines. If we give credence to this attribution, we might assume that the British Library codex records the assimilation of the Sienese mechanical tradition by one of Francesco's pupils—perhaps Guidoccio's brother, Iacopo Cozzarelli.

In the more than 160 drawings contained in the splendid *Opusculum de architectura* in the British Museum, the two corpuses consisting of Taccola's legacy and the nucleus of Francesco's new machines still coexist.[223] However, the manuscript—undoubtedly the work of Francesco, even though it does not bear his name—exhibits major innovations with respect to the *Codicetto*, and not only in its much larger format and more accurate execution of drawings. In the Vatican manuscript, Taccola's machines and those presumably designed by Francesco were juxtaposed and, as a consequence, easily distinguishable. The *Opusculum*, by contrast, shows a sequence of perfectly drafted drawings, in which Francesco's "inventions" appear fully integrated with the much more refined reproductions of Taccola's machines.

FIG. 54 Anonymous Sienese
Engineer: flying man.

FIG. 55 Anonymous Sienese
Engineer: man with parachute.

The autograph copy of the *Opusculum* contains a dedication to Federico da Montefeltro.[224] The compilation of the manuscript therefore dates from Francesco's move to Urbino, toward the end of 1477, when he felt the need to demonstrate to the Duke his consummate skills in various fields of applied technology. This is confirmed by the presence in the manuscript of ten plans of fortresses that a warlord such as Federico would have surely appreciated. The *Opusculum* has the appearance of a luxurious promotional brochure showcasing the professional services offered by the Sienese engineer and his workshop.

As a vivid graphic compendium of Sienese technological specialties, the *Opusculum* enjoyed a resounding success. I know of no other technical text that was so often copied in full or in part, or that aroused such a lasting curiosity among engineers, illustrators, and publishers.[225]

In the dedication letter to Federico da Montefeltro, Francesco intersperses personal statements with paraphrases of Taccola's remarks on the impenetrability of the inventor's mind: "It should be noted that not all that is contained in this manuscript can be explained with drawings; many things reside in the mind and ingenuity of the architect and it is impossible to express them through pictures and drawings."[226]

Composed most probably with the help of Federico's learned minister, Ottaviano Ubaldini,[227] the dedication letter of the *Opusculum* clearly sets out the guidelines of Francesco's research program. His ambition to rival the great ancient masters is manifest in the tribute paid to the Duke of Urbino, whom Francesco compares to Alexander the Great and Caesar. He thus implicitly establishes a flattering analogy between himself and Dinocrates and Vitruvius, the great engineers and architects patronized and honored by those magnificent princes of antiquity.

The evidence of his knowledge of Vitruvius is particularly important. While the corpus of technical solutions by Taccola and Francesco would undergo only marginal changes, the format of presentation of that complex of machines would evolve significantly in Francesco's later works. The effort to become an "author" led him to draft an organic treatise emulating the admired model of Vitruvius's *De architectura*. In keeping with the importance conferred by the Roman architect to the *machinatio,* Francesco assigned a central role to machines and technical devices, establishing a balanced relationship between them and a set of precepts, rules,

and insights of fundamental importance for the theory and practice of architecture and for understanding the nature of man and his place in the universe. Without these theoretical foundations, he argued, it is impossible to properly design a house, temple, fortress, or city.

I SHALL NOT DWELL here on Francesco's efforts to produce a well-structured treatise on buildings and machines (the so-called *Trattato di architettura e macchine*), nor on the complex issues relating to the dating of the many drafts of that work—none of them in Francesco's hand—that have emerged in recent decades.[228]

I shall focus instead on the evolution of the presentation format of the Sienese machines in the surviving manuscripts of the *Trattato*, starting with the earliest version of Francesco's work *(Trattato I)*, tentatively datable to ca. 1480–1482.[229] In *Trattato I*, Francesco introduces notes and drawings on underwater foundations and dike constructions that reflect a further incorporation (with respect to the *Opusculum*, where they were absent) of technical solutions illustrated by Mariano di Iacopo in *De ingeneis*.[230] He also adds a section, lacking in both the *Codicetto* and the *Opusculum*, on measuring heights and distances, in which he expands Taccola's few notes and drawings on these subjects.[231] He then presents in sequence the four categories of devices already featured in the *Codicetto* (mills, pumps, pulling and lifting machines, and wagons) and reproduced virtually unchanged in the *Opusculum*. The innovations in *Trattato I* consist of the textual commentaries on individual drawings, an appendix containing devices not included in the four categories previously illustrated,[232] and the addition of a section on the art of war and defensive and offensive weapons.[233] The latter demonstrates, yet again, Francesco's inclination to combine antiquarian pursuits with innovative solutions. On the one hand, he describes traditional war machines—such as trebuchets, attack wagons, hull-piercing devices, catapults, and siege ladders—through his customary plundering and reworking of Taccola's drawings and notes. On the other hand, he focuses on firearms, in particular on systems to transport and protect heavy mortars and bombards, and to aim them easily and accurately (Figure 56).[234] The section on the art of war also includes a number of military stratagems in which, once again, we recognize Taccola as Francesco's direct source.[235] Lastly, he offers a

FIG. 56 Francesco di Giorgio: protection and aiming systems for bombards.

series of recommendations on how to construct bombards and discusses their various designations according to their shape and dimension and to the weight of projectiles.

In the *Trattato I,* even the presentation of the four basic categories of Francesco's machines displays interesting new features with respect to the *Opusculum.* Textual descriptions complement the graphic representations of the machines with information on materials and dimensions, construction methods, and the specific applications for which Francesco recommends their use. He sometimes declares that he has personally tested the performance of certain devices. Moreover, in the section on mills, he proposes a quantitative analysis of the relations between the number of teeth and the dimension of the wheel and pinions, and the velocity with which the millstone turns, also suggesting solutions to reduce friction.

The drawings and the texts of the *Trattato I* show Francesco's professional growth and remarkable experience. The machines are now arranged not only in homogeneous categories—an innovation with respect to the *Opusculum*—but in a logical order within each category. In his presentation of mills, for example, Francesco begins by examining water mills, then windmills and man-powered mills, and lastly animal-powered mills.

This effort to classify machines reveals the importance that Francesco assigned to a coherent organization of the technical issues discussed in his treatise. This concern was extraneous not only to the early writings of Taccola and Francesco but also to all known prior books on machines. It appears evident that Francesco was inspired by Vitruvius and, in particular, by the order followed by the Roman author in illustrating the various types of waterwheels and construction instruments and machines in the tenth book of his *De architectura.*

The first version of the *Trattato* also exhibits a major change in the numerical proportions of the different categories of devices with respect to the *Codicetto* and the *Opusculum.* Mills, with fifty-eight different models, represent the category most heavily expanded, the consequence of Francesco's effort to submit to an exhaustive analysis the various types of transmission systems and energy sources. Similarly, in the section devoted to pumps he discusses a wide range of systems, often operated by unprecedentedly complex mechanisms (Figure 57).[236] By contrast, the

FIG. 57 Francesco di Giorgio: five types of pumps.

sections on carts and pulling and lifting devices—above all, those for lifting and moving columns and obelisks—illustrate far fewer examples than the *Codicetto* and the *Opusculum*.

Matching Drawings and Words

Francesco's tendency to focus on a more limited sample of devices gathered momentum in *Trattato II*.[237] In the Magliabechiano manuscript, which was probably compiled in the early 1490s, the number of images was substantially reduced. For example, only ten mills are illustrated, now rigorously arranged by energy source: an overshot bucket waterwheel; a horizontal scoop wheel, and a horizontal-axis windmill; two mills with flywheels; three man- and animal-powered mills with different transmission systems; and two horse-powered treadmills (in the first, the horse operates inside the wheel; in the second, his hooves exert pressure on the outer rim).

This process, which goes hand in hand with Francesco's attempts at a more synthetic approach in the other sections of *Trattato II,* bears eloquent witness to his new interpretation of the functions and goals of the *machinatio.* The difference between the contraptions of *Trattato II* and those of the *Codicetto* and *Opusculum* is not in the technical systems, already substantially defined at the time of the Vatican manuscript, but in the emergence of the need to reduce the potentially endless catalogue of machines to a few homogeneous categories based on common construction and operational principles.

Francesco thus moved away from the workshop tradition of handling every technical operation and the construction of every mechanical device as a case apart. In the workshop a craftsman's proficiency was measured by the number of "cases" he was able to master. The selective textual and visual descriptions of machines in the *Trattato II* took on a far different meaning with respect to the presence in the *Codicetto* of a vast number of devices, often distinguished only by marginal variations in the arrangements of their parts.

In the section on machines for lifting and pulling weights in *Trattato II,* Francesco explains the reasons for his decision to illustrate fewer devices: "and with these [examples] we conclude the section on instruments for pulling weights in construction work, since from these everyone can

easily derive all the others."[238] He reasserts this concept, in the passage discussing the potentially infinite variety of methods for applying force:

> if we want to offer examples of all the instruments that come to mind, it will be an infinite process; let the few examples described therefore suffice for the more ingenious readers, because it is easy to multiply the inventions by applying the remedies according to the defects, setting aside superfluous elements, and without omitting the necessary things.[239]

The sections on machines in the two versions of the *Trattato* mark the birth of a new literary genre: the illustrated technical treatise. *Trattato I*, as preserved in the autograph copies in Florence and Turin, appears particularly innovative not only for the introduction of a new method of portraying machines but, above all, for the page layout, designed to directly link the descriptive texts to their corresponding images (Figure 58).[240] This is a far cry from the tradition of full-page illustrations followed, for example, in the manuscripts (as well as in the printed editions) of Valturius's *De re militari*,[241] or in the earlier publications of technical texts of classical authors, from Vegetius's *De re militari*[242] to Fra Giocondo's edition of Vitruvius's *De architectura cum figuris*.[243] There is no evidence of plans for a printed edition of the *Trattato I*, which, had it been produced respecting the layout of the surviving manuscripts, would have marked an extraordinary innovation.

The originality of the graphic conventions adopted by Francesco to highlight the main structural details of the devices that he takes into account should also be stressed. Despite his mastery of the rules of linear perspective, he depicts machines effectively but not in rigorous perspective. To portray his devices in a single drawing, he consistently chooses the best point of view to show both their external appearance and the spatial distribution of their internal parts. To this end, he introduces an unprecedented graphic solution—the machines are inserted in open boxes drawn in perspective (Figure 59),[244] so as to better distribute in their internal compartments the source of energy and the principal mechanisms: men or animals powering a mill (Figure 60), the hopper, the grindstone, the vertical or horizontal waterwheel, and so on.[245] Boxes serve also to suggest the supporting structures of machines.

FIG. 58 Direct dialogue between text and images on a sheet of "tirari e alzari" (hauling and lifting devices) of Francesco di Giorgio's *Trattato I*.

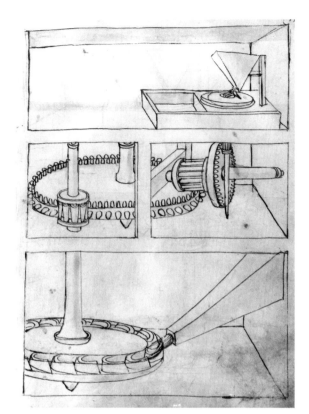

FIG. 59 Francesco di Giorgio: flour mill whose parts are distributed in box-like structures.

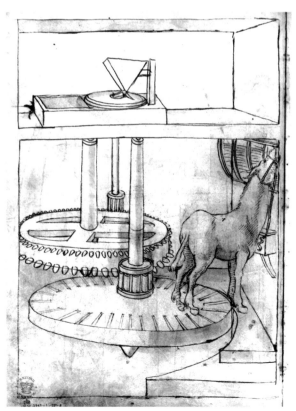

FIG. 60 Francesco di Giorgio: horse-driven treadwheel powering a mill grindstone.

Francesco's pride in the results achieved through his new method of illustration was entirely justified and explains his emphasis on his clear-cut graphic—and hence conceptual—primacy over scholars of architectural and mechanical matters who lacked skills and experience in drawing. In *Trattato II,* his criticism of authors of texts without images becomes scathing. He contrasts himself with the authors (among whom he probably included Leon Battista Alberti) who engaged in a purely textual reconstruction of the work of Vitruvius and, more generally, of classical technology and architecture. "Make the drawing match the words"[246] became his war cry against those who harbored the illusion that they could "restore to its pristine strength the lesson of the most ancient authors—above all, Vitruvius—as it were, by dint of Greek and Latin grammar."[247]

As drawing is essential for making textual descriptions of buildings and machines understandable, only architects and engineers can offer a crucial contribution to the revival of ancient technical knowledge. Not by chance, Francesco di Giorgio worked strenuously on a translation of Vitruvius's *De architectura* for his personal use.[248] In many passages of both versions of his *Treatise of architecture and machines,* he proudly reasserted the central importance of translating ancient technical texts into images, stressing how this contribution could be made only by professionals who combined technical expertise and a mastery of drawing:

> There have long been very worthy authors who have written extensively on the art of architecture and on many buildings and machines, illustrating them with characters and letters and not with drawn figures. . . .
>
> But if such authors matched the drawing with the words, it would be much easier to form an opinion by seeing the image along with the textual description, and so any obscurity would be removed. But there are many speculative minds who, through their alacrity, have discovered many things and found other ancient things as if anew by describing them with words; but because we do not have the drawings [of the ancient authors], those things are extremely difficult to

understand. Indeed, as we can see, there are many who have learning and no ingenuity, and many who have ingenuity and no learning, and others have learning and ingenuity, but lack drawing skills. Hence, if they want to explain [ancient technical and architectural] texts by means of drawings, they must ask an expert painter for help.[249]

Compared with the cultural and social context in which Taccola had conceived his works, that in which Francesco di Giorgio and, later, Fra Giocondo, Cesare Cesariano, and other architect-engineers developed their successful careers had changed substantially. The rediscovery of Vitruvius and the work of Leon Battista Alberti, one of his more authoritative popularizers, stimulated the rebirth of the programmatic integration of architecture and machines that was completely absent in the technical works of earlier generations. Francesco reintroduced into architecture the technical knowledge that had developed along a totally independent route in the works of the nonarchitect Taccola.

Despite the attempt at abstraction and the goal of establishing universal principles and rules, the two versions of the *Trattato* reveal Francesco's pride in Sienese technical specializations. The section on metals, for example, witnesses the knowledge he had acquired through his acquaintance with the Sienese technicians exploiting the Republic's abundant mining resources. Even the methods for damming rivers and constructing solid foundations on sea-, lake-, and riverbeds—illustrated in detail in *Trattato I*—reflect technical operations extensively practiced in the Sienese territory, as also documented in Mariano di Iacopo's manuscripts. It is worth recalling that Francesco was involved in rebuilding the Macereto bridge on the Merse river in 1485. He anchored the new supporting pillars of the bridge to the foundations of the old pillars washed away by a flood. His solution won praise from the commissioners charged with assessing the work.[250]

Francesco also played a role in the ambitious project to dam the Bruna river, although his involvement was most probably confined to consultations on the stability of a structure designed and built by Pietro dell'Abaco and other Sienese engineers.[251] The section of *Trattato I* devoted to underwater foundations and fish farms contains information and

technical solutions acquired through his familiarity with the plan to dam the Bruna river and build a large fish farm in the Sienese Maremma.[252]

The most explicit evidence of the direct link between the description of machines in *Trattato I* and Sienese technical specialties is offered by the sections on solutions for conveying water, in which Francesco drew on his personal experience as contractor for the *bottini* network. He gives detailed instructions and illustrations on the method for building underground galleries to collect and convey water and for maintaining the dimensions of the galleries constant during excavation; he explains the purpose of the wells or manholes *(smiragli);* he illustrates how to ensure a constant gradient of two feet per hundred for the water conduits by means of a plumb line and a carpenter's square; he shows how to excavate the gallery in the right direction using a compass; and he illustrates how to distribute purified water from the underground aqueduct to the city fountains by collecting water in settling tanks *(galazzoni),* and by forcing it through filters *(colatoi)* filled with sand and fine gravel to trap impurities (Figure 61).[253] In the pages of the *Trattato I* on measuring distance and height, Francesco also shows how to use an astrolabe to measure the difference in level between a spring and the water's final destination—be it a fountain or mill wheel.[254]

These examples—as well as his assimilation of Taccola's technical heritage as early as the compilation of the *Codicetto*—show the close relationship between Francesco's main fields of specialization as an engineer and the most critical problems of his native city and the territory under Sienese rule.

Although his resounding success as a civil and military architect had made him, at the apex of his career, eagerly sought after by the most powerful Italian rulers, for the Sienese, Francesco remained, above all, a hydraulic engineer, the man who could maximize the supply of water to the city's fountains and find the most effective solutions for preventing the dreaded collapse of the Bruna river dam. Not surprisingly, therefore, when the rulers of Siena, on September 11, 1492, implored the Duke of Calabria, for whom Francesco was strengthening fortifications in the Otranto region, to allow their fellow citizen to return home, they cited two emergencies in support of their plea: "first, the fountains, which have been very short of water, owing to the lack of maintenance of the aque-

FIG. 61 Francesco di Giorgio: sand and gravel filters to trap water impurities.

ducts; second, our lake [the dam on the Bruna river], which, as winter draws near, needs urgent works."[255]

The assimilation of Taccola's technical corpus by Francesco di Giorgio, completed between the *Codicetto* and the *Opusculum de architectura*, marks the birth of a Sienese tradition destined to be largely disseminated through treatises on architecture and machines, or albums exclusively containing drawings of devices and technical solutions for civilian and military use compiled by authors, often anonymous, over successive generations. The success of this tradition was immense. The model of the album filled with drawings of machines without descriptive texts, based on the *Opusculum* archetype, proved more popular than the more sophisticated integration of architecture and machines in the two versions of the *Trattato*. Nevertheless, the latter circulated widely, attracting the attention, among others, of Leonardo da Vinci, Giuliano da Sangallo, and Antonio da Sangallo the Younger.

In the sixteenth century, this tradition was effectively promoted by new generations of renowned Sienese architects, such as Baldassarre Peruzzi and Pietro Cataneo, and by talented technicians such as Oreste Vannocci Biringucci and Vannoccio Biringucci[256]—who made several

proud references to this homegrown tradition in his *Pirotechnia*.[257] After Siena's conquest by Cosimo I de' Medici, leading Florentine artists, men of letters, and engineers contributed to further propagate this body of knowledge,[258] especially in the Veneto,[259] also thanks to images of Sienese machines reproduced by the authors of the best-selling "Theaters of Machines."[260] However, those who obsessively replicated the "inventions" of Taccola and Francesco appear to have been completely ignorant of their authors' identity, and of the fact that this formidable technical heritage had been elaborated in fifteenth-century Siena.

The slow process through which these important contributions were finally attributed to their rightful authors began in the late eighteenth century thanks to the joint efforts of local historians, who first explored the surviving archival documentation on the activity of Renaissance Sienese artists and technicians, and military historians, seeking to shed light on the introduction and early development of firearms.

This process has yielded a more accurate portrait of the exceptional personalities of the Sienese engineers, highlighting their achievements against the background of the tensions, aspirations, and research methods characteristic of Renaissance culture, in Siena and in other Italian centers. Viewed as a tradition rather than a series of isolated episodes, this complex of innovative technical proposals and penetrating reflections on the fundamental role of images emerges ever more forcefully as a key aspect of the Italian Renaissance that has not received the attention it deserves.

Leonardo versus the "Ancient Philosophers"

Drawing, the Instrument of the Mind's Eye

While still conventional in style, Leonardo's earliest drawings of machines and technical systems, dating from the mid-1470s, already display the artist's exceptional figurative talent. In these endeavors, he conforms to the traditional paradigm of "one machine—one drawing." The sketches, haphazardly distributed in the individual folios, have no accompanying text, or, at best, brief annotations.

In these studies, Leonardo draws devices in perspective, but, like his predecessors, he does not hesitate to deliberately distort their appearance in order to visualize more effectively the articulation of their internal parts (Figure 62).[1]

Ms. B, compiled in the first years of Leonardo's lengthy sojourn in Milan, shows clear signs of the evolution of his method of depiction. It offers eloquent examples of the mastery achieved in stenographic drawing, a field in which he surpasses even Taccola's admirable models. Probably inspired by Francesco di Giorgio (whom he met in Milan, and with whose *Treatise on architecture and machines* he was familiar),[2] Leonardo inserts machines into perspective boxes (Figure 63).[3] We also glimpse his first attempts at a separate analysis of individual mechanisms.[4]

Despite their appeal, Leonardo's celebrated drawings of flying machines in Ms. B do not exhibit innovative features. Their utopian grandiloquence and the effort to emphasize the power and operational

FIG. 62 Leonardo da Vinci: drawing of cart for carrying a bombard (detail).

efficiency of these imposing structures undermine an accurate represen-
tation of the proportions and articulations of their mechanical organs.
In these drawings, he seems to assume that man can lift such incredibly
heavy devices from the ground and control them in flight by the force of
his neck transmitted to the rudder via a combination of interlinked con-
trivances (Figure 64).[5]

In this phase, Leonardo—like so many of his predecessors and con-
temporary artist-engineers—used drawings intentionally ignoring the
constraints imposed by the need for a balanced relationship between force
and resistance (Figure 65).[6] Not by chance, these images—so often cited
as icons of Leonardo's genius—were soon shelved by their author himself.
When Leonardo later resumed his dream of human flight, he focused
much less on gears, pinions, transmission belts, levers, and other devices
to be operated with the hands, feet, and head, concentrating instead on
what we would now define as gliding.[7] This new approach was nourished

FIG. 63 Leonardo da Vinci: pump operated by means of an oscillating arm.

by the careful observation of the organs of birds and their disposition during the various phases of flight.

The less dramatic drawings of the *Codex on the flight of birds,* executed fifteen years after the images of flying machines in Ms. B, are more innovative in both pictorial and conceptual terms. They express Leonardo's full awareness of the decisive influence of air, wind, and air currents and his confidence in explaining the functioning of the bird-machine by means of schematic diagrams that suggest bold analogies: "The bird is an instrument operating by mathematical law, an instrument that it is in man's power to reproduce with all its movements, but not with so much strength."[8]

Statements like this help to reveal the reasons that led him to abandon the utopian plans for man-powered mechanical flight outlined

FIG. 64 Leonardo da Vinci: man operates flying machine using even the force of his head.

FIG. 65 Leonardo da Vinci: the imposing structure of the flying machine.

in Ms. B. Elsewhere, Leonardo admits that man lacks not only the strength but also the soul of the bird, that is, the capacity to instinctively dispose its limbs in such a way as to exploit air currents and winds.[9] This was a way of recognizing, although implicitly, that even gliding was fated to remain a dream.

The years that separate Ms. B from the *Codex on the flight of birds* saw a radical change in Leonardo's conception of machines, his method of depicting them, and, more generally, of drawing conclusions from the observation of nature. During this phase, he elaborated new paradigms that were to inspire his later drawings of technical systems. He now focused on causes rather than effects, whether dealing with the operations of organic and inorganic machines or with the dynamics of natural phenomena. Moreover, he increasingly intended his technical drawings to serve as instruments for visualizing theoretical hypotheses or mental experiments.

The introduction of theory into the sphere of representation was not confined to the field of technical illustration. It also characterized Leonardo's activity as a painter, which, as is well known, became ever more complicated because of his efforts to perfectly reproduce the operations of nature: the perennial struggle between light and shadow; the loss of definition of images with distance; and the continuous variations in human and animal expressions and attitudes with changes in actions, moods, and sensations.

As regards the drawings of machines, the effects of this transformation are clearly visible in the first of the two manuscripts rediscovered in the Biblioteca Nacional de España in Madrid in 1965, which Leonardo began to compile in Milan in the early 1490s. Madrid I is generally considered as an organic text (at least by Leonardo's standards), divided into two distinct sections, one theoretical, the other practical.[10] However, while containing sequences of pages that display a great care in the layout, an orderly distribution of texts, and finely executed drawings, Madrid I exhibits the same tendency as all Leonardo's manuscripts to slip from one topic to another often totally different one. For instance, the section in which he proposes his theoretical reflections on mechanics is replete with almost obsessively reformulated definitions to reach a satisfactory definition of fundamental physical principles, such as weight, force, motion, and percussion. He also engages in intense discussions with imaginary

interlocutors, to test how well his ambitious reform project can hold up to the counter-arguments of followers of traditional doctrines.

The eminent scholars who first examined Madrid I recognized it as an advanced stage of one of Leonardo's most ambitious projects: the compilation of an organic treatise on "mechanical elements" *(elementi macchinali)* to which he refers in many of his notebooks from the late 1490s on. For Ladislao Reti, who played an important role in the redis-covery of the two Leonardo manuscripts and was responsible for their publication,[11] with the expression *elementi macchinali* Leonardo alluded to the "elements of machines," i.e., to mechanisms—many of which are indeed drawn and analyzed in detail in the opening section of the man-uscript. Thus Leonardo, Reti argued, anticipated by three centuries the in-depth analysis of the basic mechanisms of machines developed by the researchers of the École Polytechnique in Paris, which culminated in Franz Reuleaux's celebrated organic systematization in the mid-nineteenth century.[12]

As I pointed out in a study published many years ago, Reti's interpreta-tion rested on a misunderstanding of the expression *elementi macchinali*.[13] Leonardo did not refer to individual mechanisms but to a foundational analysis of the general principles of mechanics, to which he had devoted himself with increasing energy from the early 1490s. For Leonardo, the "mechanical elements" are the universal principles of mechanics, not the mechanisms. He assigned to "elements" the same meaning as Euclid in his classic text the *Elements of geometry*, in which the Greek mathematician highlighted the universal principles of all geometric demonstrations.[14]

In recent years, three German scholars formulated the opinion that Madrid I does not contain a treatise on *elementi macchinali*, an expression that—as they rightly note—never occurs in that manuscript, but rather documents Leonardo's attempt to elaborate an organic treatise on me-chanics comprising a section on principles—often referred to as "my the-oretics" *(la mia teorica)*—and a section on applications.[15] Only later, the German authors contend, did Leonardo abandon this earlier approach, devoting himself to preparing the treatise on mechanical elements, as confirmed by the numerous references in his manuscripts from the late fifteenth century on to the many books and propositions in which the *Elementi macchinali* were articulated.

I confess to some hesitation in believing that Leonardo first compiled a rather complex text on theoretical principles and their applications that he then transformed into a treatise on mechanical elements, and that these works were lost in the admittedly complicated process of transmission of his manuscripts after his death. Is it possible that no comprehensive draft of these compilations has survived?

It seems more reasonable to assume that he drafted the indexes of those treatises—indeed, multiple versions of them, given that the references to the numbers of the books and propositions are not consistent. Although Leonardo wrote many of the propositions that he intended to incorporate in the ever-shifting architecture of those ambitious systematizations, he never reached the point of organizing them in a coherent and stable structure.

TO ASSERT THAT LEONARDO used the expression *elementi macchinali* to refer to his reflections on the principles of mechanics is not to deny that he conducted a pioneering in-depth investigation on the elementary components of machines, nor that the most advanced phase of his ambitious program is indeed illustrated by the opening section of Madrid Ms. I. In those pages, Leonardo clearly states his intention to dwell on the constituent organs of mechanical devices, conducting what might be defined as an exhaustive "anatomy of machines":

> such instruments will generally be presented without their
> armatures or other structures that might hinder the view of
> those who will study them. These same armatures will then
> be described with the aid of lines, after which we shall discuss
> the levers by themselves, the strength of supports and their
> durability and upkeep.[16]

The anatomical approach implies a shift from the traditional analysis of machines as individual and indivisible entities to an investigation that focuses on the limited number of basic mechanisms whose diverse combinations yield a variety of devices.

To carry out this innovative investigation, Leonardo relies primarily on drawing. Through a wide array of illustration methods, which owe their effectiveness to his mastery of perspective (elevation and plan views

(Figure 66),[17] exploded views (Figure 67),[18] and geometric diagrams (Figure 68),[19] he takes apart and recomposes the machine organs, highlighting the direct relationship between their material structure and the operation that they perform (Figure 69).[20] Moreover, he assigns letters and numbers to the various parts of the devices, thus effectively integrating the information provided by the drawing with that of the textual description.[21]

In other instances, he illustrates the functional potential of individual mechanisms by portraying them suspended in the air (Figure 70).[22] Using the methods of modern animation, he skillfully suggests kinematic chains (Figure 71).[23] Lastly, he turns shadowing, which in his early technical drawings served a purely decorative purpose, into an instrument for visualizing the spatial relationships between the organs of machines and for emphasizing their reliefs (Figure 72).[24]

Such a purposeful use of shadowing in drawing machines was unprecedented. Referring to the classification of different types of drawings later proposed by Vasari, one could say that Leonardo's images of technical subjects mark the transition from the rough outline, i.e., the simple sketch, to the drawing made of "well delineated and proportionate contours" to which shadow and light are added to create a fully realistic portrait.[25]

In Madrid I, Leonardo also introduces hatching with curved lines to visualize the erosion produced by contact and friction, a phenomenon to which he eagerly applied himself in those same years, focusing in particular on the friction caused by dragging and rolling. Hatching with curved lines served to enhance the incidence of attrition, suggesting the dynamics of contacts between the various machine parts. The text that accompanies a drawing of an axle worn down by attrition (Figure 73) shows his confidence in visual representation as the best means of effectively conveying information almost impossible to communicate through textual descriptions:

> I found that all axles, no matter what kind of metal they are made of, are worn in such a way that that part of their length which is nearer to the center becomes thinner. . . . In this way the axle, which was originally made up of straight lines, becomes constituted of curved lines.[26]

FIG. 66 Leonardo da Vinci: overhead and ground-level views of a *tirare* (hauling device).

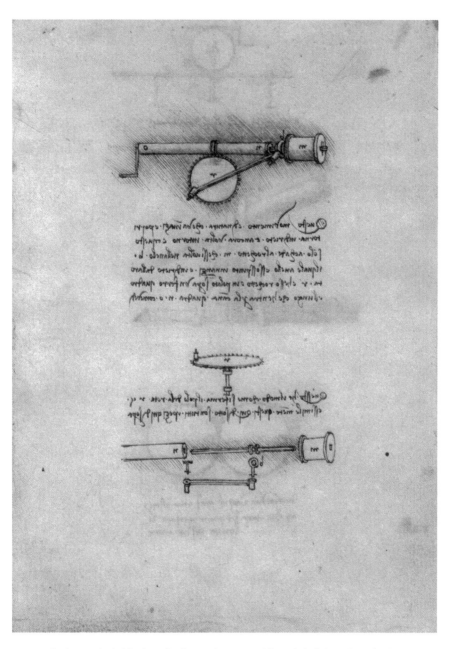

FIG. 67 Leonardo da Vinci: study of a crank system with exploded view of mechanism.

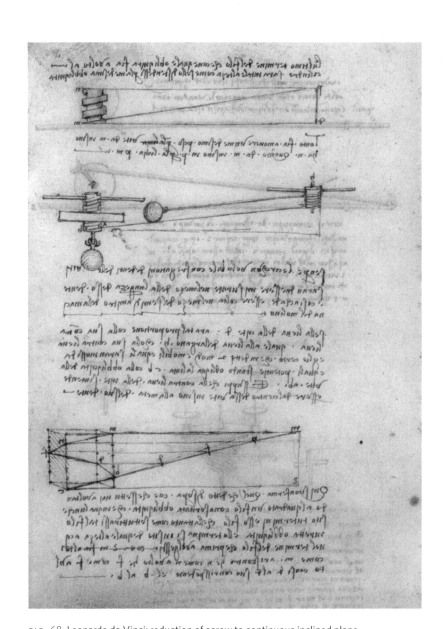

FIG. 68 Leonardo da Vinci: reduction of screw to continuous inclined plane.

FIG. 69 Leonardo da Vinci: detail of pad to reduce friction on ratchet jack.

FIG. 70 Leonardo da Vinci: detailed analysis of mechanism to generate alternating movement.

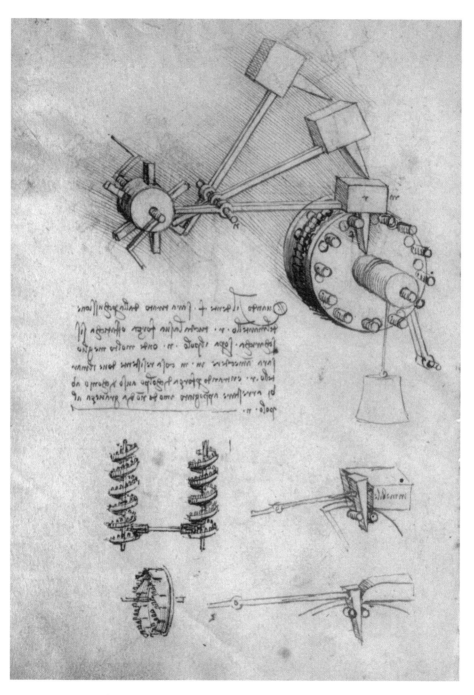

FIG. 71 Leonardo da Vinci: hammers striking gear-wheel pins in sequence.

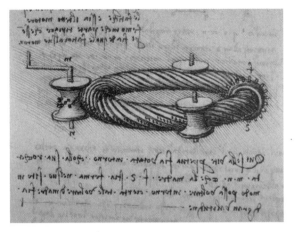

FIG. 73 Leonardo da Vinci: axle worn down by friction (detail).

FIG. 72 Leonardo da Vinci: endless screw.

This is further evidence of the density of information that he was able to stratify in a minuscule drawing, and of how theoretical motives drove him to continuously refine his graphic techniques.

Leonardo's contribution to the affirmation of a new way of conceiving and portraying machines was not confined to the field of mechanics. From the mid-1490s on, his entire production of texts and illustrations reflects the impact of the new role that he had assigned to drawing as the most effective instrument for extrapolating and visualizing the principles that govern the functioning not only of machines but of all natural phenomena and creatures, including man.

The universal application of this method of analysis finds confirmation in his studies on architecture, in which he relies on the theorems of his treatise on "mechanical elements" to account for the lateral thrusts of arches. He analyzes buildings not as static structures but as living organisms in dynamic equilibrium, of which the drawing records an ideal moment of suspension of the continuous process of transformation.

Using this paradigm, Leonardo revisited the traditional assimilation of the architect to the physician, a *topos* widely used by Renaissance authors on architecture, by shifting the emphasis from correspondences and symmetries between the body of man and that of buildings to their dependence on the same mechanical laws:

Just as doctors . . . need to understand what is man, what is life, what is health . . . , and with a good knowledge of these natures they can better repair he who is deprived of them . . . , so the same is needed for an ailing building, that is, a doctor architect who properly understands what a building is, on what rules good construction is based, and from what those rules are derived, and in how many parts they are divided, and what are the reasons that hold the building together and make it permanent, and what is the nature of weight and of force.[27]

Leonardo sees even the Earth as a living organism, traversed by a constant circulation of humors, where every ebb and flow, every rise and fall of water obeys mechanical laws and models. In the animal world, the study of the bird-instrument reveals that the same mechanical principles govern flight, which Leonardo defines as "balancing oneself in air," while comparing the action of the bird's wing to that of a wedge: "The hand of the wing is what causes the impetus, and then its elbow assumes a slanting position and the air on which it rests becomes slanting, as if in the form of a wedge."[28]

After 1500, man became one of the favorite fields of exercise for Leonardo's mechanical science. Adopting Ptolemy's cosmography as a model, he outlined his own program for an exhaustive atlas of the human body—a new, abundantly illustrated encyclopedia, based on a limited number of mechanical principles and rigorous geometric analysis. While embracing the encyclopedic ideal of the Renaissance, Leonardo radically altered its significance, replacing traditional emphasis on correspondences and harmony of proportions with dynamic processes and mechanical functions that preside over the operations of all living creatures and natural phenomena.

In the remarkable series of anatomical drawings executed after 1500, the systematic recourse to the principles and graphic models developed in his studies on mechanics in Madrid I indicates that for Leonardo the in-depth investigation of the human body largely depended on his previous anatomy of machines, from which it borrows some characteristics of the lexicon, the techniques of illustration, and many powerful analogies.[29] The corpus of his anatomical studies at Windsor abounds with

explicit statements of their dependence on the mechanical model: "Arrange it so that the book on the mechanical elements with its practice shall precede the demonstration of the movement and force of man and of other animals, and by means of these you will be able to prove all your propositions."[30] And again, in a note entitled "Of machines": "Why nature cannot give movement to animals without mechanical instruments is demonstrated by me in this book."[31]

While Leonardo's early drawings of the human body reflect the search for harmonic proportion between limbs and concentrate on the purely morphological analysis of the ancient and medieval anatomical tradition, the studies of his maturity focus on the motor contrivances of the human body. In his view, morphological description could not explain the workings of the human machine, while the in-depth investigation of the dynamic operations of the different organs revealed the mechanical processes on which they depend.[32] The shift in attention from the body form, frozen, like a corpse, in statuesque immobility—as in Mondino's illustrations—to the mechanisms that govern the infinite variety of movements of the human body was as revolutionary a break from tradition as the analysis of the elementary organs of machines in the opening section of Madrid I.

Leonardo accounts for all movements of organic machines with the same principles that govern the functioning of artificial machines. As he clearly states in the *Codex on the flight of birds,* this paradigm holds true for all living organisms: "Instrumental science, or mechanical science, is most noble and useful above all others, since by means of it all animate bodies that have motion perform all their operations."[33]

From Leonardo's anatomical investigations, the image of the human body as an extraordinary assemblage of perfectly designed devices clearly emerges: "It does not seem to me that coarse men with lewd habits and little reasoning power deserve such a beautiful instrument [the human body] or such a variety of mechanisms."[34]

He continually exhorts readers to look underneath the "armors" of the human body, exactly as he had suggested doing with machines: "break the jaw from the side in order that you see the uvula in its position";[35] and again: "I wish to lift off that part of the bone, armour of the cheek . . . , to . . . demonstrate the width and depth of the two empty cavities concealed behind that [bone]."[36]

He defines the multiple joints of the human body as "poles," emphasizing in particular the analogy between the shoulder joint and the universal pole studied in Madrid I.[37] He again uses the term "pole" to denote the axis of rotation of the ankle: "The pole a is that where a man balances his weight through the tendons n m which are to the above said leg what the shrouds are to the masts of a ship."[38]

Leonardo establishes here a mechanical analogy between the tendons, connecting the ankle to the leg, and the shrouds that keep a ship mast in a stable upright position. He reiterated the analogy in his magnificent studies of the structure supporting the head (Figure 74).[39]

As in Madrid I, joints and poles led Leonardo to study the human body's antifriction mechanisms, which he identified in the sesamoid bone of the foot: "Nature has placed the glandular bone [sesamoid] under the joint of the great toe of the foot because if the tendon to which his sesamoid bone is joined were without the sesamoid, it would do great damage in the friction made under so great a weight."[40]

Moreover, he compares the action of muscles to that of a wedge, while often referring to "levers" and "counterlevers" to explain the movements of the upper and lower limbs.[41]

Other characteristic features confirm that Leonardo's illustration of the organic machine was inspired by his investigation of the constituent organs of machines. Emulating the method for depicting mechanisms in Madrid I, he individually examines many contrivances of the human body. Examples include the drawings of single teeth,[42] whose forms and functions he derives from their mechanical action, and of the nerve, vein, artery, and muscle[43]—each associated with its specific function.

Lastly, Leonardo often resorts to geometrical diagrams to illustrate the mechanical laws that govern the functioning of the organs, as in the demonstration of the action of intercostal muscles in breathing (Figure 75),[44] and the reduction of jaw movements to the laws of levers: "The tooth has less power in its bite which is more distant from the center of its movement."[45]

Leonardo's anatomical atlas exhibits powerful analogies with his studies of elementary mechanisms also in the key role played by drawings. The complexity of the human body drives him to refine figurative methods. The number of illustrations grows exponentially. He constantly uses exploded views (Figure 76)[46] and transparent views. He produces a

FIG. 74 Leonardo da Vinci: mechanical interpretation of the structure supporting the head.

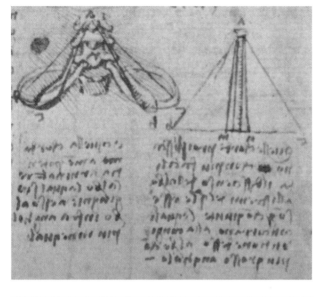

series of drawings in which he successively removes the outer strata down to the bone, and, reversing the process, covers the bare skeleton with the overlying strata. His drawings of the hand (Figure 77)[47] and torso (Figure 78)[48] are outstanding examples of this dynamic method of dissection.

Taking up the precept formulated in Madrid I on the need to remove the "armor" that impedes direct visual inspection of the internal organs of machines, Leonardo replaces muscles with lines of force,[49] representing them as metal wires rather than simple lines to emphasize their three-dimensional structure.[50]

The plan for a visual encyclopedia outlined in one of his later anatomical sheets envisaged the production, for each organ, of a huge number of drawings at different structural levels, so that:

> my configuration of the human body will be demonstrated . . . just as if you had the natural man before you. . . . Therefore, it is necessary to perform more dissections; you need three to acquire full knowledge of the veins and arteries . . . ; and another three to obtain knowledge of the membranes; and three for the tendons and muscles and ligaments; three for the bones and cartilages; and three for the anatomy of the bones, which have to be sawn through in order to demonstrate which is hollow and which is not, which is full of marrow and which is spongy. . . .
>
> Therefore through my drawing you will come to know every part and every whole . . . just as though you had the very same part in your hand and went on turning it round from one side to another.[51]

The reference to turning the actual "member" in one's hand seems to expand the boundaries of illustration from the two-dimensional to the three-dimensional level, advocating perfect illustration as even better than material models. Leonardo did, however, also produce models, such as that of the leg (Figure 79)[52]—in which the lines of force of the muscles were enhanced by copper wires—and those of the eye and aorta.

In the same sheet quoted above, Leonardo states that in compiling his anatomical atlas he drew inspiration from Ptolemy's *Geography*: "Therefore the cosmography of the lesser world [the microcosmos] will

FIG. 77 Leonardo da Vinci: drawings of the hand at different depths.

FIG. 78 Leonardo da Vinci: drawings of the structure of the torso at different depths.

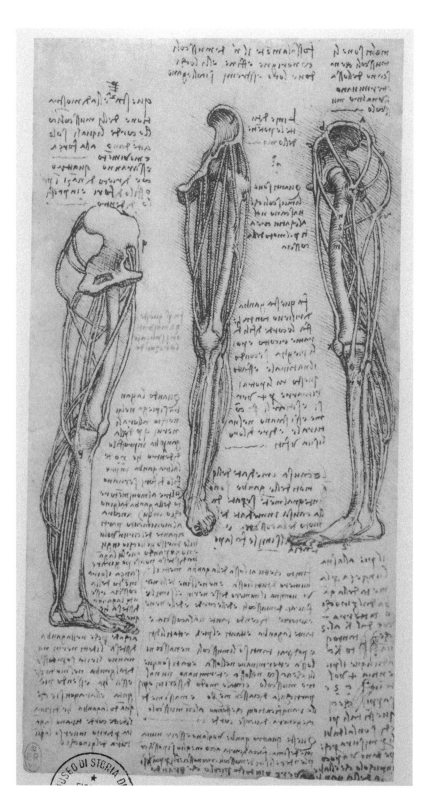

FIG. 79 Leonardo da Vinci: model of human leg.

be shown to you here complete in fifteen figures, in the same order as was used by Ptolemy in his *Cosmography* before me."[53]

In the massive series of his anatomical studies—exactly as in Madrid I—Leonardo gives precedence to graphic representation over textual description. The latter maintains a crucial function particularly for quoting or discussing a source, formulating hypotheses about the causes of the phenomena analyzed, and recording memoranda on how to prepare specimens, how to dissect, or how to describe phenomena that cannot be visualized: "Write on what sound is, and what din is, uproar, noise, etc."[54] But to illustrate observational data he relies mainly on drawing, intended not as a means to represent the apparent morphology of the human machine, but as a medium for demonstrating the principles, forces, and mechanical instruments that govern the dynamic functions of the body and its organs.

Leonardo gradually perfected his methods for representing organic machines thanks to direct experiences of dissection from which new conceptual and practical requirements emerged, as shown by the dense web of recommendations and instructions to himself that recur in his anatomical studies. Despite their extreme sophistication, the methods that he had elaborated to depict the constituent organs of machines could hardly support his plan for an overall representation of the far more complex human body.

As in the analysis of machines, drawing describes, through continuous decompositions and recompositions, the organic machine with unprecedented precision and thoroughness:

> First draw the whole ramification which the trachea makes in
> the lungs, and then the ramification of the veins and arteries
> separately. Then draw each of these structures together.
> Follow the method of Ptolemy in his *Cosmography,* but in
> reverse order, first putting information about the parts and
> then you will get a better capacity for a knowledge of the
> whole joined together.[55]

This further reference to the Ptolemaic model—but reversing its order, as Ptolemy had placed the description of the *oikoumene* (the entire known world) before that of the regions—serves to emphasize that the world, too,

is a machine ("the breathing of this terrestrial machine," he would write in the Codex Leicester).[56]

Leonardo saw this reductionist method of representation and the dissection of corpses as the best way to generate admiration for this "admirable instrument, invented by God, the Supreme Mechanic":[57] "O observer of this machine of ours, let it not distress you that you give knowledge of it through another's death, but rejoice that our Author has established the intellect on such an excellent instrument."[58]

Projected over such a vast horizon, his illustrated artificial anatomy did not fear comparison with the authors of the verbose commentaries on Galen:

> And you who want to demonstrate with words the figure of man in all aspects of his limb-formation do away—he proudly asserts—with such an idea, because the more minutely you describe, the more you will confuse the mind of the reader, and the more you will remove him from knowledge of the thing described. Therefore it is necessary to make a drawing of it as well as to describe it.[59]

Not even anatomical dissection could compete with the demonstrative eloquence of the cosmographic and analytical visual representation of the human body:

> And you who say that it is better to see an anatomy made than to see these drawings, would be right if it were possible to see all these things which are demonstrated in these drawings in a single figure. In this, with all your ability, you will not see or obtain knowledge of more than a few vessels, whereas, to obtain a true and full knowledge of them, I have dissected more than ten human bodies.[60]

However paradoxical it may seem, the massive complex of Leonardo's anatomical studies represented the most advanced laboratory of the entire Renaissance for defining the very idea of machine and for testing figurative techniques so effective as to replace the direct observation of nature. For Leonardo, drawing represents the ideal ground for investigating processes and causes because it allows the visualization of a level

of reality screened from the distorting effects of sensory appearances. The corpus of Leonardo's anatomical studies may thus be defined as a peerless collection of *machinae pictae:* devices of extreme complexity, admirably illustrated in their structure and dynamic functions.

The new role assigned by Leonardo to drawing clearly reflects the impact of the promotion by Renaissance authors of graphic expression as the fundamental tool for outlining the perfectly proportioned ideal models of which material objects were but a pale reflection. We should not underestimate these lines of convergence, in which we perceive the echo of those neo-Platonic themes that deeply penetrated even the world of artists, architects, and engineers. However, Leonardo did not view drawing merely as a refined tool for theoretical speculations on the principles of nature, nor simply as a means of generating abstract models. In his hands, it became the sharpest instrument for subjecting nature to rigorous inquiry. He transformed it into a new language, which he strove to articulate according to meticulous grammatical and syntactical structures. Many passages in his manuscripts show his awareness of creating a new visual language. An eloquent example is his annotation to the fine anatomical drawing—transfigured in a mechanistic sense—of the apparatus supporting the head (Figure 80): "This demonstration is as necessary to good draftsmen as is the derivation of Latin to good grammarians, because he who does not know what muscles cause their movements will draw the muscles of figures in the movements and actions of such figures badly."[61]

Against a Science Confuted by Practice

Codex Madrid I, Ms. I, and other notebooks compiled between the late fifteenth and early sixteenth centuries clearly display the emergence of Leonardo's novel approach to the principles and theorems of traditional mechanics. Although manifesting his admiration for the conclusions reached through rigorous mathematical demonstrations by ancient and medieval authors, he formulates ever more critical comments on their works because they focus on a level of reality that does not correspond to the world in which we live. In particular, their theorems fail to take into proper account the many disturbances that interfere with the operating cycle of material instruments—the uneven weight of the arms of a balance, the resistance of air, variations in temperature and humidity,

FIG. 80 Leonardo da Vinci: the devices supporting the human head.

and, above all, friction: "And thus, speculators—he admonishes in Ms. I—do not trust in the authors who, have wanted—using solely their imagination—to act as interpreters between nature and man, but rather only in those who have exercised their skills not with the intimations of nature but rather with the effects of her experience."[62]

The resolute condemnation of the natural philosophers who erected a purely abstract body of knowledge induces Leonardo to face the challenge of creating a new, or substantially renovated, science of mechanics. Questioning the reliability of traditional interpretations of natural and violent motion, which ignored the decisive influence of material factors, Leonardo calls attention to the interferences produced by the resistance of air and variable weather conditions on shots fired from a bombard: "What difference is there between the motions [of the projectile] made in an upwards direction or transversely or in humid weather or dry, or rainy or snowy, or with the wind against it or transverse to it, or along the direction of the ball's course?"[63]

The several diverging definitions of *scienzia* in Ms. I seem to reflect a situation of uncertainty. On the one hand, Leonardo asserts the primacy of theory: "Science is the captain and practice is the soldiers."[64] On the other hand, he extols experiment, although warning against those factors that may compromise the validity of the inferences from observational data: "how experiences deceive those who do not recognize their natures because those which oftentimes appear to be the same are oftentimes quite different."[65]

A more explicit definition of his ambitious reform project is found in a group of manuscripts of the Institut de France in Paris datable to the late fifteenth and early sixteenth centuries. Elaborating on studies that had already reached an advanced level in Madrid I, Leonardo devotes attention in Ms. I to the resistance of the medium and contact friction *(confregazioni)* analyzing these perturbating factors in quantitative terms, so as to establish a general rule for accounting more precisely for the performance of actual machines.

In this connection, a text in the same manuscript emblematically shows him as an attentive reader of the works of earlier authors. Amidst a series of notes on attrition generated by oscillatory systems, Leonardo states that to swing a large bell weighing no less than 27 million pounds by applying a force of only one pound, an extremely complex system of antifriction rollers is required.[66] To reduce the friction generated on its axis by the oscillations of a 750,000-pound bell, Leonardo proposes in a contiguous text a system so efficient that the toller will no longer exhaust himself. He does not mention a toller, however,

but a dog, thus allowing us to identify the source of his idea: Taccola's amusing picture of a dog who, tied to a bell with a long rope, causes it to ring when straining to reach food and water placed at a convenient distance.[67] He redesigns Taccola's arrangement in the light of his studies on friction-induced disturbances, which the Sienese author had neglected. Based on detailed calculations, he concludes that without effective antifriction systems, Taccola's dog would not be able to ring the bell.

Here, as in other contemporary texts, Leonardo, while applying the laws of the lever established by the medieval science of weights *(scientia de ponderibus)*, criticizes all mechanical theorems and practical solutions that fail to take the interference due to attrition into account. In another text of Ms. I, accompanied by a figure, he describes a complex antifriction device, specifying that it is the best solution for preserving the integrity of poles used "for motions that go back and forth, as in bells, saws, and things of a similar nature." Thanks to such a system, he concludes, it is possible to move with a single pound "ten thousand thousand million pounds."[68] Excited by the prospect of this incredible multiplication of force thanks to the elimination of friction, he exclaims in a blatantly self-congratulatory statement: "These are the wonders produced by mechanical ingenuity."[69]

However, his enthusiasm was soon dampened. In a sheet of the Codex Atlanticus dating from 1503–1504, he asserts that the multiplication of wheels and bearings would not eliminate friction but, on the contrary, increase it:

> The more wheels you make in your instrument the more gear teeth you will need; and the more gear teeth you have the more they will rub against their racks; and the more the points of friction the more the motor will lose force in those points, and consequently the force needed to move the whole will be lacking.[70]

In another, contemporaneous text of the Codex Arundel, Leonardo criticizes Leon Battista Alberti for having described, in his *Ludi Matematici,* the rules governing the equilibrium on the balance without considering the interference generated by the weight of the beam:

Battista Alberti says . . . that when the balance *abc* has arms
ba and *bc* in double proportion, the weights attached to its
ends . . . are in the same proportion but opposite as those
arms, that is, with the heavier weight on the shorter arm.
Experience and reason show this proposition to be false:
because where he puts weights in a proportion of 2 to 4 on
the balance that weighs 6 pounds, it should be 7 to 2, in order
that the balance remains still with equal resistance on both
arms. And here that author erred by not taking into account
the uneven weight of the arms of the balance.[71]

The meaning of Leonardo's harsh rebuke is clear. Experiments
performed with real balances, whose beams are heavy, disprove the law
of the inverse proportionality of weights to distances from the fulcrum
established by the science of weights.

In a later text, Leonardo further criticizes the authors of a science
that is confuted by practice because its principles are based on erroneous
foundations:

These beams [of the balance] were treated by ancient philoso-
phers as having the nature of mathematical lines, and their
fulcrum as a mathematical point. They considered these
points and lines incorporeal, whereas practice shows them as
corporeal, because this is what necessity demands, given that
they have to support the weight of those balances and the
weights that are appended to their arms.[72]

The conclusions of the "ancient philosophers" are the consequence
of a theoretical error. Reality cannot be replaced by the fictions engen-
dered by imagination, nor can physical impediments be ignored without
infringing the laws of nature grounded in necessity. These pronounce-
ments seem to undermine not only the science of weights but also the very
foundations of the mechanics of Archimedes, whose texts Leonardo had
eagerly sought.

It is important to underline that Leonardo's censures are directed
at ancient and medieval authors who replaced real objects and their
movements with fantasies born of their imagination, not at the use of

geometrical methods to account for physical phenomena. As shown by one of his more celebrated (but often misunderstood) statements, geometry remained for him the golden route to a full understanding of the workings of nature: "Mechanics is the paradise of the mathematical sciences, because with that one comes to the fruits of mathematics."[73]

His emphasis on the "fruits" (i.e., the practical benefits) produced by mathematical inquiry makes it clear that he praises geometrical mechanics not only for its rigorous demonstrative procedures but above all for its capacity to dictate the rules that govern the behavior not of abstract entities conceived by the imagination but of material bodies in the theater of nature.

Alongside these resolute pronouncements, Leonardo's writings of the 1500s provide explicit evidence of his concrete attempt to reform the Archimedean and medieval science of weights. His goal is to revise the theorems of traditional mechanics taking into account the interference generated by the unequal weight of the arms of the balance, by the fact that the ideal lines joining the weights applied to the balance at the center of the Earth are not parallel but convergent, and by the friction on its fulcrum. As a result an entirely new science would be created—a body of knowledge not only useful for practical operations, but also grounded on firmer theoretical foundations.

The investigation on attrition in Ms. Forster II[2] provides telling examples of his innovative approach. Leonardo engages in a quantitative analysis of attrition of a given weight on differently inclined planes. He follows the method of ancient and medieval authors to determine the propensity of weight to descend along planes with different slopes (*gravitas secundum situm*). After reiterating that it is impossible to determine the principles governing those phenomena without considering attrition (*confregazione*), Leonardo concludes that attrition is equal to zero when the plane is perpendicular and reaches maximum intensity when it is parallel to the horizon.[74]

In some folios of the almost contemporaneous Madrid I, we find one of his earliest attempts to assign a precise value to sliding friction. Leonardo determines that the propensity of a load to descend along a plane varies not only with the inclination of the plane, as established by the authors of the science of weights, but also with its contact surface. He

illustrates the concept graphically with a parallelepiped dragged first on its shorter, then on its longer side: "the weight—he remarks—having sides of different dimension will damage more the site of its contact when it is placed on its smaller side."[75] In another proposition, he formulates in rigorously quantitative terms the rule to calculate the interference of friction: "In the case of a motion over a horizontal plane, the force of friction will always amount to one-half of the weight moved."[76] The accompanying drawing clarifies that, because of a slip of the pen, Leonardo meant not one-half, but one-third, a value that recurs in other texts.

A group of sheets of the Codex Atlanticus datable to the 1500s gives the different value of one-fourth of the system's weight as the attrition coefficient: "When the smooth oblique surface causes the smooth weight to place one-fourth of its weight in the line of motion, then the weight itself has a disposition to move."[77] Leonardo claims to have determined the value experimentally: "Experiments show that the smooth object dragged on a smooth plane resists its motor during motion with a power equal to one-fourth of its weight."[78] In fact, in the Codex Arundel and the Forster II[2] he designs a series of simple experimental apparatuses (Figure 81) to measure, using static methods, the incidence of friction as a function of the smoothness or roughness of surfaces and the inclination of planes.[79] In another folio of the same manuscript, he asserts that friction, decreasing proportionally with the increase in the slope, behaves in the opposite manner to gravity: "The conditions in which weight generates motion are always opposite to those in which friction is caused."[80] And in a text in the late Ms. E, significantly entitled "calculation of frictions," he reaffirms the inverse proportionality between friction and inclination.[81]

Leonardo devotes special attention to the problem of friction on balance beams, neglected by the *filosafi*. He starts out from the law of the equilibrium of the balance with equal arms and equal weights established by the science of weights (a negligible weight appended at the end of one of its arms is sufficient to tip the balance). He states that, to break the equilibrium, the inertia of friction on the fulcrum must be overcome. Therefore, it will not suffice to apply any small weight; it will be necessary to add a weight equal to at least one-fourth of the weight of the system.

FIG. 81
Leonardo da Vinci:
experiment to measure the
incidence of attrition
(detail).

The awareness of the decisive influence of friction leads him to re-
formulate the law established by the authors of the science of weights to
define the breaking of equilibrium in mechanical systems: "On the ordi-
nary balance, the weight that prevails, I mean the weight that causes its
motion, must be heavier than the losing weight in the measure to over-
come the friction on the fulcrum, at which point any small and minimal
weight will suffice [to upset the balance]."[82]

However, in some texts of the Codex Atlanticus datable to 1508–1510,
Leonardo detects a potential threat to his reformed science of weights:
"The more you increase the weight, the more you increase resistance and
friction on the fulcrum."[83] To upset the equilibrium, another weight
equal to one-fourth of the first must be applied, thus triggering an infi-
nite process of adjustments. Alarmed by this prospect and suspecting
that not even his new mechanics could guarantee a full correspondence

between theory and practice, Leonardo does not further develop his analysis: "Although, by means of mathematical method, we can accurately demonstrate the powers and resistances of weights, nevertheless, in practice, its makers [i.e., the builders of instruments] remain confused because they fail to understand even the demonstrable adjustments."[84]

However, Leonardo perseveres in his endeavor, reasserting that it is possible to calculate with precision the effects of the perpetual conflict between force and resistance:

> Experience never fails; all that fails is your judgment promising such effects that are not caused in our experiments. Because, when a principle is set, what follows must be a true consequence of it, unless it has been impeded; and if any impediment does occur, the effect that should follow from the aforementioned principle is affected more or less by the said impediment to the extent that the said impediment is more or less powerful than the aforementioned principle.[85]

The verdict could not be clearer: the authors who, relying solely on their imagination, removed the impediments, created a false and useless science. Experience tells us that force is locked in a constant struggle with material resistances and interferences. And a science worthy of the name should explain *this* world to us. Replying, in another text, to the objections of an imaginary adversary who had questioned the utility of the rules of his new mechanics, Leonardo proudly underscores its fundamental contribution: "My rules bridle engineers and investigators so that they stop promising themselves or others impossible things, thus protecting them from being regarded as mad and deceitful."[86]

Note that Leonardo is talking here about rules, not practical precepts—rules that serve not only to unmask boasters but also to channel engineers' efforts along the paths of reality, tearing them away from the misty terrain of imagination.

The analysis of the problem of "indifferent" equilibrium of balances with equal arms and weights that Leonardo began to elaborate in his manuscripts of the mid-1490s appears fully convergent with his critical revision of the abstract theorems of the science of weights. His targets, once more, are the authors who asserted that a balance of equal arms and

weights remains in stable equilibrium regardless of the position in which its beam is placed. In some folios of the late Ms. E, he accuses those authors of having overlooked the fact that, in actual balances with equal arms and weights, the mathematical center and the center of revolution coincide only when the instrument is in a perfectly horizontal position. Here Leonardo's diagrams highlight the thickness of the beam of the balance and consequently its weight.[87] He stresses that, when the instrument is tilted, a larger (and thus heavier) portion of the beam remains above the center of suspension. It, therefore, cannot remain at rest, but—contrary to the claims of the authors of the science of weights—it will descend:

> The balance with equal arms and weights when displaced
> from the position of equilibrium will make unequal arms
> and weights, so that necessity constrains it to reacquire the
> lost equality of the arms and weights. This is proved by the
> second [proposition] of the treatise on mechanical elements
> and it is proved because the higher weight is more remote
> from the center of the revolution than is the lower weight,
> and therefore it has a weaker support, so that it descends
> more easily and raises the opposite part of the weight upward,
> conjoined to the extreme of the smaller arm.[88]

In an adjacent text, Leonardo specifies how a material balance with equal arms and weights will behave when tilted. Because of the difference in weight between the portions of the beam above and below the center of revolution, the higher portion will descend and, after a series of oscillations—which Leonardo defines as "ventilations"—it will settle in stable equilibrium in a horizontal position.[89]

He then proposes a general rule that reforms the one established by the authors of the science of weights, introducing it as one of the fundamental propositions of his treatise on "mechanical elements":[90]

> Every parallel body of uniform thickness and weight that is
> positioned obliquely has in itself two divided gravities, of
> which the one tends toward the center of the world and the
> other is transverse. But the one is natural and simple and the

other accidental and composite. But if this body situated in
this manner has free descent within the air, the centers of the
two gravities will transform into one another for some time
and at the end there will remain only one common center for
the entire body.

Having defined the rule, Leonardo hastens to point out that its va-
lidity is not absolute. If the beam of the balance with equal weights and
arms is extremely thin—in other words, if it can be equated with the geo-
metrical beams considered by the authors of the science of weights—its
mathematical center and the center of revolution will be so close as to be
virtually indistinguishable. In that case—but only in that case—when the
balance is shifted from the position of equilibrium, it will remain stable
in any position, displaying at most a nearly imperceptible oscillation.

Leonardo had developed a similar analysis in the opening sheet of the
Codex on the flight of birds (Figure 82). In the central column, he draws four
rectangular material balance beams, clearly distinguishing in the top three
the mathematical center from the center of revolution.[91] Focusing on the
disturbances caused by the weight of the beam, he traces the parallel to the
longer sides of the rectangle passing through the center of revolution (which
divides the beam into two unequal parts) and the tangent to the center of
revolution. Next to the lowest diagram, which shows an inclined rectan-
gular beam, he adds a note that sheds light on his reasoning:

> This diagram shows that the oscillation of the balance is not
> caused by the inclined position of the two equal weights
> because indeed it would be impossible; nor is it caused by the
> fifth above [i.e., the fifth proposition of his treatise on
> mechanical elements], but by the seventh it is proved that the
> cause is the material beam.[92]

The next sheet of the same manuscript clarifies the rationale behind
Leonardo's critique of one of the theorems of the medieval science of
weights. He resorts to his method of simulating a discussion with an
"adversary"—who, in this case, was hardly imaginary but can be identi-
fied with renowned authors such as Jordanus Nemorarius or his follower
Biagio Pelacani. Leonardo begins by presenting his opponent's thesis:

FIG. 82 Leonardo da Vinci: studies on the mathematical center and the center of revolution of balances.

when the balance with equal arms and weights is shifted from equilibrium, the inclinations of the extremities of its arms to descend are unequal because the higher arm, being more distant from the center of the Earth, has a greater propensity to move downward. This conclusion is wrong—Leonardo states—given that the higher arm's inclination to descend is perfectly counterbalanced by the lower arm's resistance to being raised. This is confirmed by the arcs plotted by the two extremities, which are perfectly equal in their distance from the vertical and in length. At this point, Leonardo formulates the rule establishing the true cause of that phenomenon: when the balance with equal arms and weights, in which the center of suspension and the mathematical center do not coincide, is shifted from equilibrium, the arm above the revolution center becomes heavier. It will therefore descend and trigger the "ventilation" of the balance beam until the equality between the weights of the two arms is restored.[93] He concludes that the material instrument remains stable in any position only if suspended exactly from its mathematical center, as shown by the "round or circular balance in which ventilation does not occur, because its parts are always equally distributed around the center."[94]

WHILE NOT EXCLUSIVELY CONFINED TO MECHANICS, Leonardo's reform project reached its most advanced state in that field. The manuscripts of his maturity suggest a vision of science as inspirer of applications, but not based on practice and experience alone. He continuously denounces the authors who replace sense experience with ideal models. For Leonardo, all things are governed by the cosmic law of consumption, as he emphasizes in a passage of Ms. Forster II, in which he launches a venomous attack on those who prefer to exercise their minds only on mathematical objects, ignoring the real bodies perpetually subject to wear:

> It is impossible that a perfect thing exists or can be produced;
> for if you want to make a perfect circle by moving one of the
> points of the compasses, and you admit . . . that this point is
> completely worn away after being used for a long time, it will
> be necessary to conclude that if the whole point is worn away
> in a certain time, a part of the same point will be consumed
> in part of this time, and that the beginning of such consump-
> tion will be indivisible in the indivisible time.[95]

Using bold analogies, Leonardo transfers the principles inspiring his revision of the abstract science of weights to other research fields. The explanation of the cause of the oscillation of the beams of the balance of equal arms and weights serves to formulate a new interpretation of the medieval *quaestio* of the imperceptible movements of the Earth, which he attributes to the continuous displacement of the centers of gravity of the two heavy elements, water and earth. Based on this vision, he accounts for major geophysical phenomena such as erosion, the unstable relationship between the surface of water and that of emerged lands, earthquakes, floods, and so on. He also resorts to purely mechanical causes to explain the presence of marine fossils on mountain tops.

For Leonardo, attrition is the cosmic antagonist of force. It is no coincidence that he models his definition of attrition on that of force as a "spiritual" power in Ms. B:[96] "Although it affects bodies, friction does not have a body of its own, but is an accidental power, resulting from the violent motion of a moving body over a stable or mobile body."[97] Those who seek to unveil the strict laws through which nature operates cannot ignore attrition, which presides over fundamental phenomena such as the heat of the blood that feeds the organic machine, or the voice.

Even his quantitative analysis of the decreasing heights of successive bounces of a ball, of the progressive diminution of the arcs described by the oscillations of a weight suspended from a string,[98] or of the effects produced by successive blows whose force is continuously doubled[99] derive not from experiments but from the analogic transfer of the results of his research on the attrition coefficient. As evidence of this, the rate at which such phenomena decrease is always measured in terms of the now familiar factor of one-fourth.

Following the chronological evolution of Leonardo's other mechanical investigations, such as those on "supports" *(sostentacoli),*[100] or on the tension of ropes, we detect the same characteristic transition from earlier studies based on rigorous geometrical procedures to reformulations in which he tries to take into account friction and the uneven composition of material bodies.

Although it is crucial to understanding Leonardo's vision of the operations of nature and man, this transition is completely missed in the anthologies of his texts on mechanics, such as *I libri della meccanica* by Arturo Uccelli.[101] In publications of this kind a collection of Leonardo's

fragmentary drawings and notes sketched and written in different man-
uscripts decades apart and extracted from their contexts is magically
transformed into a well-structured and coherent treatise conceived as
such by its author.

The importance of Leonardo's mechanical studies does not depend
on their success. They did not—nor could they—produce the radical re-
form of mechanics that he had envisaged. With hindsight, we can say that
they followed a path that was in part mistaken and in part viable only
with methods of analysis vastly more advanced than those available to
him. At some point, having become aware of these limitations, he ac-
cepted some compromises. He reduced the discordant results of static
measurements of friction to a convenient standard value; then, he feigned
ignorance of what he knew well, namely, that the friction coefficient also
varied according to the roughness or smoothness of the contact surface.
Moreover, he cut short his discussion on the nature of the fulcrum of the
balance, admitting that it could coincide with a mathematical point, as-
suming the same position as to the centers of gravity of the elements and
of the Earth. Not coincidentally, Leonardo's studies of mechanics in his
final years are almost entirely devoid of mathematical analysis, although
formulated in texts that emulate the concise style of the geometrical the-
orems of the science of weights.

Leonardo's critical assimilation of traditional scientific knowledge
also characterizes his investigations in other fields such as hydraulics, the
science of flight, acoustics, and anatomy.[102] At a rather early stage, disap-
pointed with the abstractions of traditional science, he gradually developed
a reform program aimed at establishing a set of new or revised princi-
ples to account for the behavior of the material bodies that populate the
theater of nature. Owing to the complexity of the phenomena analyzed
from this fresh perspective, Leonardo began to realize the difficulty of
reaching such an ambitious goal. His studies on water, for example, became
so detailed as to compel him to make an endless list of specific "cases"
until losing confidence in the possibility of reducing them all to a few gen-
eral principles. The same outcome is even more apparent in the late Ms. E,
where Leonardo resorts to a de facto restoration of qualitative physics, not
through choice, but because of his inability to account in a systematic
manner for the infinite variations of natural phenomena.

The cross-boundary character of Leonardo's approach is confirmed by his studies on optics—which, with statics, was traditionally characterized by a rigorous geometrical method of demonstration. In the initial phase, he displays his faith in the perfect correspondence between artificial and natural perspective, contrasting the certainty of images created following the rigorous rules of linear perspective with the unreliability of visual sensations:

> Perspective succeeds where the judgment is faulty in the diminishing of things. The eye cannot ever be a true judge in determining with accuracy how much a quantity [diminishes] underneath and near to another one equal in size, when the other one is positioned so that its top is even with the eye observing these parts, except by means of the perspective screen, the master and guide of perspective.[103]

Later he became aware that the perspective of painters, based on the visual pyramid, is an abstraction rooted in the imagination to be corrected by means of the perspective of colors and "losses" *(perdimenti)*. The perspective of colors and losses is the equivalent, in optics, of attrition and material impediments in mechanics. Once again Leonardo's goal is to make science match concrete natural effects, while denouncing the distortions produced by mathematical abstractions.

The optical research in his mature years shows his attempt to define a radical reform program aimed at constructing a science of vision freed from the artificial abstractions of painters' perspective. The program is based on a critique that echoes the arguments used against the authors of the science of weights. Perspective painters err not in using geometry and proportions but in claiming to replace real phenomena with schematic representations conceived by their imagination. His reform is based on a strictly quantitative treatment of the mechanisms of vision, to which he assigns absolute primacy, rejecting all attempts to marginalize it as imprecise and unreliable. This process culminates in Ms. D, datable to 1508. At this point, the distance between Leonardo and perspective painters is striking. He is familiar with and is able to calculate the effects of refraction, ignored by perspective painters. He performs a quantitative analysis of the divergence between perspectival reconstruction and visual

image in the case of a distant wall perpendicular to the viewer's eye, concluding that perspective painters will regard the entire surface of the wall as equidistant from the apex of the visual pyramid, while the eye will perceive its different parts as being at different distances. Moreover, Leonardo demonstrates, by means of ingenious experiments, that the visual faculty extends across the entire surface of the pupil and is not "reduced to a point, as the perspective painters assume."[104] Lastly, he focuses his attention on the way in which images are formed through binocular vision—natural vision—showing its irreducible distance from the visual pyramid of linear perspective.[105]

Once again, however, Leonardo ended up by regarding it as impossible to put the results of these penetrating analyses into practice. He was forced to seek a viable compromise between the principles of his new science of vision and the conventions traditionally adopted for reproducing organic and inorganic nature in drawing and painting.

Fire from Mirrors

It is not only in his analysis of linear perspective that Leonardo challenged ancient and medieval authors who had transformed optics into a rational discipline based on a few general principles from which a set of rigorous mathematical demonstrations were deduced. The same critical spirit drove him to carefully scrutinize the laws that govern the reflection of solar rays in concave mirrors of different curvatures.[106] As usual, while still grappling with the assimilation of the traditional principles and demonstrations of this branch of optics, he began to ask himself whether they were of practical use to craftsmen engaged in the production of high-performance burning mirrors.

Leonardo displayed a lifelong interest in the theory and practice of burning mirrors. The first signs of his interest date from the early 1470s, during his apprenticeship in Verrocchio's workshop where burning mirrors were used to smelt metals.[107] Evidence of this is found in folios of the Codex Atlanticus dating from 1478–1480. The folio containing a diagram of a cone inside of which Leonardo has traced a parabolic section is especially noteworthy. In the text below the diagram, he recommends

using a parabolic profiler to grind "a concave sphere that, turned toward the Sun's rays, would ignite whatever comes inside its pyramid"[108] (formed by the reflected rays), thus demonstrating his awareness that solar rays reflected by concave parabolic mirrors all converge in the focus. However, the device sketched on the same page shows a circular profiler. By contrast, in the machine for grinding burning mirrors depicted on another sheet of the Codex Atlanticus from the same period, the profiler appears to display a parabolic section (Figure 83).[109] Both machines feature very simple mechanical solutions: the profiler, stone or metal, presses down on the surface to be shaped, which is rotated by hand.

Leonardo resumed his research on the *ignie* (his usual term for burning mirrors) in Florence between 1503 and 1505 and then in 1507–1508. During his stay in Rome between 1513 and 1516, he focused again on the geometry of burning mirrors and on the most suitable systems for manufacturing them.[110]

The exquisite diagrams and the annotations on one of the double folios of the Codex Arundel (1503–1505),[111] which contains theoretical reflections and geometrical demonstrations to determine the optimal curvature of burning mirrors, offer precious clues to Leonardo's method of inquiry.[112] In the text above and below the diagram on the left-hand side (Figure 84), he remarks that to concentrate the solar rays reflected by a mirror of circular profile in a small area, the mirror's curvature must be minimal: "The flatter the mirror the greater the sum of the rays that will be reflected on the same place. And, conversely, the more concave the mirror, the fewer rays it will reflect on the aforementioned place."[113] He thus recommends using mirrors whose profiles correspond to small arcs from circles of great diameter, i.e., mirrors of almost imperceptible curvature.

As a concrete example, Leonardo refers to a mirror one *braccio* long with the same curvature as an arc of identical length from a circle of 400 *braccia* in diameter—in other words, an almost flat mirror: "if the mirror has a diameter of one *braccio,* and is taken from a circle of 400 *braccia* in diameter, it will not be very curved, and will cast its rays at 100 *braccia,* that is, ¼ of the diameter of the circle." Leonardo then states the general rule: "The mirror of uniform concavity casts the refracted rays up to a

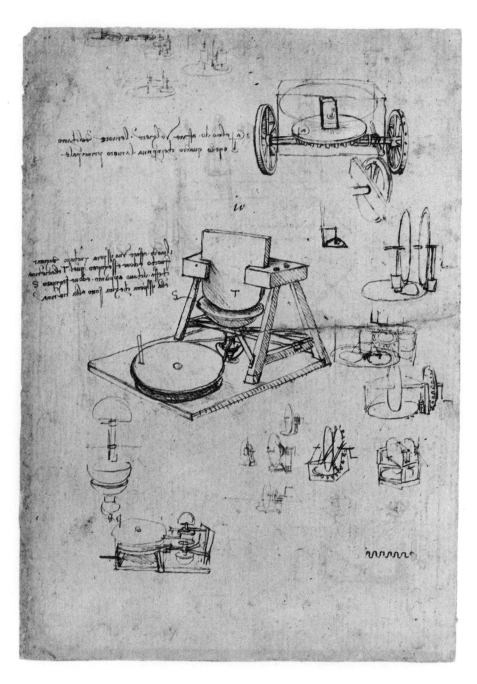

FIG. 83 Leonardo da Vinci: mirror-grinding machine.

FIG. 84 Leonardo da Vinci: reflection of solar rays on a hemispheric mirror and a polygonal mirror.

distance equal to the fourth part of the diameter of the spherical body from which such a mirror has been taken."[114]

This rule is intuitive in the diagram delineating the section of a mirror equal to one-fourth of the circumference. It clearly shows that the solar rays striking the upper part of the mirror repeatedly bounce off its internal surface and are dispersed. By contrast, the rays striking the lower part of the mirror converge in a small area of roughly triangular shape, whose farthest point from the lower edge of the mirror lies in the middle of the circumference's radius (i.e., at a distance equal to one-fourth of its diameter). By means of curved lines, Leonardo connected each incident ray with its corresponding reflected ray, thus clearly visualizing why hemispheric mirrors of small diameter perform less efficiently than mirrors whose profile is that of small arcs taken from large circles. In the latter, the rays, while not converging in a single point, are reflected in a limited area where intense heat will thus be generated.

The drawing in the lower left margin of the same page shows that Leonardo regarded the geometric demonstration as a theoretical reference for moving on to the manufacture of efficient burning mirrors. It shows an instrument for grinding a mirror with the same circular section as that analyzed in the upper diagram. A very slightly curved copper pro-filer (the *sagoma*) resting on two vertical supports is driven back and forth by a rack-and-pinion mechanism. The mirror to be ground, also made of copper, is pressed up against the profiler, shaped like a hemispheric vase, which, rotating on its vertical axis, confers a uniform curvature to the mirror. Leonardo states that the curvature can be set to the desired value by moving the two supports of the profiler closer or farther apart. While he does not reveal his method for giving the profiler the desired curvature, he takes care to point out that the dimensions of the mirror being ground are identical to those of the mirror illustrated in the diagram above: the profiler's section is indeed equal to a small arc of an enormous circumference with a diameter of 400 *braccia* (over 230 meters!).[115]

Leonardo was therefore engaged in what we would now define as technology transfer. Based on information drawn from texts of geometric optics, he designs and builds an apparatus to test their conclusions. A positive outcome would open the way to the production of high-performance burning mirrors—an exciting prospect given the potentially large economic benefits. It is precisely this expectation that led Leonardo, here and in later studies, to record his thoughts in an incomplete form and to hide the metals he planned to use for the profiler and the mirrors behind anagrams or their alchemical names.[116]

The geometric demonstration and notes of f. 84v of the Codex Arundel form the premise for the analysis conducted on the facing page (Figure 85).[117] Leonardo divides the rectangle in the large central diagram into eighteen small equal rectangles by drawing seventeen lines parallel to its shorter sides. In its lower portion he traces a line (indicating the section of a mirror) that has the appearance of the arc of a circle, whose center lies outside the figure. The seventeen points of intersection of the parallels to the shorter sides of the rectangle with the near-arc of a circle are joined to the upper left vertex of the rectangle, indicated with the letter *b*. Next to each point of intersection, Leonardo places pairs of increasing

FIG. 85 Leonardo da Vinci: reflection of solar rays on a polygonal mirror.

numbers: $1/1, 2/2, 3/3 \ldots 17/17$ from right to left, in keeping with the natural sequence of his left-handed writing. He clarifies the meaning of this construction in the note under the diagram: the vertex b of the rectangle "is the point of convergence of the rays, which all reflect with angles equal to the angles of incidence, that is, each pair of contingent angles are equal to one another"[118] (hence the pairs of increasing equal numbers in the diagram).

Having illustrated on the opposite page the shortcomings of spherical mirrors—even those with a modest curvature—Leonardo now proposes

a mirror capable of reflecting all incident solar rays in a single point. To obtain this result, he could have used a parabolic section, with whose properties, as we have seen, he was familiar.[119] But that solution does not seem to interest him here. He prefers to generate, point by point, a different type of reflecting surface. The section of the mirror outlined in his diagram is composed of a series of small segments, each slightly inclined with respect to the next, so that the incident rays are all made to converge in the focal point. Its profile does not correspond to the arc of a circumference (although it is very close to that of a circle with a radius more than twice the length of the shorter side of the rectangle) and even less to a parabola. In actual fact, it is not even a curve, given that—as revealed by a close inspection of its outline—Leonardo did not trace it with a compass but by carefully drawing small segments freehand and joining them to form a polygonal section with innumerable sides.

The folios of the Codex Arundel that we have analyzed indicate that, around 1504, the manufacture of parabolic burning mirrors was not Leonardo's priority. He preferred to use arcs of circles with a modest curvature, or to produce polygonal mirrors by assembling mini-segments so as to make all reflected rays converge in the desired point.

The sheets dating from 1507–1508 offer clues as to why he opted for mirrors with a profile other than parabolic. While aware that parabolic mirrors reflect all solar rays in the focal point, he knew that imparting an accurate parabolic profile to a large reflecting mirror was an extremely difficult, if not impossible, operation. He thus conceived an alternative solution to manufacture by means of a mechanical process mirrors with comparable performance and with curvatures that could be adjusted to the desired focal length.

The prospect of manufacturing this innovative type of reflecting surfaces on a nearly industrial scale and, above all, their potential for military applications prompted Leonardo to adopt an attitude of discretion. Not coincidentally, in a late folio of the Codex Arundel (ca. 1514), containing studies on the focal length of the caustics of reflection, Leonardo evokes the use of burning mirrors by Archimedes to set fire to the Roman fleet, led by the Consul Marcellus, which besieged Syracuse in 212 BCE.[120] This famous episode highlighted the strategic importance of

mirrors with very long focal lengths, such as those reportedly used by Archimedes, given that the Roman fleet could not get too close to the walls of Syracuse.

No less promising appeared the industrial applications to which Leonardo refers in a concise text in the Codex Atlanticus: "With this [i.e., with the burning mirror] one can make any cauldron in a dyeworks boil and, with this, fishponds will be heated, because there will always be boiling water."[121] And elsewhere: "Mortar will be produced without need of firewood."[122]

Both fields of potential practical applications of burning mirrors—military and industrial—made caution a necessity. Leonardo had to entrust workmen with the construction of the grinding and polishing devices, and able apprentices could easily master and exploit for their own benefit the manufacturing process and the tools that he had devised. His fears were not ungrounded, as demonstrated by an incident in Rome that occurred in 1514 or 1515. An apprentice of German origin, named Giovanni, had been assigned to him by his patron, Giuliano de' Medici, Commander of the Papal army, who had instructed Leonardo to design and manufacture high-performance burning mirrors. From the draft of Leonardo's letter to Giuliano, we learn that he was dissatisfied with his apprentice not only because of his indolence but above all because he suspected him of wanting to purloin his method of manufacturing the profiler in order to grind mirrors with the optimal curvature:

> He then requested the finished timber models [of the profiler], since they had to be made of iron and he wanted to take them back to his country. I refused, telling him that I would give him a drawing with the width, length, and thickness and shape of the models, leaving it to him to build them; and so we remained in disagreement.[123]

This understandable reticence makes it problematic to reconstruct Leonardo's method of producing metal plates for mirrors—he seemed to prefer copper, homogeneous and easily malleable, silvered to increase its reflective power—and of building machines to grind and polish them. He worked strenuously on this project, designing ever more complex solutions.

His guiding rule was that of the inverse relationship between the degree of curvature and the burning performance. The latter depended not only on the maximum degree of concentration of reflected rays but also on the possibility of obtaining focal lengths suitable for multiple uses.

The studies and calculations on the "section of the pyramid" (formed by the bundle of reflected rays) in a sheet of the Codex Arundel dating to 1515[124] and the contemporary studies in Ms. G[125] document Leonardo's search for the most satisfactory solution. In the Codex Arundel, he equates the burning mirror with the base of the pyramid formed by the reflected rays. He cuts the pyramid at ever greater distances from the base, generating pyramidal frusta with ever smaller bases. In a note next to the diagrams, he states that the smaller the mirror base, the more heat is produced by the rays reflected by it.[126] He reasserts the same concept in Ms. G: "If the base [of a pyramidal frustum] of four *braccia* sends the power into one *braccio* of space, the heat of the base increases 4 times. And if this base reduces to one-quarter *braccio,* this power acquires sixty-four degrees over this base."[127]

In a table on the same folio, Leonardo compares the surfaces of the bases of the pyramidal frusta with their heights and with the heat concentration produced by the rays reflected by them.[128] These notes and calculations reinforce Leonardo's conviction that to concentrate reflected rays at a great distance the mirror curvature had to be minimal. Indeed, in his analysis of the pyramidal frusta, he compared it to a flat surface.

The absence of parabolic sections in these studies confirms that Leonardo sought not so much to deepen the analysis of the purely theoretical aspects of the geometry of reflections as to identify parameters for the production of high-performance, multipurpose burning mirrors. Evidence of his efforts in this direction is offered by the blue folios of the Codex Atlanticus and many sheets of Ms. G dating from the most advanced phases of his studies on the caustics of reflection. While trying to establish the curvature of burning mirrors for specific applications, he designed instruments for making mirrors whose profiles could be adjusted to the desired focal lengths and even to the inclinations at which the mirror would be exposed to solar rays.[129]

The complex demonstrations and notes in the blue folios of the Codex Atlanticus (Figure 86) enable us to reconstruct the solutions that Leonardo was developing.[130] He begins by defining the point where the rays reflected by the mirror should converge. Then, through a geometric analysis, he determines the section of a reflecting surface with the desired focal length. He thus reverses the method adopted on f. 84v (P 65v) of the Codex Arundel, in which, assuming a given curvature (in that case, circular), he visualized the area on which the rays reflected, enhancing their partial dispersion. Now he first establishes the desired point of convergence of the rays, customizing the curvature of the mirror accordingly. The sections of the mirrors described in the blue folios of the Codex Atlanticus are formed by a series of small adjacent segments that generate a quasi-curve with a continuously varying inclination that reflects solar rays onto a predetermined focal point. His "rectification" or "squaring" of the circumference bent mathematical reason to practical requirements for the construction of high-performance and variable-focus burning mirrors.[131]

In an earlier sheet (1503–1505) of the Codex Atlanticus, Leonardo had described the manufacturing process of "polygonal" burning mirrors. He recommended preparing a flat modular element, which he called the *maestra,* a tablet that, when joined to other identical tablets at nearly flat angles, generated a surface reflecting all incident solar rays onto a single point: "cut a thin tablet—he wrote— . . . ; but it would be better to have two similar boards and connect the one with the other, and so on up to the end . . . , and then those lines [the reflected rays] would converge in a point and all of them would do so."[132]

The idea of constructing burning mirrors with small plane components that formed a near-curved but actually polygonal profile was a pioneering intuition. It is the method used today to build state-of-the-art telescopes fitted with huge mirrors. Portable solar ovens popular with outdoor enthusiasts have the same design as well.

The studies on the caustics of reflection in the Codex Arundel and the blue folios of the Codex Atlanticus are resumed in several folios of Ms. G dating from 1515. Leonardo's main goal here is to determine the profile of the reflecting surface as a function of the desired point of convergence

FIG. 86 Leonardo da Vinci: method to establish the desired focal length of burning mirrors.

of the rays: "To find the lines converging to a point, and to give to that the periphery suitable for that point, as the center of a circle. And it can be of whatever size you want."[133]

Leonardo, however, never forgets earlier solutions, even when he seems to have abandoned them. One eloquent example of his characteristic cyclical modus operandi is offered by the retrieval of the solution for grinding mirrors with a circular profile but minimal curvature. In a note in Ms. G entitled "On the method to determine the curvature of the profiler,"[134] Leonardo conceives an ingenious and extremely simple mechanical method to trace arcs of circles with an almost imperceptible curvature (Figure 87):[135] an axle with a wheel of different diameter at each end; when the axle rotates around the smaller wheel, the other plots the arc of a circle. The longer the axle, the larger the circle, from which small and thus nearly flat arcs can be taken as models for the profiler of burning mirrors with long focal lengths. In all likelihood, the practical viability of this system is precisely what led him to reconsider circular mirrors with imperceptible curvatures. Yet again, however, he promptly shelved the idea pending future "resurrections."

Leonardo's research on the caustics of reflection culminated in Ms. G. He faced considerable challenges in the production of the profiler and the machine for grinding mirrors with long focal lengths. His first designs of a profiler and a lathe for grinding mirrors were the extremely simple solutions sketched on f. 17v of the Codex Atlanticus and f. 84v (P 64v) of the Codex Arundel, analyzed earlier. Shortly after, he conceived a more sophisticated version illustrated on a sheet of the Codex Atlanticus (Figure 88), which Pedretti dates to 1503–1504.[136] In the upper right-hand drawing, the lathe now seems powered by a waterwheel defined as the *primo mobile*. Meshing with a lantern gear, the *primo mobile* drives the vertical axle supporting the profiler, which adheres tightly to a hemispheric vase. The screw mechanism at the base of the grinding machine presses the plate to be ground against the profiler, which resembles the curved metal rod depicted on sheet 84v (P 65v) of the Codex Arundel. Here, however, the profiler is fitted with a rigid arm to maintain its curvature during the mirror-grinding process. On the left side of the machine, an additional transmission system—also actuated by the *primo mobile*

FIG. 87 Leonardo da Vinci: method for drawing arcs of circles with very large diameters.

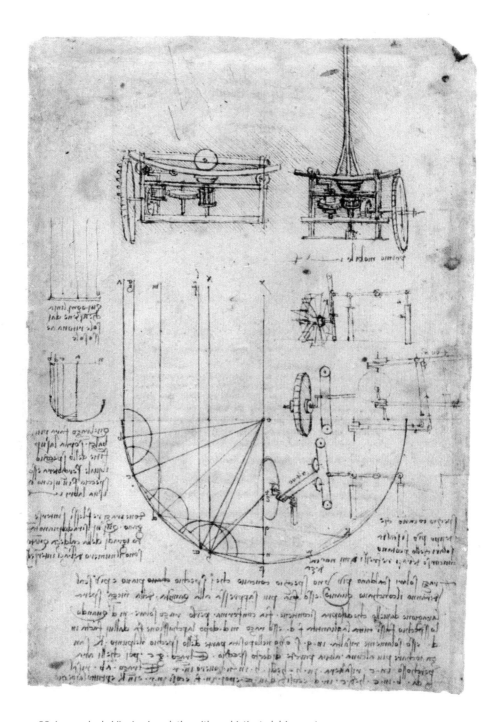

FIG. 88 Leonardo da Vinci: mirror lathe with sophisticated drive system.

and operated by means of a handle mechanism—forces the profiler to os-
cillate from right to left.

Next to this grinding machine, Leonardo drew a partly modified de-
vice with a rigid frame and a dragging wheel to avoid the deformation of
the profiler and an articulated arm causing it to oscillate. Under the
drawing of the first mirror lathe, Leonardo sketches, as was his habit,
various alternative solutions for transmitting motion from the *primo
mobile* and variants of the handle mechanisms for oscillating the pro-
filer. The note to the drawing, repeated twice ("400 braccia," "braccia
400"), and the texts and diagrams on the reflection of solar rays in mir-
rors identical to those of f. 84v (P 65v) of the Codex Arundel, indicate a
direct conceptual and chronological continuity with the studies recorded
in the British Library manuscript.

Other sheets of the Codex Atlanticus show Leonardo's steady efforts
to develop the most efficient device for manufacturing profilers with the
right curvature and resistance to wear for uninterrupted operation. Evi-
dence of his in-depth examination of these issues is also provided by
many sheets of Ms. G, which contain dense sequences of reflections and
technical proposals to be tested. Although those notes and diagrams do
not always allow a precise reconstruction of his plans, it appears clear that
he considered a variety of ideas, subject to constant changes, probably
because of the unsatisfactory results of experimental verifications. This
explains his constant alternation between returns to theoretical analysis
and the formulation of new practical solutions, incompletely described
for fear of inquisitive eyes.

Leonardo's studies in this final phase confirm his preference for mir-
rors composed of thin copper blades, silver-plated or coated with reflective
enamel,[137] assembled and soldered together with burning mirrors,[138]
and then backed with a rib, to obtain a rigid polygonal reflecting surface.[139]
As a logical consequence of his primary concern with manufacturing pro-
cesses, Leonardo devotes considerable attention in Ms. G to machines
for drawing metal plates,[140] to the construction of modular profilers to
be fixed to robust brick supports (Figure 89),[141] to the design of complex
waterwheel-powered devices[142] for grinding and polishing, and of belt-
and-roller systems to move a large profiler[143] so as to set up automated
production cycles and guarantee perfect mirror curvature (Figure 90).

THE SAME DYNAMICS AND INTELLECTUAL tension that characterized his contemporaneous studies of optics and mechanics emerge from Leonardo's long-standing dedication (ca. 1478–1515) to the science and technology of burning mirrors. While striving to master the conclusions of classical and medieval science, he felt it imperative to verify, through careful observation of natural phenomena and ingenious experiments, whether the rules established by the authors of the mathematical tradition could be applied to manufacturing processes. Having reached a negative conclusion on this issue, he conceived an ambitious reform project to bring that abstract body of knowledge into line with the practical demands of craftsmen. The emphasis on practical applications based on rigorous and universal rules obliged him to return continually to theoretical elaboration; this, in turn, produced fresh generalizations and formalizations—triggering a further round of questions regarding beliefs underpinned by highly respected traditions.

The studies on the caustics of reflection offer a host of examples of this steady, nonlinear interaction between theory and practice, which characterizes Leonardo's method of inquiry. One of the most suggestive is provided by a sheet of the Codex Atlanticus datable to 1513. In his excitement over his mirrors' huge potential benefits, a key question flashes through his mind: "I wonder whether the [vertex of the burning] pyramid condenses so much power [of the sun's rays] into a single point; and, if it becomes heavier than air, what supports it?"[144] The work bench packed with instruments, models, the grinding tools that he was testing, and the noisy chatter of assistants all vanish at the sudden emergence of a crucial philosophical dilemma. The massive production of heat promised, according to his calculations, by his mirrors depended on the condensation of rays in a single point. As condensation implies an increase in density and thus in weight, Leonardo senses a potential conflict with the Aristotelian theory of the elements. By all converging in one point, the rays would form a body heavier than air; how could the latter support the highly condensed and therefore very heavy tip of the burning pyramid?

It is hard to find a more eloquent example of the mature Leonardo's aversion to the traditional separation of natural philosophy from mathematical analysis and operative practices. No one else at the time would

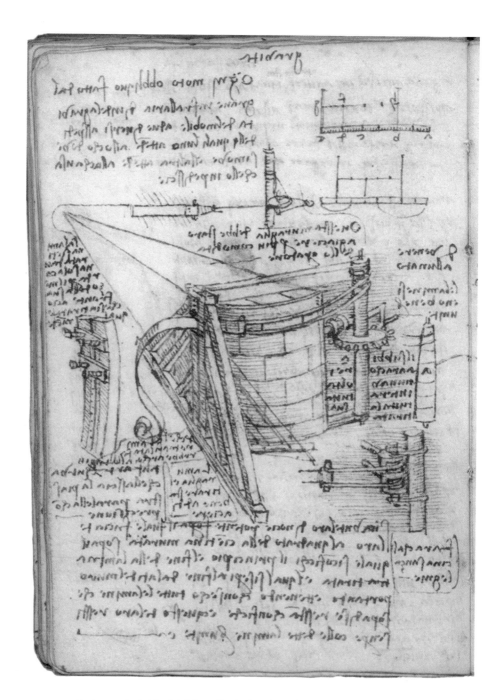

FIG. 89 Leonardo da Vinci: brick profiler for burning mirrors.

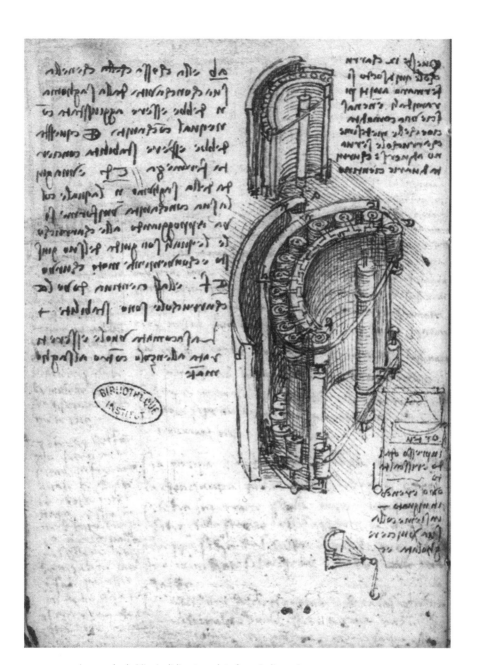

FIG. 90 Leonardo da Vinci: sliding template for grinding mirrors.

have dared to establish such a linear connection between the outcomes of experimental activities and the conclusions of geometric research into burning mirrors, on the one hand, and a fundamental question regarding the universal laws of nature, on the other. Here, as in countless other cases, Leonardo's mind strives to capture the hidden principles that govern the working of the universal machine in the simplest and most ordinary operations of nature and man.

CHAPTER 3

Immaterial Machines

Visual Glosses

In the previous chapters, I often emphasized the impact of the rediscovery of Vitruvius's *De architectura* both in humanist circles and among architects and engineers from the mid-fifteenth century onward.

One of the early protagonists of the Vitruvian revival was Leon Battista Alberti, who, in *De re aedificatoria* (published in 1485), devoted considerable attention to the work of the Roman architect, albeit sometimes distancing himself from his positions. Drawing inspiration from Vitruvius's model, Alberti underlined the close integration and interdependence between architecture and machines, focusing on the technical devices required for the practice of architecture.[1] He also assigned a central role to drawing, which he regarded as an essential skill for an architect, along with the mastery of mathematics.[2] Alberti defined drawing as the perfect delineation of the form and proportion of a building—the essential starting point of the construction process.

Alberti's treatise did not present images. His descriptions of ancient buildings and machines were based solely on the interpretation of literary sources, which he compared with surviving archeological evidence that few readers of *De re aedificatoria* were likely ever to have seen. This gap was filled only a century later by the richly illustrated printed edition of Alberti's treatise, translated into the vernacular by Cosimo Bartoli.[3]

Some years later, Antonio Averlino, better known as Filarete, often mentioned Vitruvius's work in his *Trattato di architettura*.[4] Unlike that of Alberti, Filarete's text contained many illustrations, although only few

portrayed machines and technical systems. The author frankly declared his dissatisfaction with some of those images. Referring, for instance, to the drawing of the iron foundry at Grottaferrata (Figure 91), he stated that it "was hard to describe in words and cannot be fully explained even in drawings."[5] Looking at the image, it is indeed difficult to understand how the river current powers the camshaft operating the bellows. While gifted in graphic renderings of architectural structures, Filarete clearly lacked the skill to produce effective illustrations of mechanical devices and their operating cycles.

The dissemination of Vitruvius's *De architectura* underwent a significant acceleration with the first printed edition of the Latin text by Johannes Sulpicius Verulanus around 1486[6]—roughly at the same time as Francesco di Giorgio was working on his translation into the vernacular of the Roman architect's masterpiece for his own use.[7] Sulpicius's edition, completely lacking in illustrations, represented one of the first systematic attempts to use the most refined tools of humanistic philology to "restore" the corrupt manuscripts through which the Vitruvian treatise had been transmitted.

In the decades between the late fifteenth and early sixteenth centuries, this goal was pursued by representatives of two worlds that, until then, had seldom shared interests and programs: on the one hand, philologists—such as Sulpicius himself—who deployed their considerable competence in Greek and Latin language and culture to decipher the many obscure passages of *De architectura;* on the other hand, artist-engineers, eager to acquire the know-how for designing and constructing buildings modeled on admired classical exemplars, and to master the secrets of the celebrated civil and military machines of Antiquity described by Vitruvius in Book X. The philologists carefully collated the available manuscripts, comparing the Vitruvian descriptions of Roman buildings with surviving archeological evidence. The artist-engineers, relying on their technical knowledge and their experience in design and building, translated into drawings the textual descriptions of the form and structure of architectures and machines.

Sulpicius admitted that illustrations would help to achieve a better understanding of many of Vitruvius's passages. But he abandoned the idea of producing them for two reasons: first, he had failed to find drawings

FIG. 91 Filarete: Grottaferrata iron foundry.

in the sources available to him; second, translating textual descriptions into images entailed risky interpretations and considerable work to engrave and print them.[8] However, he deliberately adopted a page layout with wide margins, so that if, at a later date, "either he himself or other scholars were to delineate those images, they could be placed beside the descriptive texts."[9] While warmly inviting readers to join forces to restore clarity to the Vitruvian text,[10] he confined his invitation to the *literati*, ignoring the contribution that could be offered by architects, artists, and engineers: the *machinae pictae* remained outside the scope of Sulpicius's Vitruvian philology.

However, it was becoming ever clearer that interdisciplinary expertise and the use of illustrations were crucial to fully deciphering Vitruvius's text. This realization found concrete expression in the first illustrated edition of *De architectura*, published by Fra Giovanni Giocondo in Venice in 1511.[11] The central role played by illustrations was made explicit by the title: *Vitruvius castigatior factus cum figuris* (Vitruvius's text elucidated with the addition of images). Fra Giocondo, who started work on the edition of *De architectura* in the early years of the sixteenth century, had a very different profile from Sulpicius. An excellent philologist and, at the same time, an expert architect, he possessed great technical skills and considerable experience in drawing both buildings and machines. While editing and illustrating Vitruvius's text, Fra Giocondo cooperated intensively with Giovanni Lascaris, a leading philologist, Giovanni Marco da Lendinara, an expert in optics, and Nana Germanicus, a competent mathematician.[12]

Fra Giocondo stood at the intersection between the world of humanistic culture and that of craftsmen and engineers. Indeed, in the documents that attest to his busy career—which saw him conduct major projects throughout Italy and in France—he is variously qualified as *architectus*, *mechanicus*, and *antiquarius*.

One of his specialties was the illustration of machines. From a document of 1492, we learn that he prepared 126 drawings for two works by Francesco di Giorgio "on architecture, artillery, and war-related subjects."[13] The drawings correspond in number to those of the second version of Francesco di Giorgio's *Treatise on architecture and machines*. Fra Giocondo came into contact with the Sienese artist-engineer in Naples, when both were in the service of the Duke of Calabria. He also aided Ermolao

Barbaro in deciphering Pliny's obscure description of Curio's mobile theater. Ermolao, unable to interpret the text by means of philological analysis, turned to Fra Giocondo who, thanks to his expertise in architecture and in graphic representation, translated it into an image.[14]

Fra Giocondo has also been regarded as the author of the illustrations of the first edition of Valturius's *De re militari,* published in Verona in 1472 by "Ioannes ex Verona oriundus" (Giovanni from Verona).[15] The dates fit, but the modest quality of those drawings suggests a namesake.

Among his publications that successfully integrated textual philology and masterful illustrations of technical subjects, we should also mention his edition of Julius Caesar's *Commentaries,* published by Aldus Manutius in 1513, in which Fra Giocondo included the first graphic representation of the bridge built by the Roman emperor on the Rhine.[16] Fra Giocondo emended the description of the bridge in Book IV of the *Commentaries,* by comparing it with Caesar's *De bello civili,* Book V of Vitruvius's *De architectura,* and Alberti's interpretation of Roman bridges in *De re aedificatoria.*[17] The outcome of this collation was not a new textual interpretation, but an image of striking clarity. Also of considerable interest are Fra Giocondo's woodcuts for the Aldine edition of the authors of *De re rustica,* published in Venice in 1514.[18]

Fra Giocondo explicitly exalted the contribution of images to the interpretation of ancient architectural and technical texts. In his words, "images enlighten obscure texts."[19] It is not surprising, therefore, that he was the first to combine the philological emendation of the Vitruvian text with a rich corpus of no fewer than 136 illustrations. In the dedication to Pope Julius II that opens his edition of the *De architectura,* he explained that he had followed a twofold method. On the one hand, he collated a large number of manuscripts; on the other, he systematically compared the text of Vitruvius with surviving archeological evidence.[20] These details enable us to understand how Fra Giocondo prepared the many images showing plans, overhead views, and architectural details of buildings. But they do not tell us how he managed to draw the machines and technical systems described in Book X of *De architectura* despite the lack of surviving material evidence.

Even though he does not highlight this aspect in the dedication letter to Pope Julius II, the iconographic approach to classical texts was a

distinctive feature of his method. This is confirmed by Guillaume Budé's precious account of the lectures on Vitruvius given by Fra Giocondo in Paris between 1500 and 1505—lectures that triggered interest in the masterpiece of the Roman architect in France: "I had the good fortune to have as a most competent preceptor, Fra Giocondo, architect of the King [of France], extremely knowledgeable in classical culture, who in his lessons relied not only on words, but also on images."[21]

Fra Giocondo's routine use of graphic representation is confirmed by an exemplar of Sulpicius's second edition of Vitruvius (Venice 1497) with its wide margins filled with notes in Budé's hand and sketches clearly modeled on the illustrations that Fra Giocondo was to include in the 1511 edition.[22] Budé had diligently followed Sulpicius's recommendations to readers to add comments and illustrations in the margins of his edition.

Fra Giocondo's woodcuts illustrate only some of the devices described by Vitruvius in Book X. He explains his parsimonious strategy in the long marginal caption to the image (Figure 92) of the pump of Ctesibius *(machina ctesibica)*. He states that he would have liked to have prepared a detailed commentary and produced several drawings for each machine, so as to show its external appearance and internal parts. But the difficulty of the task induced him to provide only a limited number of visual representations that helped to better understand the Roman author's textual descriptions of technical devices.[23] Perhaps it is no coincidence that Fra Giocondo placed this *excusatio* next to the woodcut of the pump invented by Ctesibius, whose functioning is unclear because the image does not show the valves alternately opened and closed by the two pistons operated by a rocker arm.

Even in the *legenda* to the following illustration of the hydraulic organ, Fra Giocondo admits that his *pictura* shows neither the hidden mechanisms nor the dynamics of the flows inside the instrument's pipes (Figure 93).[24]

He strikes a different tone in his marginal comment on an illustration of the device to measure the speed of a sailing vessel described by Vitruvius (Figure 94). Fra Giocondo tells the reader that his image does not follow the Vitruvian text, which describes a ship with two paddle wheels placed one on each side of the hull.[25] In his opinion this solution is not viable, because

I nfeqͭ nͧc de ctefibica machina q̃ ĩ altitudinē aquã educit mōſtrare,Ea fit ex
ære,cuĩ ĩ radicib°modioli fiͧt gemelli paulͧ diſtátes hͭtes fiſtulas (furcil/
læ ſuͭ figura)fiͭr coherétes,ĩ mediͧ catinͧ cócurrétes,ĩ quo catino fiát axes ĩ
fuperiorib°narib°fiſtulaꝛ coagmétatióe fubtili collocati,q̃ pobturátes fo/
ramina nariͧ,nó patiuntͤ exire id/q̃ d̃ fpiritͧ ĩ catinͧ fuerit expſſum,Supra
catinͧ penula,ut ĩnfudibulͧ iuerſͧ,ē attēperata, q̃ etiã p fibulã cum catino
cuneo traiecto,cótineͭ & coagmétaͭ,ne uis iflatióis aquæ eã cogat eleuare,
Infup fiſtula q̃ tuba diciͭ eͣagmétata,in altitudíe fit erecta,Modioli auͭ hͭt
iſtra nares iferiores fiſtulaꝛ,axͤs iterpofitos fupra foramina eaꝛ q̃ ſuͭ in fun
dis,Ita de fupnis ĩ modiolis ēboli maſculi torno politi & oleo fubacti cóclu
fiꝗ regulis & vectib°cóuoluuͭ,q̃ ultro citroꝗ frequéti motu pmétes,aeré
q̃ erit ibi cͧ aq̃ axib°obturátrib°foramía cogut & extruduͭ iflãdo pſſióib°
pfiſtulaꝛ nares aquãĩ catinͧ,e quo recipiͤs pͤula fpͧs exprimit p fiſtulã ĩal
titudiné,& ita ex iferiore loco caſtello collocato ad faliédͧ aq̃ fubmiſtraͭ.

(marginal notes left of main text)
deͤſt illud
nͣaſculͭ
+ +
+ +
+ +

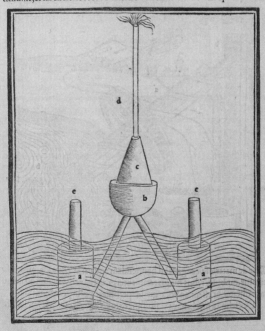

(left margin column)
a. modioli
ærei
b. catinus
c. penula uti
infudibulum
inuerſam
d.fiſtula quæ
tuba diciͭ
e. emboli
maſculi. R eſi
qua ex littera
ſatis iͭtelligu̇
tur a peritis.
Singula eni
& in his ma-
chinis & in
multis fupe-
rioꝛ reꝛ de-
ſcriptióib°ſi-
q̃s declarare
uellet op°eͤt
& plura ſcri-
beret:& cuiuſ-
que rei uari
as figuratio
nͧ facies pin
gereiqb°& q̃
reb°ipſiͧ itra
ſuͭ & extrat
mōſtrati poſ-
ſent:ſed ſatis
mihi feciſſe
uideor apuiſ-
ſe.ſ.ſtudioſis
fores & oſtē-
diſſe ſemitas
qb°hic au-
ctor intelligi
ualerͤt.

FIG. 92 Ctesibius's pump in Fra Giocondo's edition of Vitruvius.

nes extollentes fundos intra modiolos uehementi pulfus crebritate, & ob/
turátes foramina cymbalis fuperiora, aera qui eft ibi clufus preffionib° co/
actum, in fiftulas cogunt, per quas in lignea concurrit & per eius ceruices in
arcam, motione vero uectium vehementiore fpiritus frequens compreffus
epiftomiorum aperturis influit, & replet anima canales, Itaq; cũ pinnæ ma/
nibus tactæ propellũt & reducunt cõtinenter regulas, alternis obturãt fora
mina alternis aperiundo ex muficis artibus multiplicibus moduloꝗ varie/

tatibus fonantes excitant uoces.
Quátum potui niti ut obfcura res
per fcripturã dilucide pronũciare
tur contendi, Sed hæc non eft faci/
lis rõ, neq; omnibus expedita ad i/
telligendũ præter eos, qui in his ge
neribus habent exercitatione, Qd
fi qui parum intellexerĩt e fcriptis
cum ipfam rem cognofcent, profe
cto inuenient curiofe, & fubtiliter
omnia ordinata.

Qua ratióe rheda vel naui ve
cti peractum iter dimetiamur.

Caput. XIIII.

Transferatur nunc cogitatus fcri
pturæ ad rationé non inutilem fed
fumma folertia a maioribus tradi/
tam qua in uia rheda fedentes vel
mari nauigátes fcire poffumus quot milia numero itineris fecerimus, Hoc
autẽ erit fic. Rotæ quæ erũt ĩ rheda fint latæ per mediam diametron pedum
quaternũ & fextantis, vt cum finitum locum habeat in fe rota, ab eoq; inci/
piat progrediens in folo viæ facere verfatioñe, perueniendo ad eam finitio/
nem a qua cœperit verfari, certum modum fpatii habeat peractum pedum
xiis. His ita præparatis tunc in rotæ modiolo ad partem interiorem tympa/
num ftabiliter includatur habens extra frontem fuæ rotundationis extantẽ
denticulum vnũ, Infuper autẽ ad capfum rhedæ loculamentũ firmiter figa/
tur habens tympanum verfatile in cultro collocatum & in axiculo conclu
fum, In cuius tympani froñte denticuli perficiátur æqualiter diuifi, nume/
ro quadringenti cóueniétes denticulo tympani inferioris, Præterea fuperio
ri tympano ad latus figatur alter denticulus prominens extra détes, Super
autem tertium tympanum planũ eadem ratione dentatum inclufum in al/
terum loculamentum collocetur, conuenientibus dentibus denticulo qui
in fecundi tympani latere fuerit fixus, in eoq; tympano foramina fiat, quã/
tum diurni itineris miliarioꝗ numero cum rheda poffit exiri, min° plufue

FIG. 93 Hydraulic organ in Fra Giocondo's edition of Vitruvius.

Hæc nauis de
scriptio non
ea rōne facta
estq̃ ab au-
ctore tradit:
sed alia ñ mi-
nus solerti.Is
nanq̃ pcipit
rotas fieri de-
bere extra la-
tera nauis.S;
ea quotiēs in
alterā parte
inclinat ut ra
tio exigit ué-
toq̃ & ueloq̃
eiusq̃ lateris
rota i eādem
parte inclina
tatatq̃ prona
iacēs:nimiū i
mergit aquæ
si eq̃ nauiga-
tioné ipedit:
neq̃ ipa iustā
rotationé psi
cit:altera
quoq̃ rota
excelsi⁹ elata
atq̃ sisp̃nat
nihil uel pa ẽ
aquā tangit:
minusq̃ hac
diuersitate al
terā iuuat uel
ab ea iuuat .
ut nõ possint
quouis mō
expeditam iu
staq̃ psicere
rotationem .
Quæ oia uni
ca rota i me-
dia naui posi
ta (ut figura
monstrat)
emēdant:dū
tñ catina i eo
medio gemi-
netur atq̃ in
utroq̃ quoq̃
coeat capite.
Nā ita nauis
facili⁹ fluitat:
& quocunq̃
mō i alteram
pte iclinet ro
ta sine fine rotationé suam peragit.

calculi rotundi,In theca eius tympani(siue loculamentum est)unū foramē
excauetur habens canaliculum,qua calculus liberatus ab obstātia cum ce-
ciderit in vas æreum sonitum significet,Ita nauis cum habuerit impetū aut
remorum aut uentorum flatu pinnæ quæ erunt in rotis tangentes aquā ad
uersam uehementi retrorsus impulsu coactæ versabunt rotas,Eæ aūt in uol
uendo se agent axem,axis uero tympanum,cuius dens circumactus singu-
lis uersationibus singulos secundi tympani dentes impellendo, modicas ef
ficit circuitiones,Ita cum quatercenties ab pinnis rotæ fuerit versatæ,semel
tympanum planum circumagent impulsu dentis,qui ad latus ē fixus tym-
pani in cultro,Igitur circuitio tympani plani quotienscūq̃ ad foramē per-
ducet calculos emittet per canaliculū,Ita & sonitu & numero indicabit mi-
liaria spatia nauigationis.

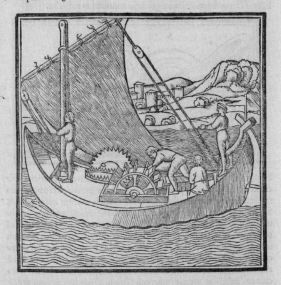

Quæ pacatis & sine metu temporibus ad vtilitatem & delectationem parā-
da quemadmodum debeant fieri peregisse videor.

De catapultarum

when wind causes the ship to tilt, one of the wheels will lose contact with the water, while the other will be too deeply immersed, impeding navigation. For this reason, he drew a single wheel "placed at the center of the ship." He defines this intervention as an *emendatio* (emendation), which, however, he formulated not in a marginal gloss to Vitruvius's text but through an image. In this case, he relied more on his experience as a skilled *ingeniarius* than on his philological competence.

Of no less interest for understanding the importance assigned to visualization as a sharp interpretative tool is Fra Giocondo's illustration of the catapult (Figure 95), which he claims to have taken "from those very same Greek authors cited by Vitruvius."[26] He explains that he could not fathom how the machine worked either from the text of Vitruvius or from the image of the device in the Greek manuscript that he had examined. He decided to publish his drawing nonetheless, in the hope that "scholars and engineers [not only *literati* like Sulpicius!] might succeed where I have failed."[27] The image of the machine is displayed here in its unresolved obscurity alongside the undecipherable Vitruvian text so as to motivate readers—in the spirit of the collective undertaking envisaged by Sulpicius—to help clarify it.

For the *balista,* too, of which Vitruvius described multiple versions, Fra Giocondo provides a single illustration[28] inspired by an image found in the same Greek manuscript.[29] Its source was the Greek Ms. 1164 of the Vatican Library containing texts of Greek authors on poliorcetics (siege warfare), owned at the time by Angelo Colocci, whom Fra Giocondo probably met during the many years spent in Naples.[30] The image of the *balista,* he hoped, would assist readers to unravel the obscure description of the device in Vitruvius's *De architectura.* In any event, they would not complain of the lack of an illustration.

Fra Giocondo's efforts to translate the Vitruvian textual descriptions of architectures and machines into images testify to the keen interest of Renaissance engineers and architects in the work of the Roman author. We have already mentioned Francesco di Giorgio's endeavors to assimilate Vitruvius's lesson. Shortly after the publication of Fra Giocondo's edition, Raphael commissioned, from Fabio Calvo of Ravenna, a vernacular translation of *De architectura* based on Sulpicius's edition, which he intended to illustrate and publish.[31]

capitulum fuerit(quod catatonum dicitur)propter uehemetiam, brachia
paulo longiora conftituentur,uti facile ducantur.Náq; quéadmodum ue/
ctis cum elt longitudine pedum quatuor qd onus quinq; hominib° extol/
litur,is fi eft pedum octo a duobus eleuatur,eodem modo brachia,,quo ló
giora funt mollius,quo breuiora durius ducuntur.

a. ϖερί ϑι/
ϱν
b. χοινικίς
c. ϑάϖεζά
d.αὐτεϖεί/
ςιον
e.ἀſκὼϑ
f.αὐτιςά/
τις
g.Διάϖηξ
h. Sucula cũ
uectibus
Hác catapul,
tæ defcriptio
né ex iifdé ha
bui græcis au
ctorib° quos
Vitruuius ci
tat:quá quo,
q; iildem di,
ctióibus græ
cis annotaui
quas ibi inue
nitut ftudio,
fis & igenio,
fis nô deefſét
q forfan ibi.p
fieẽf poterũt
ubi ego defe
ci:qñ neq; ex
uitruuioneq;
ex ipfis aucto
rib°(ut inge
nii mei tenui
taté fatear)i
tegrá rectam
ne itelligétiá
extorq̃re ua,
lui.

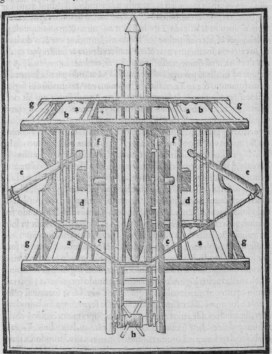

De baliftarum rationibus. Caput. XVI.

Catapultarũ rões ex quibus membris & portionibus cóponant dixi, Bali/
ftarum autẽ rationes variæ funt & differentes'vnius effectus caufa compara
tæ,Aliæ enim uectibus & fuculis:nonnullæ polyfpaftis,aliæ ergatis, quædá

FIG. 95 Catapult in Fra Giocondo's edition of Vitruvius.

In later years, other prominent artists strove to elucidate and disseminate *De architectura* through richly illustrated editions. Suffice it to mention the Sangallos, particularly Antonio and Giovan Battista, known as the "Hunchback." Giovan Battista filled the wide margins of his personal copy, now preserved in the Biblioteca Corsiniana in Rome, of the *editio princeps* of Sulpicius's edition with annotations and numerous illustrations.[32]

Another gifted artist, Cesare Cesariano—a member of Bramante's circle and great admirer of Leonardo—published the first printed edition of Vitruvius in the vernacular in Como in 1521.[33] This splendid book includes 119 illustrations, a translation into the vernacular (based on the Sulpicius and Fra Giocondo editions), and a monumental commentary up to Book IX, when he abandoned the project owing to disagreements with the printer.[34] Although sometimes critical of Fra Giocondo's work, Cesariano drew inspiration for many illustrations from his predecessor, while others were his own creations. Using Cesariano's draft of the commentary and his illustrations, Bono Mauro and Benedetto Giovio completed Book X.

The fact that Cesariano backed out of the project before drafting the annotations to Book X represents, from our standpoint, a serious handicap. The technical expertise of the two authors who replaced him was inadequate for the task. Their commentary failed to exploit the considerable expressive power of Cesariano's images, which combined overviews with illustrations of numerous details. Moreover, Bono Mauro and Benedetto Giovio spared no effort in finding fault with his graphic work.[35] As a result, Book X is extremely disappointing, above all for the absence of any dialogue between the descriptive text and the images.

In the opening paragraphs of *De architectura,* Cesariano praises the function of "the science of representation, that is, painting" ("antigraphida scientia, id est la pictura").[36] Echoing Da Vinci's emphasis on painting as the supreme science, he qualifies representation as a strictly intellectual activity, the prerequisite for any form of knowledge. He reasserts the dignity and nobility of drawing and painting in the commentary to the paragraph in which Vitruvius illustrates the three divisions of architecture, introducing *machinatio* as the third. Cesariano views *mach-*

inatione as a conceptual elaboration that is expressed through drawing: "*machinatione* . . . —he writes—is the activity that excogitates, performs, and invents all manual operations."[37] After highlighting that *machinatione* derives from the Greek μηχανάομαι ("i.e., I deliberate, excogitate, construct"), he defines it as the mental activity on which "the construction of working instruments" depends. "Intellective machination"—he states—is the main quality of "artists who are able to forecast the outcome of anything we want to accomplish."[38]

For Cesariano, *machinatione* does not consist of theoretical activity alone. It also performs the vital function of inspiring practical operations and guiding them to a successful conclusion. This dual role prompts him to describe it as "adulterous" *(machinatione adulterina),* for "through our intellect it conceives instruments or tools to build or destroy . . . and, with these instruments, it constructs anything in the world, a world defined by Vitruvius in Book IX as a *Machine*."[39]

Cesariano's emphasis on the hybrid nature of *machinatione* served to praise the professional skills of the new generations of artist-engineers: Francesco di Giorgio, the Sangallos, Raphael, and—above all—Leonardo da Vinci, of whom Cesariano regarded himself as a colleague and emulator. His commentary gave voice to the expectations of those technicians who claimed to be the only ones who could decipher Vitruvius's arduous text—precisely because their technical skills and mastery of drawing made them the natural interpreters of the "machinatione adulterina," whose primacy rested on the unchallenged *auctoritas* of the Roman architect. In Cesariano's commentary we find clear evidence of the fundamental role played by *machinae pictae* in the process that led to the professional affirmation and social recognition of the leading Renaissance architects and engineers.

The emphasis on the close connection between *machinatione* in the Vitruvian sense and drawing skill also served to draw a sharp cultural and social distinction between the new, ambitious engineers endowed—in Alberti's words—with "concept and drawing," and the ordinary practitioners. The function of drawing as a clear dividing line between these two categories of technicians was forcefully emphasized by Vannoccio Biringucci, one of the most successful representatives of the sixteenth-century revival of interest in machines, in his *Pirotechnia:*

> Some masters work iron well and steel poorly; others work
> steel well and iron poorly, which in truth ... seems unbeliev-
> able. ... And lastly, considering what this craft [i.e., that of
> the ironsmiths] is, it seems that their activity is entirely based
> on practical experience, for such workers are people who can't
> draw, and mostly rustic and coarse people, and if they can do
> one thing they can't do another.[40]

In the early 1540s, the awareness of the need for multiple skills to re-
solve the obscurities in the text of *De architectura* led to the foundation of
the short-lived Accademia della Virtù, also known as the Accademia Vit-
ruviana, promoted by Claudio Tolomei in Rome.[41] According to the de-
tailed program spelled out in Tolomei's letter to Count Agostino de' Landi
in 1542,[42] the Accademia intended to foster cooperation between persons
well-versed in philology (such as Guillaume Philandrier, who published
his learned *adnotationes* on Vitruvius in 1544[43]), competent antiquarians
(such as Tolomei himself), and gifted architects and engineers (active
members of the Academy included Jacopo Barozzi da Vignola and Antonio
and Giovan Battista da Sangallo).

The Accademia launched a collegial project to prepare a definitive
edition of *De architectura*, both in the original Latin and in "the beautiful
Tuscan tongue," with an extensive commentary and iconographic appa-
ratus. For Tolomei,

> Vitruvius certainly prepared many figures in order to make
> some parts of his work more comprehensible ... , but these
> figures have not been found yet. Hence, in recent times, Fra
> Giocondo from Verona ... prepared and printed many
> beautiful images. He deserves utmost praise for this, as his
> labors have made this author [Vitruvius] far easier to
> understand.[44]

However—Tolomei continues—Fra Giocondo made several errors and,
above all,

> skipped, without illustrating them, many passages, that
> would have benefited from illustrations. ... This has
> prompted those men [the promoters of the Accademia

Vitruviana] to produce all the illustrations, drawing them with the greatest grace and refinement possible, and correcting those where Giocondo erred.[45]

The Accademia Vitruviana also planned to produce an illustrated atlas of all ancient machines:

> of the three parts to which architecture devotes its efforts, the one which deals with machines is very useful and very difficult; to make its study possible we will try to rediscover the true aspect of ancient machines, first, hydraulic machines, then, siege machines and, lastly, machines that move weights, portraying them in a clear manner and showing the stages of their construction.[46]

In addition, the Accademia would conduct fieldwork on the Roman aqueducts, producing sets of drawings to show their structure and functioning.[47]

The program outlined by Tolomei could be defined as an integrated philological program based on the collation and emendation of texts, on on-site archeological investigations and, above all, on an exhaustive iconographic campaign—an undertaking for which, given its scope, the Accademia planned to simultaneously employ over one hundred artists.[48] The awareness of the fundamental role played by images of technical devices in elucidating the Vitruvian text clearly emerges in Tolomei's letter to Luca Contile of 1543. The Sienese patrician stressed the extreme difficulty of interpreting Book IX and especially Book X of *De architectura;* he had found the latter "almost impossible."[49] Five years later, writing to Francesco Sansovino, who had asked for his assistance regarding some obscure passages of the Vitruvian text, Tolomei admitted that his ambitious plan for an iconographic atlas of ancient machines had foundered. The greatest obstacles were encountered in Vitruvius's Books IX and X, which defied comprehension, because these books illustrate

> lost instruments, of which no examples or depictions survive. I remember that, among other things, we were in great trouble particularly as to Hydraulics and the Catapult. However, we made some progress on both and rediscovered

some principles, so it could indeed be said that we under-
stood some parts of those subjects. And for the Catapult we
concluded that the one described or depicted by Giocondo is
not that of Vitruvius. What else? From Naples we were sent a
drawing of a [catapult] that we found unsatisfactory as
well.[50]

Slightly over a decade after the dissolution of the Accademia Vitru-
viana, Daniele Barbaro, Patriarch of Aquileia, published his annotated
and illustrated vernacular translation of Vitruvius,[51] which he reprinted
in 1567 with a revised commentary, and an emended edition of the Latin
text.[52] Among the many publications of the Roman architect's master-
piece across the sixteenth century, Barbaro's edition stands out by far. His
vast commentary reveals his intention of presenting architecture and en-
gineering as disciplines firmly rooted in theory. A man of great doctrine,
Barbaro also maintained close ties with refined artists (he was on friendly
terms with Palladio, who contributed to the numerous architectural il-
lustrations) and competent mathematicians (such as Francesco Barozzi,
Federico Commandino, and Giuseppe Moleti). Barbaro's commentary
aims at highlighting the theoretical knowledge and scientific principles
to be mastered in order to build perfectly proportioned architectonic
structures, bend nature to man's purposes, and even live ethically in
society.

For Barbaro experience is not the principle of art; rather, it

resembles the track, left by wild animals, because just as the
tracks are the means to find the deer, although it is not a part
of the deer, so experience is the means to find the arts,
although it does not belong to any art; because the things
exposed to the senses are not the principles of art, but simply
occasional stimuli . . . , because the principle of art is uni-
versal and does not depend on the human senses.

Consequently, "art is more excellent and more virtuous than sense
experience, because, being closer to knowledge, it understands the causes
and reasons of things, whereas experience operates without reason."[53] For

Daniele Barbaro, the Vitruvian architect must be versed in the mathematical sciences, clearly distancing himself from workmen who, "using their hands, strive to model material objects according to the ideas concealed in their minds."[54]

There appears to be a direct connection between these views—clearly inspired, like his entire commentary, by Neoplatonic ideals—and his interpretation of the meaning assigned by Vitruvius to *machinatio*. He states that *fabrica* and *machinatione* are "general and specific names." In their general meaning, the terms denote the activity that presides over "the composition of all things" through abstract reasoning, while in their specific sense, they designate an individual building or machine.[55] Although recognizing the need to integrate mental design and practical execution, Barbaro states that the architect should be capable, above all else, of *fabricare* and *machinare* at the theoretical level. To use Cesariano's terminology, Barbaro's *machinatione* is entirely "intellectual"; he takes great care in distinguishing it from the *machinatione adulterina*.

Drawing represents the junction between the mental design and the operational level. Barbaro clearly distinguishes drawing from proficiency in draftsmanship, defining it as the delineation of abstract and perfect forms:

> drawing is a firm determination conceived in the mind [and] expressed with lines and angles . . . , whose purpose is to assign to buildings an appropriate place, a perfect proportion, a noble aspect, and a graceful order. This rational principle does not depend on the kind of matter, but is the same in all matter. . . . Therefore, it is necessary that the architect be able to draw.[56]

Drawing captures with the mind's eye the mathematical ratios and symmetries, translating them into models that the architect must keep in mind throughout the design and construction process.

Barbaro saw drawing as the direct expression of the movements of the soul. Abandoning the world of ideas—"where speech is visible, and thoughts are expressed without words, where there is motion without place, and learning is instantaneous"[57]—and becoming incarnate, the soul stays

connected through drawing and mathematical reasoning to the perfect models of the spiritual dimension from which it has detached itself.

The same approach characterizes Barbaro's analysis of the *machinatio* in Book X. Warning against confusing it with craftsmen's empirical know-how, he stresses that *machinatione* "is a rational activity that demonstrates the way of making machines . . . and a discourse that first takes place in the mind and then dictates the rules that govern construction processes."[58]

The *machinae pictae* that illustrate Book X of Barbaro's vernacular version of Vitruvius comply with this paradigm. Their chief purpose is not to offer a realistic image of the devices but to illustrate the principles that govern their operation. Unlike Fra Giocondo and Cesariano, Barbaro represents the devices for lifting and moving weights with schematic and decontextualized drawings, so as to highlight their geometric structure. To visualize the internal mechanisms of hydraulic and pneumatic machines (indicated in the text by letters) he uses transparent views: the helix of Archimedes's screw (Figure 96);[59] the alternating movement of valves and pistons in the Ctesibian pump;[60] the hydraulic or manual driving mechanisms in bucket wheels;[61] and the instruments for conveying water to the pipes of the hydraulic organ, with emphasis on the mechanism for alternately opening and shutting valves (Figure 97).[62]

Barbaro's rational interpretation of the *machinatio* and his innovative approach to the depiction of machines also inspire his commentary on Vitruvius's discussion of war machines.

> Here we do need God's help—the Patriarch of Aquileia
> implores—because these machines are nowhere to be found
> either in the text of Vitruvius, or in any drawing, or in any
> ancient models . . . and it would be risky to try and figure
> them out by guessing, because through clever reasoning one
> could succeed in making some of those instruments for
> launching rockets or arrows, but if they were exactly as
> described by Vitruvius, that would be a great thing.[63]

Barbaro therefore begs pardon for not providing drawings of these machines. Significantly, he limits himself to elucidating the theoretical principles through which we can grasp the purpose assigned by Vitruvius

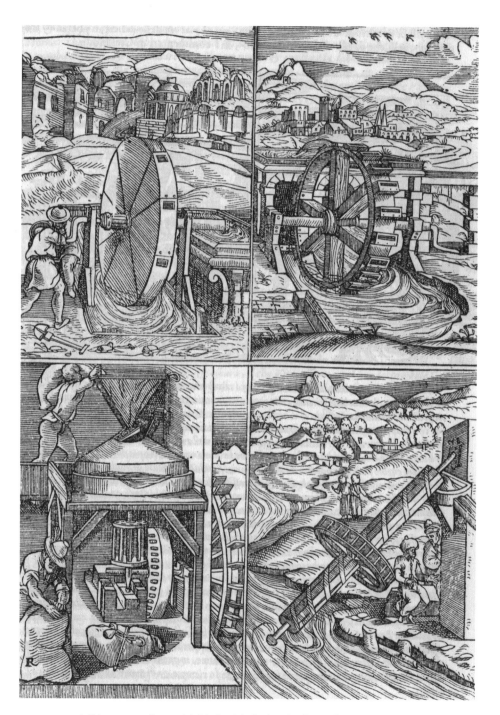

FIG. 96 Worm screw (lower right) in Daniele Barbaro's edition of Vitruvius.

FIG. 97 Hydraulic organ in Daniele Barbaro's edition of Vitruvius.

to all war machines—to violently launch weights over long distances. This goal is achieved, he stresses, by thorough knowledge of the nature of weight and the ability to harmoniously assemble a variety of mechanisms. Mastery of the golden rule of proportionality of parts, essential for architects, is also a prerequisite for mechanics worthy of the name: "the module used to erect proportionate architectural structures must be taken into consideration also in the construction of machines, because symmetry and order are required in this field as well."[64]

Barbaro's commentary on Vitruvius, particularly his reading of the *machinatio,* marks a departure from the interpretation of earlier Renaissance editors, such as Fra Giocondo and Cesariano. While the latter too sought to emphasize the conceptual dimension of technical activity, their main goal was to realistically depict the machines described by the Roman architect, rather than explain the mathematical and mechanical principles governing their operations.

Best-Selling Machines

Sixteenth-century editors and commentators of Vitruvius were not alone in emphasizing the intellectual foundations of mechanical activities, based on drawing and mathematical reasoning. The same vision informed the *Theaters of machines,* a literary genre that proved immensely popular in the late sixteenth century and throughout the seventeenth.[65] In the prefaces to these lavishly illustrated volumes the same lofty claims as those of Cesariano and Barbaro on the intellectual dimension and nobility of the study of machines continuously resonate. However, these claims are seldom matched by the contents of these works, which present a sample of images of machines reflecting the Baroque taste for all things curious, surprising, and exaggeratedly complicated. The beautiful engravings of the *Theatres of machines* display Herculean, redundant contrivances, intricately assembled so as to provoke astonishment (Figure 98).[66] The authors introduce readers to a universe of "artificious" (*artificiose*) machines, thus defined in the frontispiece of the volume targeted at the international market by one of the genre's most successful authors, Agostino Ramelli.[67]

FIG. 98 Agostino Ramelli: intricate pump mechanisms.

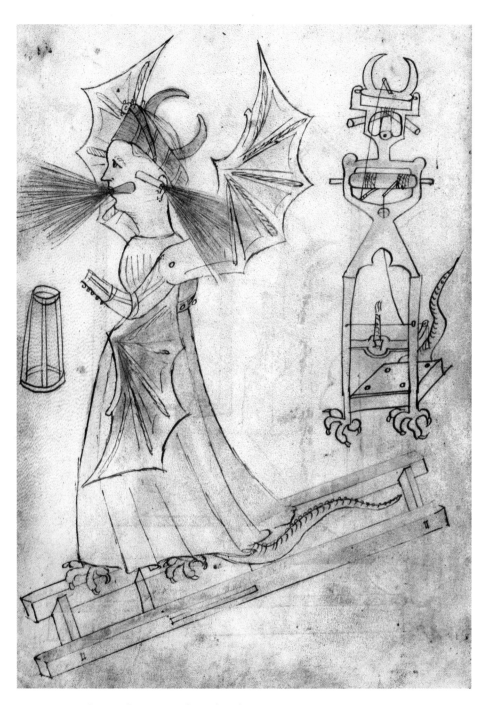

FIG. 99 Giovanni Fontana: mechanical witch.

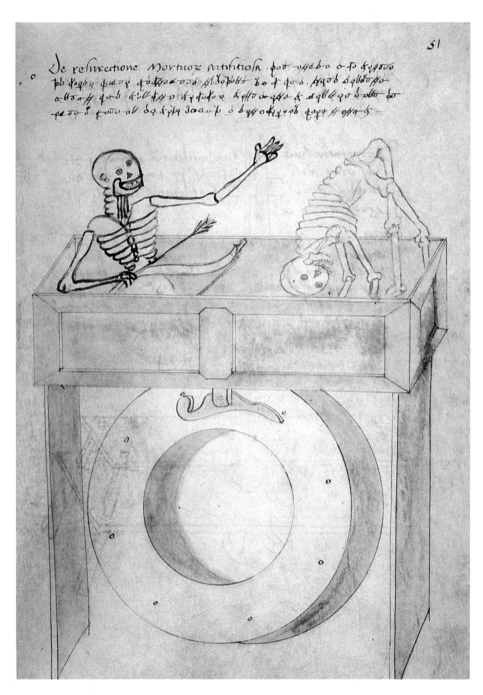

FIG. 100 Giovanni Fontana: skeleton rising from the tomb.

Those machines were no less *artificiose* than much of the artistic, architectural, and literary production of the early seventeenth century, unscathed by the contemporary explosion of mathematical rationality that, thanks to the protagonists of the Scientific Revolution, would produce in a few decades a radical renewal of knowledge of nature and of man.

The *Theaters of machines* reflect and amplify the image of the Renaissance engineer as author of unbelievable and almost miraculous achievements—think of Fontana's eerie witch (Figure 99)[68] and skeleton rising from the grave (Figure 100),[69] or Aristotele Fioravanti's displacement of brick towers—equated with the most astonishing exploits of natural magicians.

A group of Jesuit Fathers engaged in defending the traditional architecture of knowledge from the challenges launched by the Scientific Revolution contributed to keeping fascination with the baroque contrivances of the *Theaters of machines* alive well beyond the mid-seventeenth century.[70] Father Athanasius Kircher, a leading figure of the Society of Jesus, was the promoter of a museum filled with amazing inventions and the author of many large volumes packed with beautiful illustrations and introduced by spectacular frontispieces featuring carefully crafted and subtly allusive images.[71]

The production of Kaspar Schott, a student of Kircher, was no less impressive.[72] Readers could not fail to be struck by the dense sequences of "iconisms" (as he defined the illustrations) in his works that depicted wondrous phenomena, machines, and experiments of enthralling complexity. Schott deliberately avoided explaining the processes through which they were generated by using elliptical and unconventional terminology—proof, in itself, of the quest for the exceptional and the curious that characterized the intellectual horizon of the Jesuit Fathers. The illustrations in Kircher's treatises and Schott's iconisms offered the reader a universe of singular effects and inventions. They included mechanical-organic machines,[73] sometimes nonchalantly cruel, such as the musical organ fitted with needle-tipped keys and filled with cats (Figure 101). When pressed, the keys injured the cats, whose caterwauling generated a variety of harmonies.[74]

The world depicted by Schott was a world of domesticated magic, aimed at entrusting the Jesuit Fathers with the exclusive task of explaining

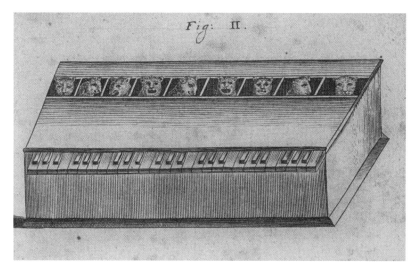

FIG. 101 Kaspar Schott: mechanical-organic organ.

to the reader what was true and what was false, how to distinguish legitimate or even pious natural magic from demonic magic, or the ordinary operations of nature from the supernatural interventions of the hand of God.[75]

The identification of the Renaissance engineer with the natural magician was based on the belief—whose origins date back to oldest antiquity—that art can, by deceit, force nature to perform actions outside of its ordinary course. The stunning success of the leading protagonists of the Renaissance of machines helped to revive that belief. Hydraulic-pneumatic contraptions (Figure 102),[76] perpetual-motion machines, mills turning in dead water, automatons imitating human and animal movements, sophisticated astronomical clocks reproducing and forecasting with admirable accuracy the motions of the heavenly spheres—all these devices proved that human ingenuity could rival nature and even free it from the iron rules that govern its operations.

Not coincidentally, the engineers responsible for the most remarkable achievements were often compared to the mythical or real protagonists of the most spectacular technical enterprises of classical antiquity—not only Daedalus (of whom Brunelleschi was regarded as a reincarnation) but also Archytas and Archimedes.

FONS PULCHER sufficit vndas

MECHANICA
HYDRAVLICOPNEVMATICA
Ad Eminentiss:S.R.I.Principem
Ioannem Philippum
ElectoremMogunt:
Auctore
P. GASPARE SCHOTTO.
Soc:Iesu

FIG. 102 Hydraulic devices in frontispiece of Father Schott's treatise.

Mechanics Resuscitated from the "Deep Darkness"

Although informed by radically different motivations and purposes, the astonishing devices of the *Theaters of machines* and Father Schott's *Iconisms* were to coexist with the impetuous explosion of rationality that characterized the affirmation of the new mathematical science of mechanics.[77]

The exponents of this cultural movement—the so-called "restorers of ancient mathematics and mechanics"—included, among others, Francesco Maurolico, Federico Commandino, Niccolò Tartaglia, Francesco Barozzi, Giovan Battista Benedetti, Guidobaldo dal Monte, Alessandro Piccolomini, Bernardino Baldi, as well as Alessandro Giorgi and Giovanni Battista Aleotti, up to Galileo. Their writings are replete with emphatic pronouncements on the nobility of mechanics, based on its rigorous mathematical structure. They drew a clear distinction between the theoretical definition and mastery of the universal principles and the practical activities depending exclusively on experience.

Drawing inspiration from the Archimedean model, research in mechanics took an increasingly abstract direction.[78] These new authors no longer built machines. Nor did they aspire to recognition as authors of innovative contrivances. Moreover, they seldom depicted machines, preferring to provide geometric diagrams of their elementary mechanisms. Their efforts focused on identifying the general laws governing the operation of machines, on establishing their perfect proportions, and on calculating their performance by means of strictly quantitative analyses. They proudly asserted that no craftsman could operate efficiently without knowledge of mechanical principles.

This new generation of scholars did not take up Leonardo's invitation to dedicate themselves to the foundation of a rigorous mathematical science that took into account the many factors of disturbance at work in the real world. Nor did they follow his innovative analysis of elementary mechanisms, which he regarded not as geometric abstractions but as physical entities. The restorers of ancient mathematics identified the basic elements of mechanics with the five simple machines. This choice was not only aimed at reducing the number of common principles of all machines. It also met the requirement of substituting the immac-

ulate magnitudes of geometry for the irregularities and imperfections of material mechanisms.

The leading figures—who were both learned philologists and highly proficient in mathematics—applied their expertise to restoring to mechanics the status of scientific discipline that it had enjoyed in the classical world. Unsurprisingly, therefore, they devoted considerable energy to the retrieval, translation, and interpretation of texts on mechanics by classical authors, particularly the Greeks, concentrating their efforts on the pseudo-Aristotelian *Mechanical Questions,* Hero's treatises on pneumatics, and, above all, the works of Archimedes. These long-forgotten ancient texts made a triumphal comeback, restored in their original language, translated into Latin and the vernacular, and carefully paraphrased and commented on.

The restorers of ancient mechanics regarded their undertakings as perfectly attuned to the ideals that animated the entire humanistic movement. This emerges clearly in the work of one of the protagonists of this cultural movement, Filippo Pigafetta, who explicitly proclaimed that the effort to resurrect that long-forgotten knowledge was by no means a marginal aspect of the *studia humanitatis:*

> The noblest arts and doctrines, such as *le belle lettere* called humanities, Philosophy, Medicine, Astrology, Arithmetic with Music, Geometry, Architecture, Sculpture, Painting, along with many others, *and especially Mechanics,* seem, for some time now, to have been resuscitated from the deep darkness where they lay buried and brought back into the bright light.[79]

Shortly afterward, Alessandro Piccolomini, in the preface to his *Paraphrasis* of the pseudo-Aristotelian *Mechanical Questions,*[80] remarked that the restorers of classical mechanics had made the unbridgeable gap between those who master the mathematical science of mechanics and those who acquire their skills through practice alone abundantly clear. The latter, he stated,

> operate and build with subtle inventiveness a fine machine,
> but then—because they lack the second part of their science,

which Vitruvius calls *ratiocinatione*—cannot provide any rationale for it. This goes against the precept of Aristotle, who says that it is not enough to state one's opinion, but that one must support it with proofs and demonstrations.[81]

In Piccolomini's view, the clear-cut distinction between those who mastered the principles of mechanics and practitioners also implied membership of a different social class: "I call mechanical sciences those from which one can derive the causes and principles of many practical arts, improperly called mechanical, because they should instead be called manual, sedentary or purely aimed at profit."[82]

Echoing Filippo Pigafetta's definition of the science of mechanics as a discipline suitable only "for a worthy and refined person,"[83] Piccolomini stated that the work performed by practitioners is useful rather than honest.[84]

One of the most influential restorers of classical mathematics and mechanics, Guidobaldo dal Monte, from Pesaro, took as a key reference the *Equilibrium of planes* by Archimedes, of which he produced a learned *Paraphrasis*.[85] In the opening statements of his treatise, Archimedes informed the reader that he would develop his demonstrations on plane figures assuming them to be endowed with weight. On the basis of these figures, the Syracusan mathematician defined the functions and properties of the center of gravity—the fundamental principle to establish the conditions of equilibrium of weights in mechanical systems. To bridge the gap between the abstract Archimedean model and the operations performed by craftsmen and engineers on material bodies, another leading restorer of ancient mechanics, Federico Commandino, greatly admired by Guidobaldo, extended to solids the Archimedean analysis of the centers of gravity of plane figures.[86]

While clearly distinguishing knowledge of the principles of mechanics from operations performed solely on the basis of practice and experience, Guidobaldo had no intention of rigidly separating the two approaches and, much less, of opposing them. His purpose was to demonstrate that an understanding of the general principles of mechanics was necessary to successfully perform practical activity. Not coincidentally, Filippo Pigafetta—translator and commentator of Guidobaldo's *Mechan-*

icorum liber[87]—emphasized, right from the frontispiece, that the work was intended for "captains of war, engineers, architects, and all technicians who aim, through machines, to produce marvelous and near-supernatural works."[88]

As we noted when examining Leonardo's attitude to the theorems of the science of weights, the abstract Archimedean method of demonstration proved incomprehensible and of doubtful value to practitioners. Indeed, nature offers no examples of plane surfaces endowed with gravity, centers of equilibrium coinciding with a geometric point, or bodies possessing perfectly regular shapes and a homogeneous structure. Guidobaldo was keen to stress that Archimedean mechanics did not describe a world apart. On the contrary, an understanding of its principles would help practitioners to avoid errors that could jeopardize their professional reputation.

He elaborated his defense of the Archimedean method of analysis in the final paragraph of the *Praefatio* to his *Paraphrasis,* significantly entitled *De scopo horum librorum* (On the goal of these books).[89] He admitted that Archimedes's demonstrations might seem, at first sight, totally disconnected from reality, and conceded that there are no two-dimensional surfaces in nature, not to mention two-dimensional surfaces endowed with weight.[90] However—he added—nothing prevents us from conceiving them in our imagination and then applying our ingenuity to determining, through rigorous demonstrations, their center of gravity, and its properties. He regarded such an operation as legitimate not only on an abstract level. Indeed, Archimedes's model was extremely useful in determinating the centers of gravity of material bodies.[91]

That was precisely the purpose of the *Paraphrasis:* to turn the Archimedean theorems, based on rationally plausible but abstract assumptions, into a rigorous science of the equilibrium of weights that would provide valuable guidance to practitioners, certifying the quality of their work and ensuring that their efforts yielded reliable results.

The key function assigned to the principles established by analyzing geometrical magnitudes explains why the images of machines that filled the manuscripts of Renaissance engineers and the lavishly illustrated *Theaters of machines* disappeared from the books by the restorers of ancient mechanics. One would search in vain for drawings of machines in

Guidobaldo's *Mechanicorum liber* or in his *Paraphrasis* of the Archimedean treatise on the equilibrium of planes. His works display numerous geometrical figures that visualize the properties and functions of the five simple machines. We have come a long way not only from the realistic portraits of machines and mechanical systems that continued to enjoy a wide circulation at the time but also from Leonardo's efforts to reduce the infinite variety of mechanical devices to a limited number of elementary mechanisms subject to wear and tear.

The toughest challenge facing Guidobaldo and his colleagues was to demonstrate that the revisited Archimedean mechanics was indeed a fundamental instrument for optimizing the operations performed by practitioners. He spared no efforts to produce tangible evidence of the truth of this paradigm.

An eloquent example is offered by the time and energy devoted to the construction of a material balance to demonstrate that the behavior of bodies in the real world is governed by the universal laws of geometrical mechanics. The instrument (a balance with equal arms and weights that, when suspended exactly from its center of gravity, remained stable regardless of its inclination) would be used to dispel the skepticism of those who considered the principle of indifferent equilibrium as an abstraction impossible to transpose to physical bodies.[92]

Having succeeded in manufacturing a balance equiponderant in any position, Guidobaldo hastened to recommend to Filippo Pigafetta that he insert the news in his vernacular translation in progress of the *Mechanicorum liber*.[93] He sought to make the most of a proof that he saw as crucial for crediting the thesis that all mechanical operations had a theoretical matrix. He therefore personally wrote the text on the balance of indifferent equilibrium,[94] a hybrid object that symbolized the embodiment of the laws and abstract figures of geometry. To give maximum credibility to his account, he instructed Pigafetta to mention the authoritative testimony of a learned patrician, Giovan Francesco Pinelli, who had personally verified the instrument's performance: "I suggest that you write that you had seen that balance at the home of Signor Pinelli, so that people would not believe that it was a fantasy impossible to manufacture or put into practice; and if, by chance, the balance I sent were broken, I shall send you one whenever you want."[95]

Can Art Challenge Nature?

Guidobaldo issued peremptory judgments on those technicians who claimed to have designed and built machines capable of performing miraculous feats, to the point of violating the ordinary course of nature. In his successful works of commentary, revision, and interpretation of the pseudo-Aristotelian *Mechanical Questions* and, above all, of the works of Archimedes, he repeatedly stated that all mechanical operations, even the most astonishing, are based on the imitation of natural processes and on a knowledge of their underlying causes. In no way could the art of mechanics evade the inviolable laws of nature. Admittedly, with the aid of machines, man could lift weights far heavier than those that he could raise with his force alone. However, these operations were achieved by means of technical solutions fully compliant with the universal principles that govern nature. Such solutions, Guidobaldo explained, consist merely in assembling and arranging material objects in such a way as to generate effects that, while not observed in nature, should not be regarded as outside the order of nature, which, if it so wished, would be perfectly capable of producing them.[96] While condemning the hubris of those who claimed to transcend the limits of nature, he conceded that practical mechanics addresses nature creatively, bending its principles for the convenience and benefit of man.[97]

A few years later, a young professor of mathematics at the Paduan Studio, Galileo Galilei, intervened in the lively discussions on the relationship between art and nature. An attentive reader of the works of the restorers of ancient mechanics and of Guidobaldo, Galileo used far less accommodating tones to dispel the paralogisms of those who claimed to be able to fool nature with art. In the opening section of the second draft of his treatise on mechanics, most probably written in the mid-1590s,[98] he drew a sharp distinction between the technicians who, conscious of the rules governing the operations of nature, applied their know-how to finding the best solutions to concrete problems, and those who boasted unattainable achievements with their machines: "I have seen all mechanics delude themselves by wanting to accomplish many operations impossible by nature with their machines, whose performance was disappointing; while others [those who commissioned the work] were deprived

of the hopes they had conceived based on their promises [i.e., those of the mechanics]."[99]

These letdowns were due to the misleading assumption that with machines man could deceive "nature, whose instinct or, to put it better, constitutive principle is that no resistance can be overcome by a force that is not greater than it."[100]

Galileo recognized that machines produce important benefits. However, when analyzed attentively, their operations do not appear miraculous, or against nature; on the contrary, they are fully consistent with the laws that regulate its operations. When man raises or moves heavy weights using machines, he applies his own force for much longer than if he could raise or move them himself. Thus, what is gained by mechanical devices is offset by the loss of time and the increase in the space traveled by the force. The advantage offered by machines is simply that they make it possible to move or raise, in a single operation, a weight too heavy for a man's strength. He would have to divide the weight into several parts and carry them one by one to their destination. In this way, and in an equal amount of time, he would obtain the same result as with machines.[101] Machines, therefore, do not achieve miracles, nor do they violate the laws of nature.

With this peremptory conclusion, Galileo formulated, for the first time, a key principle of mechanics, known as the conservation principle: there does not exist, nor will there ever exist, the possibility of moving "with lesser force" a "greater resistance" with the same velocity and therefore in the same time. Such an operation would be "outside the constitution of nature," hence "impossible to perform with whatever machine that has ever been or that can be imagined."[102]

Only by stripping ourselves of the illusion that we can surpass the operations of nature with art can we appreciate the many advantages of employing machines: lifting a heavy weight; pumping water from ship hulls, where buckets are useless when the water level is too low; sparing man from toil by harnessing, through ingenious mechanical solutions, horsepower, or the natural energy of rivers and wind. Such are the great benefits provided by machines, not those that "engineers with poor understanding [of the universal rules of mechanics] dream up, while they

seek to tackle impossible enterprises, with the consequence of deceiving so many princes and losing their reputation."[103] The reference to the cheating of princes shows that Galileo had in mind those engineers who offer powerful leaders fanciful solutions for civil and military use, which invariably fail to meet expectations.

Unlike Guidobaldo, who had endeavored to reconcile Aristotle and Archimedes, Galileo saw the teachings of the Syracusan mathematician as totally incompatible with Aristotle's interpretation of natural phenomena, and, in particular, with his theory of motion. Justly celebrated above all as a key figure in the conceptual revolution that led to the emergence of modern science, Galileo displayed a lifelong interest in technical matters, successfully designing and building innovative calculation, measurement, and observation instruments:[104] the *bilancetta* ("small balance"),[105] the thermoscope,[106] the pendulum clock, and the geometrical-military compass[107]—not to mention his fundamental improvements to the telescope and microscope.[108]

In the employ of the Most Serene Republic of Venice for almost two decades and then of the Grand Duke of Tuscany, Galileo was often asked to examine and assess proposals for machines and technical solutions submitted by craftsmen who boasted their unrivaled performance. Moreover, in the early years of his stay in Padua as professor of mathematics in the local university, he applied to the authorities of the Republic of Venice for a patent for a device that drew water from a well delivering it simultaneously to twenty spouts.[109]

When examining the remarkable variety of issues in applied mechanics addressed by Galileo during his long career, a characteristic common feature emerges. He repeatedly denounced the superficial and deceitful approach of technicians who lacked mathematical learning. Their serious errors and fallacious claims were due to their ignorance of the universal principles that govern all mechanical operations. Had they been aware of those principles, they would no longer have deluded themselves or others that they could outdo nature with their art. For concrete results, technicians had to learn the grammar and syntax used by nature in producing its effects. That grammar and syntax, as Galileo stated in a famous passage of *The Assayer,* are based on the figures and rules of

geometry.[110] Ignoring this paradigm, mechanical work was doomed almost inevitably to failure, and to seriously tarnishing the image of a discipline of highly noble origin and extreme utility.

This message was conveyed by Galileo in his reply to a question from Iacopo Contarini, Superintendent of the Venice Arsenal, on the optimal arrangement of the deck of the oarsmen on the large Venetian galleys to fully exploit their energy.[111] He repeated it in the opening pages of the first *Day* of the *Two New Sciences*,[112] where he expressed his reservations regarding the methods of the Venetian Arsenal's skilled workmen, the famed *proti*. Gifted with consummate practical expertise but lacking mathematical learning, the *proti* determined empirically by how much the dimensions of a galley's load-bearing structures should be increased when doubling the length of the ship. Being unable to accurately calculate the increments required to obtain the same resistance to structural collapse as in the smaller galley, they overestimated their scale, wasting materials and adding useless weight that made the vessel harder to maneuver.[113]

While the opening pages of the *Two New Sciences* have been the object of many in-depth studies, less attention has been paid to a series of texts—never published in his lifetime—in which Galileo assessed the effectiveness of devices conceived by inventors who made much of their performance. These short writings document his efforts to expose the errors and deceptiveness of mechanical solutions designed by improvised inventors, ignorant of the universal principles that govern the relationship between force and resistance.

One of these severe assessments, presented in the form of a brief dialogue between Salviati and Simplicio, dates in all likelihood to the period after the publication of the *Two New Sciences*, when Galileo was planning to publish a revised and expanded edition of the work.[114] With pungent irony, Salviati refers to he who "is such a simpleton *(semplice)*"—note the deliberate ambiguity between *semplice* and Simplicio, Salviati's interlocutor and a keen defender of Aristotle—

> that he wants to use pumps to raise so much water that when
> it falls it will drive a mill, which could not be driven by the
> force he applies to raise the water; can you possibly believe
> that you can obtain from the water more force than the force

you have imparted to it? Is it possible that you don't under-
stand that the force that sufficed to raise the water will
suffice to move the grindstone?[115]

A note by Vincenzo Viviani, Galileo's last disciple, who inherited
his papers, identifies in two "truly ingenious Florentine practitioners"
the targets of this polemical attack.[116] Their miraculous device was a
recirculation mill, of which many variants are described in the manu-
scripts of Renaissance engineers—particularly in those of Francesco di
Giorgio[117]—and in the *Theaters of machines*. For Salviati-Galileo, there is no
point in using such a highly complex mechanical architecture for an op-
eration that can be achieved in the same time, and without loss of power
due to friction, by raising the water manually with a bucket. His harsh
judgment on superfluously elaborate machines designed to impress pa-
trons by technicians who lack mathematical knowledge recalls the witty
gloss by an anonymous reader on a sheet of Francesco di Giorgio's *Opus-
culum de architectura* depicting an extremely complicated machine for
drawing water from a well: "it does not take as much force to lift a mere
bucket of water."[118]

Galileo adopted a similar position in his reply to a request from the
Grand Duke of Tuscany for an opinion on the model of a machine to raise
weights or large quantities of water, powered by the oscillations of a heavy
pendulum. His report, which has survived in three different drafts, il-
lustrates his effective three-step strategy for refuting the proposal of
the anonymous engineer.[119] As in countless other cases, he begins by
welcoming his arguments—indeed, he cleverly builds them up. Next, in
measured tones, he expresses some minor reservations. Then, through rig-
orous reasoning, he demolishes the proposal by ruthlessly exposing its
weakness.

In the assessment in question, after stating his unconditional admi-
ration for the extraordinary invention, Galileo introduces the opinion of
those who claim that nature cannot be "deceived by art" without explic-
itly subscribing to it.[120] He then begins advancing arguments that seem
to lend some credit to that principle, up to the point where he outlines a
conceptually and literarily brilliant argument to prove that the impos-
sibility of overcoming the operations of nature with art is an inviolable

and universal law. We are surprised—Galileo remarks—and imagine that we have managed to transcend nature with art when, applying a counterweight of just ten pounds to the balance, we level the scales or even lift a bale weighing over a thousand pounds. Does this not prove—he continues—that it is possible, "using art, to overcome a huge resistance with a very small force?"[121] After elaborating on his interlocutor's reasoning, he strikes a deadly blow: "From these same experiments, I shall argue the exact opposite."[122] While we are amazed that the small weight lifts a very heavy bale, or that the force of a single man operating a hoist is sufficient to raise a 3,000-pound stone, we should be no less amazed if, reversing the perspective, we were to note that a 1,000-pound bale cannot lift the 10-pound weight, or that the 3,000-pound stone cannot overcome the resistance of a man whose strength does not exceed 100 pounds. Galileo's conclusion is peremptory: "as to the production of force, art gains nothing against nature's resistance."[123]

The opposite belief is based on a superficial observation of the processes that occur when using mechanical instruments: "a thousand times a day we use the weight to lift and weigh bales of merchandise, and manpower to pull very heavy stones uphill; while we seldom use bales of merchandise to lift weights, or stones to push men back."[124]

If we focus not on the action of the weight and man but on that of the bales of merchandise and stones, we realize that art does not win over nature.

To reaffirm the notion that what is gained in force with machines is offset by the time lost in performing the operation—he defines it as "idle time" *(tempo ozioso)*—Galileo converts the material model of the pendulum-driven machine submitted by the anonymous "inventor" into a geometric diagram that provides "a clearer explanation of my concept."[125] The drawing (Figure 103) transfigures the inventor's model, stripping it of its rhetorical, redundant trappings and reducing it to the skeletal bareness of its working principles. We intuitively grasp the strictly mathematical matrix of these principles, based on the properties of simple machines: the lever, the circle, and the balance. Illustrating the rational physiology of this system with a diagram, Galileo exposes the flaws in the arguments of the incautious inventor—who, like so many of his colleagues, was misled by his lack of mathematical understanding and ig-

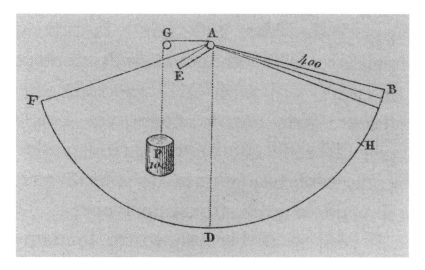

FIG. 103 Galileo Galilei: geometrical diagram of functioning of pendulum-driven lifting device.

norance of the laws governing mechanical operations. The conversion of the physical model into a geometric diagram reproduces the mental process that enables us to express an objective assessment of its effective potential without even having to conduct empirical tests.

A later technical assessment by Galileo, almost certainly at the request of the Grand Duke of Tuscany, is also relevant to our analysis. It concerns a machine for pounding charcoal and saltpeter submitted by an unidentified author, who, like his predecessor, made extravagant claims about his invention's performance.[126] The output of his sixteen-piston mill operated by one man—he boasted—would vastly exceed that of systems with one or two pistons generally in use.

This time Galileo goes straight to the heart of the issue. Mechanics—he writes—is a highly useful art, provided, however, that its contrivances have been designed and validated by "professors fully cognizant of the science of machines."[127] The inventor of the sixteen-piston mill does not belong to that category because he lacks the "mathematical principles, which demonstrate the intrinsic nature of the basic and simple instruments from which all machines are composed."[128]

The demolition of the claims of the incautious inventor rests, as usual, on the paradigm of the impossibility of outdoing nature with art.

True to form, Galileo debunks the inventor's unfounded expectations in a sentence of blinding clarity:

> the inventor should realize that the amount of work pro-
> duced [by pounding machines] does not depend on the
> number of pistons, but on the frequency of strokes; because a
> single piston will produce as much work as a thousand,
> whenever the single one delivers one thousand strokes in the
> same time as each of the thousand will deliver one stroke.[129]

To demonstrate that his sixteen-piston mill does four times the work of the machine with only four,

> [the inventor] must show me that in the same time as the
> other [machine] delivers one stroke for each of its four
> pistons, his own [machine] will deliver one stroke for each of
> its sixteen; which is the same as saying that in the time that
> the small wheel operating the four-piston machine makes a
> full turn, so will the large [wheel operating his sixteen-piston
> machine].[130]

In actual fact, that is impossible. When the same force is applied to two wheels of different diameter and weight operating a shaft fitted with a different number of cams, the time to complete a full rotation of the larger wheel will be longer. Indeed, because of the greater friction, the larger wheel driving the sixteen pistons will produce "an entirely different effect"[131] than what its inventor expected.

Galileo's demolition of the pendulum machine for raising water or heavy weights, and his severe verdict on the multi-piston mill, show how he distances himself from the Renaissance engineers who, while often illustrating such devices in their manuscripts, never seem to realize that, with equal force, the multiplication of pistons does not increase efficiency.[132] The multi-piston mill for pounding charcoal and saltpeter also appears in many of the *Theaters of machines,* such as Vittorio Zonca's *Novo Trattato* (Figure 104), printed in Padua in 1609—a text with which it is hard to imagine that Galileo was not familiar. The apparatus designed and described by Zonca features two camshafts driving twelve pistons.[133]

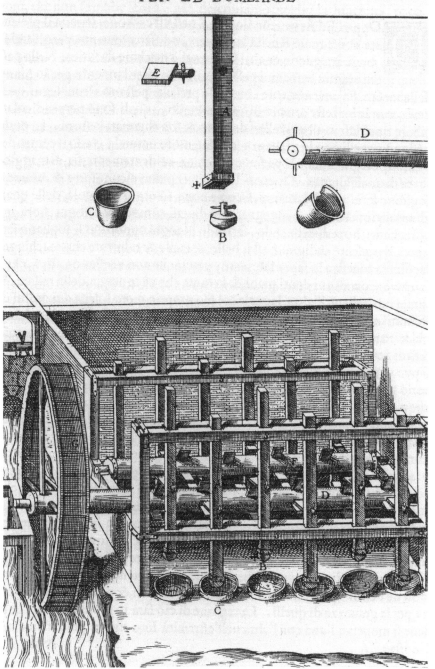

FIG. 104 Vittorio Zonca: gunpowder mill.

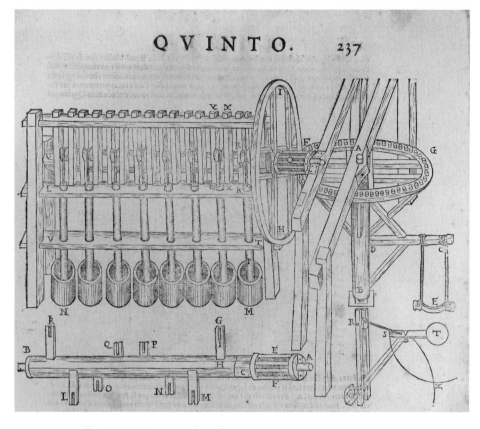

FIG. 105 Bonaiuto Lorini: gunpowder mill.

In another text certainly known to Galileo—the treatise on fortifications by Bonaiuto Lorini, who was born in Florence but settled in Venice—we find a different type of gunpowder mill (Figure 105), whose camshaft operates eight pistons striking in sequence.[134]

Although he never mentions the authors of the *Theaters of machines,* Galileo takes great pleasure in demonstrating the weakness and unfeasibility of the proposals contained in this vast editorial production, successfully marketed among courts and rulers across Europe. His severe judgements on those "museums on paper," which celebrated man's ancient dream of becoming the lord of nature, and his tone in voicing them, reveal not only his intellectual annoyance at their lack of principles and of robust demonstrations; they also show his yearning for recognition by

the powerful of the far more concrete and promising practical prospects offered by his rigorous mathematical analysis of the universal principles of mechanics.

"A Purely Imagined and Abstract Matter"[135]

In the first two *Days* of his *Two New Sciences*,[136] Galileo illustrated through rigorous geometrical demonstrations the most advanced results of his efforts to elucidate the universal principles governing mechanical operations, focusing in particular on the conclusions he had reached in his investigations on the resistance of materials.

Having underscored the limitations of the workmen at the Venice Arsenal, whose operating skills were based solely on practice, Galileo proposed a series of general principles and brilliant demonstrations to convince readers that, ignoring those principles, all mechanical operations were doomed to fail or to produce results that would not match expectations or the investment in materials and in human capital.

The first two *Days* of the *Two New Sciences* were well received by scholars throughout Europe. However, they also elicited lively manifestations of dissent—prompted, above all, by skepticism on whether the abstract mathematical rules formulated by Galileo could effectively account for the behavior of material bodies.

The animated debate over Galileo's laws of the resistance of materials began even before the *Two New Sciences* were published. With the author's consent, the manuscript draft of the first two *Days* was submitted for prior review to a few readers. The manuscript was circulated by the Servite Friar Fulgenzio Micanzio—a follower of Fra' Paolo Sarpi—who had maintained a relationship of esteem and friendship with Galileo for many years. Through this Venetian channel, in March 1635, the manuscript draft of the first two *Days* also ended up, albeit for only a single day, in the hands of a talented French engineer, Antoine de Ville,[137] an expert mainly in military fortifications, who had been working for the Venetian Republic for years.[138] He had been following Galileo's work for some time and had been greatly impressed by the *Dialogue concerning the two chief Systems of the World.* Indeed, his reading of that work had made him a supporter of the Copernican system.[139] De Ville did not disguise his contempt

for the verbose culture of Aristotle's followers, which he saw as completely detached from reality. He severely criticized the Jesuits, in particular, as stubborn champions of Aristotelian ideas.[140] His animosity toward the Fathers of the Society of Jesus helps us to understand his close bond with Fulgenzio Micanzio, a sworn enemy—like his master Sarpi—of the followers of the rule of St. Ignatius.

De Ville appreciated Galileo's method of using rigorous mathematical demonstrations to establish universal conclusions, verifying their validity by means of experiments performed on material bodies.[141] The French engineer had fully embraced the guiding principle of the *sensata esperienza* (that is, experience validated by reason), an expression often used by Galileo. Moreover, he was a sincere admirer of Galileo and fully supportive of his battle for the radical renewal of Aristotelian natural philosophy. However, de Ville was an independent thinker, instinctively inclined to verify on a practical level the conclusions reached by the author of the *Two New Sciences* through ingenious mathematical reasoning and demonstrations. The few hours passed in reading the manuscript of the first two *Days* were not idly spent. The letter he sent to Galileo on March 3, 1635, shows that he had examined those pages attentively.

From our standpoint, de Ville's opinion is of special value. Thus far, we have analyzed the Tuscan scientist's harsh judgments on the proposals of practically minded technicians. Reversing the perspective, we can now hear the opinion of an engineer who was anything but ignorant of Galileo's theoretical conclusions and, above all, of their potential contribution to improving operations performed on material bodies.

While reiterating his admiration for Galileo, de Ville explicitly voiced his disagreement. The first two *Days* did not convince him—not at all! He could not accept the author's contention that theoretical principles established by abstract geometrical investigations should form the basis for applied activities.

This was not a minor objection, for it was aimed at the very core of the fundamental paradigm that supported the entire argumentative and demonstrative architecture developed by Galileo, and not only in the *Two New Sciences*. For de Ville, one cannot lend any credence to rules formulated by systematically excluding the impediments of matter and the irregularities of the bodies of the real world. In the *Two New Sciences*—de

Ville remarks—Galileo attributes homogeneous properties and characteristics to matter. But reality cannot be reduced to that model. A science of mechanics that ignores the variations and imperfections of matter is a purely abstract construct of no practical value whatever. If we take into account the imperfections and infinite structural diversity of material bodies, we cannot escape the conclusion that it is impossible to establish a rigorous, universal science of the resistance of materials. There are no rules, nor will there ever be, that apply to all substances, or even to substances belonging to the same species:

> The wood of the white poplar will differ in its effects from oak, and oak from boxwood; and, in boxwood, the root will differ from the trunk, and the trunk from the branches . . . ; then, the same [wood] cut on one side will not have the same effect as when cut on another; cut in the fall different from the spring; in damp weather it will be tighter than in dry weather: then [one should also take into account] the knots, the veins . . . , whether it is old or new, how it is polished, filed down . . . and a thousand irregularities that one encounters constantly. How can one ever possibly give a firm rule on these matters?[142]

Through abstract mathematical analyses, Galileo had explained why machines that operate effectively when of modest dimensions become fragile or even collapse under their weight when their size is significantly increased, even if all their components are proportionally scaled. For de Ville, this phenomenon—familiar to engineers since antiquity as well as to the *proti* of the Venice Arsenal—does not depend on the theoretical foundations elaborated by Galileo. It is due precisely to those imperfections of matter that he has excluded from his inquiry. Galileo's matter—de Ville continues—is "a purely imagined and abstract matter," as is that of "cubes, cylinders, etc. in geometrical demonstrations." But where, he concludes in an abrupt manner, "does one find such matter?"[143] The mind can abstract from the accidents and imperfections of matter, but "art will never be able to precisely reproduce the models conceived by the mind."[144]

De Ville could not have distanced himself more sharply. They diverged—he stressed—not only on principles, but also on the meaning

assigned to the same terms: "you do not want one to say what has been commonly said until now; because as we well know a circle of ink is not a perfect circle, nevertheless, no one has stopped calling it a circle; and the same goes for other things, which, being material, are never perfect."[145]

The French engineer's severe critique did not stop here. He also took issue with Galileo's proposed method for measuring the force of the vacuum,[146] and his subtle interpretation, based on the principle of the infinite divisibility of geometrical magnitudes, of the paradoxes of Aristotle's wheel—an ingenious demonstration that he compared to Zeno's paradoxes of motion.[147]

Galileo replied to this volley of criticisms with some embarrassment.[148] He recognized that his science of the resistance of materials was based on the deliberate exclusion of impediments and ignored the structural diversity and irregularities of material bodies. Had he taken these factors into account—on this point, he concurred with de Ville—he would not have been able to establish a rigorous science of the resistance of materials.[149] While expressing himself with calculated ambiguity, he admitted that his rules and the demonstrations on which they were based merely described the behavior "of two solid figures made of the same matter, which are similar but unequal as to their dimension."[150] However, he proudly claimed credit for being the first to demonstrate that when one figure is stretched, "by how much more its thickness must be increased than its length, so that larger figures maintain the same strength as smaller ones."[151] These, he vigorously proclaimed, are the true and universal principles that govern the resistance to breakage of solid bodies when their dimensions are increased. That these universal principles are subject to infinite interferences due to the irregularities of natural bodies in no way diminishes the importance of their contribution to the improvement of practical activity. They make it possible, for example, to calculate with precision in what measure the dimensions of the supporting structures of a galley must be either reduced, or increased, thus permitting a considerable reduction in the overall weight and, consequently, in costs.[152]

The frank discussion with de Ville helps to shed light on the ambiguities in the new Galilean science of the resistance of materials, which formed a complex of prescriptive norms that was met—and would continue

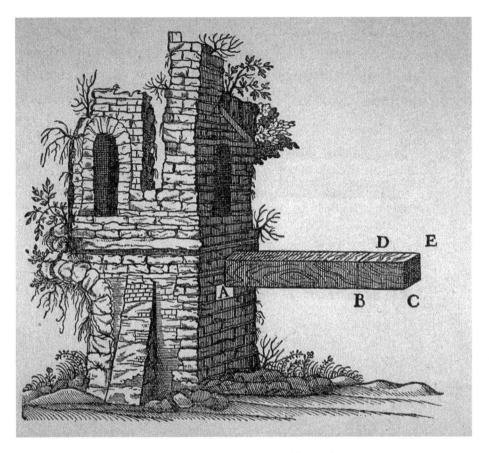

FIG. 106 Galileo Galilei: resistance of a beam supported by a wall.

to be met—with perplexity and skepticism among technicians engaged in practical work. Galileo was fully aware of this delicate implication, even before de Ville had directly pointed it out to him. Ever since his early treatise on mechanics, he had tread carefully along the slippery ridge that divides the abstract rules and principles of geometrical mechanics from the irregularity of natural bodies and the concrete processes of the transformation of matter.

Alarmed by the reaction of one of the first readers of the opening sections of the *Two New Sciences,* Galileo attentively calibrated the terms used in the final draft of his new science of the resistance of materials. He attached great importance to preserving a space for dialogue and

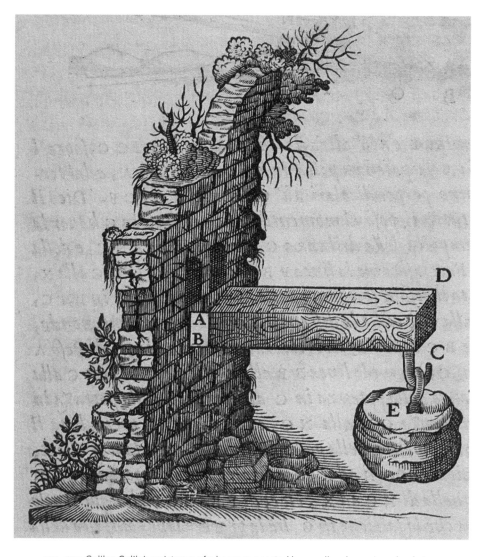

FIG. 107 Galileo Galilei: resistance of a beam supported by a wall and carrying a load at the free end.

constructive confrontation between his method of demonstration and the practical experience of technicians. Not by chance, he placed the opening scene of the *Two New Sciences* on a construction site—indeed, the construction site *par excellence:* the Venice Arsenal. He also designed the iconographic apparatus with deliberate ambiguity. In the first two *Days*

Galileo did not rely only on the immaterial figures of geometry as he had done in his early treatise on mechanics, and in his assessments of the "inventions" of technicians lacking mathematical reasoning. To drive home the message that his theoretical analysis could be directly transferred to the handling of material bodies, he introduced engravings that portrayed scenes of concrete realism, such as that illustrating a beam, clearly made of wood, with one end sealed in a solid stone and brick wall (Figure 106).[153] In another engraving, the realistic effect was made even more striking by an irregularly shaped stone hanging with a strong iron hook from the end of a wooden beam (Figure 107).[154] In these engravings the images of real machines—which had no longer found room in Galileo's mathematical universe, or in that of the restorers of ancient mechanics—finally made a comeback. It was, however, only a fleeting appearance, for in the following pages of the *Two New Sciences,* geometrical figures regained absolute primacy.

In an odd twist of history, a few decades later, the triumphant figures of geometry would meet the same fate as that of the *machinae pictae* at the dawn of the Scientific Revolution. With the advent of algebra and, later, of infinitesimal calculus, and with the ever deeper inroads of these new methods of analysis into the study of mechanics, the abstraction from real machines went far beyond the frontier of geometric schematizations. In the complex equations of analytical mechanics, no reference would be found either to the materiality of machines or to their oliagrammatic representation in the Euclidean space.[155]

Notes

1. Villard de Honnecourt 2009.

2. Guido da Vigevano 1993. Although usually described as a native of Vigevano, Guido was, in all likelihood, born in Pavia.

3. "Intentional" drawings denote images intended to provide a realistic view of the structure and functioning of technical systems—as distinct from drawings of machines produced chiefly for decorative purposes and/or to characterize the setting in which the illustrated episode takes place.

4. I do not know of any exhaustive study on these questions, essential to a critical assessment of the authenticity of illustrations in the oldest known codices containing Greek, Latin, and Arab technical treatises. We should, however, consider Andrea Giardina's observations on the relationship between the illustrations in the fifteenth-century manuscripts of the treatise *De rebus bellicis* and the *picturae* that originally accompanied this anonymous late fourth-century treatise (Anonymous 1989, pp. LIII–V). Also worth noting is Drachmann's comment on the Leyden manuscript of the ninth century containing the Arabic translation of the *Barulkos* of Hero of Alexandria. The eminent Danish scholar demonstrated the substantial interventions in the text and in the figures of the original Greek codex by the Arab translator, or by an earlier copyist (Drachmann 1963, pp. 22–32). On the illustrations of the Leyden manuscript, see also Salvatore Settis (*Machina* 2005, pp. 3–4). Giangiacomo Martines stressed the problematic relationship between the drawings of machines, particularly war machines, in the Byzantine parchment manuscripts (the oldest of which date from the eleventh century) containing the treatise on poliorcetics (siege warfare) by Apollodorus of Damascus (second century CE), and the illustrations originally drawn on papyrus by the great Syrian engineer (La Regina ed., 1999, esp. pp. 95–96).

5. Manuscripts of illustrated texts on technical subjects by ancient authors were regarded as exceptionally valuable—as reflected in Lorenzo Ghiberti's keen interest in a lavishly illustrated Greek manuscript containing the *De machinis et instrumentis bellicis* of Athenaeus (second century BCE). Ghiberti was able to briefly examine this manuscript on siege warfare in 1427 thanks to Ambrogio Traversari, to whom it had been lent by Giovanni Aurispa, who had brought it to Italy after one of his voyages to the East between 1421 and 1423. Three years later, Ghiberti asked Traversari to persuade Aurispa to exchange this document (clearly of great value to Ghiberti) with another ancient manuscript (see Sabbadini 1931, pp. 67 and 69). Aurispa agreed, on condition that he would receive a *Vergilius antiquus*. The deal, however, fell through because Aurispa later negotiated with Traversari the exchange of the Athenaeus manuscript with a Sallust manuscript. Aurispa's codex is in all likelihood the Greek manuscript no. 1164 now in the Vatican Library. The Athenaeus manuscript later passed into the hands of Angelo Colocci. It should be noted that Ghiberti inserted into the preface to the *Commentarii* a free adaptation in the vernacular of Athenaeus's dedication of his treatise to the Consul Marcellus, who, in 212 BCE, led the Roman conquest of Syracuse, the town defended by the mythical war machines invented by Archimedes. On this episode, see Rose 1975, pp. 28–32 and 60 (note 41).

6. On Mariano di Iacopo—whose nickname Taccola ("jackdaw") was probably inspired by his grandfather's aquiline nose—there is a vast literature that will be cited extensively later on in this volume. Here I limit myself to citing the only attempt at a comprehensive biography of the Sienese engineer by Gustina Scaglia and Frank Prager (Prager and Scaglia 1972). The regrettably very scarce surviving documents on Taccola's life and work were first published by James Beck in his edition of Book III of *De Ingeneis* (Mariano di Iacopo 1969, pp. 27–31). New documents were later discovered and published by Giuseppe Chironi (Galluzzi ed., 1991, p. 471).

7. See Kyeser 1967 (with the facsimile reproduction of one of the most important *Bellifortis* manuscripts, now in Göttingen: Cod. Philos. 64) and Long 1997.

8. Kyeser 1967, f. 114v.

9. On Giovanni Fontana, the essential study is still that of Eugenio Battisti and Giuseppa Saccaro del Buffa (Fontana 1984), with the complete edition of the *Bellicorum instrumentorum liber* and other writings by Fontana. See also Clagett 1976 and Prager 1971.

10. See Fontana 1984, p. 278.

11. Ibid., pp. 18–24.

12. See, for instance, the drawing of the articulated ladder (ibid., f. 2r).

13. In the vast literature on Brunelleschi, an essential, albeit dated, study remains that of Eugenio Battisti (Battisti 1975).

14. See the classic study on the life and works of Aristotele Fioravanti by Luca Beltrami, who published many archival documents on the life and works of the Bolognese engineer (Beltrami 1912). See also Tugnoli Pattaro 1976 and Oechslin 1976.

15. The autograph copy of the first two books of *De ingeneis* is in the Bayerische Staatsbibliothek, Munich: CLM 197 (critical edition and facsimile: Mariano di Iacopo 1984a). The third and fourth books of *De ingeneis* are to be found in another autograph manuscript at the Biblioteca Nazionale Centrale, Florence (Mariano di Iacopo 1969).

16. The autograph manuscript of *De machinis* at the Bayerische Staatsbibliothek, Munich (CLM 28800) was published (transcription and facsimile) by Gustina Scaglia (Mariano di Iacopo 1971).

17. Venturi 1815, pp. 12, 14, 18, 19, 21, 23, 42. On the history of the rediscovery of *De machinis,* see Mariano di Iacopo 1971, esp. I, pp. 27–28.

18. Ms. Lat. 7239 Bibliothèque Nationale de France, Paris. See Mariano di Iacopo 1971, pp. 13–14. Next to Santini's signature, Scaglia read *Ducensis,* drawing the conclusion that this unknown figure came from Duccio in Piedmont (ibid., p. 39). In my view, the correct reading is *Lucensis,* i.e., from Lucca. Furthermore, Santini is a common surname in the Lucca area. On the splendidly illuminated Paris manuscript, see Galluzzi ed., 1991, pp. 196–197. Manuscript 7239 was published (transcription and facsimile) by Eberhard Knobloch (Mariano di Iacopo 1984b).

19. See Mariano di Iacopo 1971, I, pp. 37–50.

20. Napoleon III-Favé 1846–1862 (I, p. 39, and III, pp. 112–116).

21. Berthelot 1891, p. 437, and 1900, pp. 289–420.

22. Beck 1899, pp. 271 and 283–293.

23. Thorndike 1955, pp. 7–26.

24. See Gille 1964 and 1972. A few years after the publication of Gille's important study, Paul Lawrence Rose provided a further detailed analysis of Mariano di Iacopo's manuscripts (Rose 1968).

25. Bargagli Petrucci 1906.

26. On the outstanding success of the Sienese machines, see the catalogue of the exhibition *Prima di Leonardo* held in Siena in 1991 (Galluzzi ed., 1991).

27. Prager and Scaglia 1972, pp. XI-XII.

28. Mariano di Iacopo 1984a.

29. Mariano di Iacopo 1971.

30. Mariano di Iacopo 1969.

31. Also worth citing is the catalogue of Taccola's drawings published by Bernhardt Degenhart and Annegrit Schmitt (Degenhart and Schmitt 1982).

32. Francesco di Giorgio 1967.

33. Ms. 197.b.21, British Museum, London. See Galluzzi ed., 1991, p. 203 and Mussini 1993, pp. 377-378.

34. Francesco di Giorgio 1989. See Galluzzi ed., 1991, p. 202 and Michelini Tocci 1962.

35. As shown by the autograph annotations and sketches that Francesco di Giorgio recorded in the manuscript containing the first two books of *De ingeneis* (Mariano di Iacopo 1984a, II, ff. 127r-130v).

36. Francesco di Giorgio 1989.

37. Reti 1963.

38. See Gustina Scaglia's chart of manuscripts derived from Taccola and Francesco di Giorgio (Mariano di Iacopo 1984a, I, p. 162). Later studies have identified other manuscripts directly linked to the tradition of the Sienese machines.

39. See the essay by Daniela Lamberini ("La fortuna delle macchine senesi nel Cinquecento") in the catalogue of the exhibition *Prima di Leonardo* (Galluzzi ed., 1991, pp. 135-146). See also ibid., pp. 218-271.

40. Vasari 1966-1987, III, pp. 383-385.

41. On the relationship between the manuscripts of engineers active between the late fourteenth and early sixteenth centuries and the motives and expectations of rewards and recognition from the patrons to whom they were dedicated, see Long 1997 and McGee 2004, pp. 53-84.

42. See esp. Long 1991, 1997, and 2001.

43. Prager and Scaglia 1972 (esp. §2–5 of chap. II, pp. 34–149). See also Lamberini 2003, McGee 2004, pp. 53–54 and 72–87, Scolari 2005 and Nanni 2013, pp. 135–161.

44. Mariano di Iacopo 1969, f. 1r.

45. See Prager and Scaglia 1972, pp. 14–15; see also Beck 1968.

46. Mariano di Iacopo 1969, f. 1v; see Scaglia 1968 and Prager and Scaglia 1972, pp. 169–174.

47. Mariano di Iacopo 1969, f. 17v.

48. Ibid., f. 42r.

49. Ibid., f. 48r.

50. Ibid., f. 1r.

51. "Incipit liber tertius de ingeneis et edifitiis non usitatis" (ibid., f. 2r).

52. Mariano di Iacopo 1971, II, f. 21r.

53. Ibid., II, f. 14r.

54. Ibid., II, pp. 59–60 (the dedication text, missing in the Munich autograph manuscript, is attested by the copy in the New York Public Library in which Taccola is mentioned as author of the work: Ms. Spencer 136, f. 2r).

55. Ibid., I, p. 81 (f. 13v).

56. Ms. Lat. 7239 of the Bibliothèque Nationale de France, Paris, edited by E. Knobloch (Mariano di Iacopo 1984b).

57. Ibid., f. 1r.

58. McGee 2004, pp. 82ff.

59. For Taccola's relations with humanists active in the Sienese Studium, see Galluzzi ed., 1991, pp. 19–24.

60. In the important copy of *De machinis* dated 1449 (New York Public Library, Ms. Spencer 136) the author is defined as "Marianus Tachola alias Iachobi dictus Archimedis de Senis" (f. 102r). On the New York manuscript, compiled by Eimo de Borsatis, see Gustina Scaglia's observations in Mariano di Iacopo 1971, pp. 35–37, and Mariano di Iacopo 1984b, pp. 9–39.

61. Mariano di Iacopo 1984a, I, p. 125 (f. 96r).

62. Mariano di Iacopo 1984a, II, f. 1r. See the portrait of the astrologer (Fig. 15), whom Taccola regards as vitally important for advising the

military leader on the most favorable moment to declare war in the copy of *De machinis* in the Bibliothèque Nationale de France in Paris (Ms. Lat. 7236, f. 2v); see also Mariano di Iacopo 1984b, pp. 62–63.

63. Mariano di Iacopo 1984a, II, f. 36v. On Taccola's drawing of the man-microcosmos, see Prager and Scaglia 1971, pp. 42 and 167; see also Prager and Scaglia 1972, pp. 167–169.

64. Mariano di Iacopo 1984a, I, p. 46 (f. 11r).

65. Ibid., I, f. 21r.

66. Mariano di Iacopo 1971, I, p. 108 (f. 36v).

67. On the interest in Brunelleschi's machines for the construction site on the part of engineers of later generations and on their graphic representations of them, see Scaglia 1960–1961 and 1966, Reti 1964, Prager and Scaglia 1970 (in particular, pp. 70–84); Galluzzi 1996a, pp. 21–25 and 99–116, and Saalman 1980. For an overview of the contrivances designed and used by Brunelleschi in the various phases of the dome's construction, see Ricci 2014, pp. 143–155.

68. Prager was the first to cite this extraordinary document (Prager 1968), which was later analyzed and contextualized by Scaglia (Scaglia 1981) and in the biography of Taccola by Prager and Scaglia (Prager and Scaglia 1972, pp. 11–13 and 62). The two scholars reexamined the so-called Brunelleschi "interview" in their edition of the first two books of *De ingeneis* (Mariano di Iacopo 1984a, I, pp. 13–15). See also Eugenio Battisti's observations on the document in his biography of Brunelleschi (Battisti 1975, p. 201), and Galluzzi 1991, pp. 19–21.

69. Mariano di Iacopo 1984a, II, p. 134 (f. 107v).

70. Ibid., II, f. 108v.

71. Ibid., I, p. 134 (f. 107v), translation amended.

72. Ibid.

73. Ibid.

74. Ibid., pp. 135–136 (f. 108v).

75. Mariano di Iacopo 1969, p. 144 (f. 15v).

76. Mariano di Iacopo 1984a, II, f. 108v (detail).

77. Ibid., II, f. 30r.

78. Ibid., I, p. 63 (f. 30r), translation amended.

79. Ibid.

80. Ibid., II, f. 31r.

81. Ibid., I, p. 64 (f. 31r), translation amended.

82. Ibid., I, p. 136 (f. 108v).

83. Ibid., II, ff. 108r–110r.

84. Ibid., I, pp. 82–83 (f. 61r).

85. On Taccola's self-attributed inventions, see Prager and Scaglia 1972, pp. 63–65.

86. Mariano di Iacopo 1984a, I, pp. 136–137 (f. 108v).

87. Mariano di Iacopo 1969, ff. 10r and 11r.

88. Leonardo da Vinci, Codex Atlanticus, f. 1083v.

89. Mariano di Iacopo 1971, I, p. 104 (f. 33r).

90. Ibid., I, p. 108 (f. 36v).

91. On the *badalone,* see Prager 1946, Prager and Scaglia 1970, pp. 111–123, Nanni 2011, and Ricci 2014, pp. 197–201.

92. Mariano di Iacopo 1969, ff. 14v–15v.

93. Ibid., p. 144 (f. 15v).

94. Ibid.

95. Prager and Scaglia 1970, pp. 128–129; see also Uzielli 1904. For a detailed reconstruction, based on documentary evidence, of Brunelleschi's role in the project, as well as the causes of the failure of the attempt to flood Lucca, see Benigni and Ruschi 1977 and 2015.

96. Machiavelli mentions the failure of the projects in *Historie fiorentine* (Machiavelli 1532, Book IV, p. 107). For the documents that shed light on the unsuccessful operation, see Benigni and Ruschi 1977.

97. Mariano di Iacopo 1969, II, f. 8v (Ms. Spencer 136, f. 8v).

98. Ibid., I, p. 75 (f. 11v).

99. Mariano di Iacopo 1969, p. 154.

100. Mariano di Iacopo 1971, I, p. 86 (f. 17v), translation amended.

101. Ibid., p. 87 (f. 18r).

102. Mariano di Iacopo 1969, f. 39r.

103. Ibid., ff. 44v–45r.

104. Mariano di Iacopo 1971, II, f. 38v.

105. See, for instance, the gigantic siphon powering the wheel of a watermill (ibid., ff. 29v–30r).

106. Mariano di Iacopo 1971, II, f. 8v.

107. See the diver who helps to raise a column from the seabed in Mariano di Iacopo 1969, f. 18r; see also Mariano di Iacopo 1984a, II, f. 57r.

108. Ibid., f. 36r.

109. Mariano di Iacopo 1971, II, f. 75v.

110. Mariano di Iacopo 1984a, II, f. 21r.

111. Ibid., I, p. 58 (f. 21r).

112. See Prager and Scaglia 1972, pp. 160–167, Kemp 1991, Galluzzi 1993, Long 2004, Popplow 2004. On drawing methods and conventions employed in architectural and technical drawings, see Scolari 2005 (Italian ed.) and 2012 (English ed.); see also Nanni 2013, pp. 135–161.

113. See the roughly foreshortened image of a winch in Mariano di Iacopo 1984a, II, f. 12v.

114. See the clumsy disposition of the cam-driven bellows for a blast furnace in Mariano di Iacopo 1971, II, f. 43v.

115. See the drawing of the assault tower in Guido da Vigevano 1993, c. 52v; see Scolari 2005, esp. pp. 229–283, and Nanni 2013, pp. 135ff.

116. See, for example, Mariano di Iacopo 1984a, II, f. 96v.

117. Mariano di Iacopo 1969, f. 5r.

118. Ibid., f. 29r.

119. Mariano di Iacopo 1971, II, f. 42v.

120. Giovanni Fontana's *Bellicorum instrumentorum liber* offered pioneering anticipations of this revolution. It should be noted, however, that the drawings were not Fontana's work. Moreover, there were only a few dozen of them—versus Taccola's over 2,000—and they illustrated devices whose mechanical complexity often greatly exceeded that of Mariano's machines.

121. Mariano di Iacopo 1969, ff. 18v–19r.

122. Mariano di Iacopo 1971, II, f. 81v.

123. Fane 2003.

124. Ibid., pp. 141–142.

125. Mariano di Iacopo 1984a, II, f. 11r.

126. See, for example, Mariano di Iacopo 1971, II, ff. 83v–84r.

127. Ibid., I, p. 111 (f. 40r).

128. Ibid., I, p. 112 (f. 41v) and p. 115 (f. 50r and v).

129. Ibid., I, p. 100 (f. 29r).

130. Ibid., I, p. 101 (f. 29v).

131. Ibid., I, p. 103 (f. 32r).

132. Mariano di Iacopo 1984a, II, f. 40r.

133. Mariano di Iacopo 1969, ff. 8v–9r.

134. Ibid., f. 36r (detail).

135. Mariano di Iacopo 1984a, II, f. 90v.

136. Mariano di Iacopo 1969, f. 24r.

137. Mariano di Iacopo 1971, II, f. 88v.

138. Ibid., f. 59v.

139. Ibid., f. 83v.

140. Mariano di Iacopo 1984a, II, f. 123r.

141. Ibid., II, f. 48v (detail).

142. Ibid., II, f. 111r.

143. Mariano di Iacopo 1971, II, f. 76v.

144. Mariano di Iacopo 1984a, II, f. 99r.

145. Mariano di Iacopo 1969, f. 14v.

146. Ibid., pp. 13 and 27.

147. Ibid., f. 37v (detail).

148. Mariano di Iacopo 1984a, II, f. 38v.

149. Ibid., f. 38v (detail).

150. Ibid., f. 54v (detail).

151. See Leonardo da Vinci, drawing of a scythed chariot, Biblioteca Reale, Turin, inv. 15583.

152. See, for instance, Mariano di Iacopo 1971, II, f. 61v.

153. *Bottini* derives from the Latin *buctinus,* or "barrel vault," such as those of the underground galleries through which the water coursed. On Siena's underground aqueduct, in addition to the previously cited study by Bargagli Petrucci (Bargagli Petrucci 1906), see *Bottini* 1993 and Kucher 2005.

154. Mariano di Iacopo 1969, f. 33r.

155. Ibid., ff. 6v–7r.

156. See the Archimedean screw shown in an upright position (ibid., f. 38v).

157. Mariano di Iacopo 1984a, II, f. 107v; see Fig. 9.

158. Mariano di Iacopo 1971, II, f. 88r.

159. Mariano di Iacopo 1969, ff. 27v–28r.

160. Mariano di Iacopo 1984a, II, f. 3v.

161. Mariano di Iacopo 1971, II, f. 61r.

162. Mariano di Iacopo 1984a, II, f. 119r.

163. Mariano di Iacopo 1971, II, f. 84r.

164. Mariano di Iacopo 1984a, II, f. 119r.

165. Adams 1984, pp. 768–770.

166. Lisini 1935, p. 216. On the Sienese fishery-lakes, see also Galluzzi 1991, pp. 28–29, and Adams 1984.

167. Mariano di Iacopo 1984a, II, f. 114v.

168. Ibid., II, f. 119v.

169. Mariano di Iacopo 1969, f. 36r.

170. Mariano di Iacopo 1984a, II, f. 73r (detail).

171. Ms. Palatino 767, Biblioteca Nazionale Centrale, Florence, p. 9; see Galluzzi ed., 1991, p. 208.

172. Kyeser 1967, f. 54r.

173. Mariano di Iacopo 1984a, I, pp. 95–113 (II, ff. 77r–79r).

174. Ibid., II, f. 57r and Mariano di Iacopo 1969, f. 18r.

175. Mariano di Iacopo 1984a, II, f. 130v.

176. Mariano di Iacopo 1969, f. 18r; see Fig. 20.

177. Kyeser 1967, I, p. 40 (f. 62r).

178. Mariano di Iacopo 1971, II, f. 48v.

179. Ibid., f. 3r.

180. Ibid., f. 77r.

181. Mariano di Iacopo 1984a, II, f. 10v.

182. Ibid., I, p. 46 (f. 10v).

183. Ibid., II, f. 21v.

184. Ibid., I, p. 59 (f. 21v).

185. Ibid.

186. Ibid., I, p. 53 (f. 16r).

187. Mariano di Iacopo 1971, I, p. 143.

188. Ibid., II, f. 6r (Ms. Spencer 136, f. 2r).

189. Ibid., f. 7r (Ms. Spencer 136, f. 7r).

190. See Fig. 47.

191. Mariano di Iacopo 1984a, II, f. 124v.

192. Ibid., f. 82r (detail).

193. Mariano di Iacopo 1971, II, f. 57r.

194. Mariano di Iacopo 1969, pp. 153–154 (f. 42r).

195. Michelini Tocci 1962. Francesco's autograph notes and sketches are on ff. 127r–130v of the Munich manuscript of *De ingeneis I–II.*

196. Ibid., f. 130v. For Taccola's drawing of Brunelleschi's *badalone* copied by Francesco, see Fig. 15.

197. For the drawing of Taccola's floating pontoon, see Fig. 20.

198. For the drawing of Taccola's floating mill, see Fig. 17.

199. For a critical analysis of the debate among scholars on the timeline of Francesco di Giorgio's manuscripts, see Mussini 1993 (pp. 358–379).

200. Francesco di Giorgio, *Codicetto,* Ms. Lat. Urbinate 1757, Biblioteca Apostolica Vaticana, Rome. The manuscript was published in facsimile with an introduction by Michelini Tocci (Francesco di Giorgio 1989).

201. See Michelini Tocci 1962; Galluzzi 1991, p. 202, and Mussini 1993, pp. 359–360.

202. Francesco di Giorgio 1967, II, p. 493 (Ms. Magliabechiano II, I, 141, Biblioteca Nazionale Centrale, Florence, f. 89v).

203. See Galluzzi 1991, pp. 30ff. On Francesco di Giorgio's artistic and architectural activity, see the catalogues of two exhibitions held in Siena in 1993 (Fiore and Tafuri 1993 and Bellosi 1993). Both contain references to the vast bibliography on the great Sienese artist, technician, and architect. See also the essays and bibliography cited in Galluzzi ed., 1991.

204. Chironi showed that the poulterer in Francesco's family was not his father but his grandfather (Chironi 1991, pp. 471-472: document III.1).

205. Ibid., p. 472, doc. III, 6; see also Bargagli Petrucci 1902; see also Kucher 2005, p. 136.

206. See Weller 1943, p. 10.

207. See Bernini Pezzini 1985.

208. See Weller 1943, pp. 351-352.

209. On the genesis and dating of the *Codicetto,* in addition to Michelini Tocci 1962, see Francesco di Giorgio 1989 (the introduction by Michelini Tocci), Galluzzi ed., 1991, p. 202, and Mussini 1993, pp. 359-360.

210. Francesco di Giorgio 1989, f. 118r.

211. Ibid., f. 116v.

212. See, for example, the complex mechanisms of the column-lifting machine in the *Codicetto* (Francesco di Giorgio 1989, f. 118r).

213. See Beltrami 1912, pp. 108-111.

214. Francesco di Giorgio, *Opusculum de architectura,* Ms. 197.b.21, British Museum, London, f. 26r. It should be pointed out that Francesco successfully undertook a project comparable to that of Fioravanti: he raised the roof of the church of San Francesco in Siena without damaging it (Papini 1946, I, pp. 176-177).

215. Ms. Additional 34113, British Library, London. On this important source, which is still unpublished, see Prager and Scaglia 1972, pp. 199-201, Scaglia 1988, pp. 93-94, and Mariano di Iacopo 1984a, I, pp. 160-171.

216. Borrowings from Valturius are also present in Francesco di Giorgio's *Codicetto.*

217. Ms. Add. 34113, f. 189v.

218. Ibid., f. 200v.

219. Ibid., ff. 17v, 129r and 194v.

220. Ibid., f. 224r. For the dependence of the Anonymous Sienese Engineer's manuscript on Francesco di Giorgio and its influence on Leonardo, see Scaglia 1981, pp. 16–32.

221. Mariano di Iacopo 1971, I, pp. 30–31.

222. Anonymous, Ms. Palatino 767, Biblioteca Nazionale Centrale, Florence; see Galluzzi ed., 1991, p. 208.

223. See above, note 214. On the *Opusculum*, see Scaglia 1991, pp. 47–80, Galluzzi ed., 1991, p. 203, and Mussini 1993, pp. 377–378.

224. A complete transcription of the dedication is in Scaglia 1991, pp. 78–79. The name of the Duke of Urbino has been canceled but is still legible. The *Opusculum* is also attested by a sixteenth-century copy (Ms. Serie Militare 383, Biblioteca Reale, Turin) that explicitly mentions Federico da Montefeltro as dedicatee and Francesco di Giorgio as author. See Galluzzi ed., 1991, p. 203 and Mussini 1993, pp. 377–378.

225. Ladislao Reti was the first to stress the remarkable and enduring success of Francesco di Giorgio's *machinae pictae* (Reti 1963). Since Reti's monograph, the inventory of manuscripts derived from Francesco, particularly from the *Opusculum,* has grown substantially. In this connection, see Gustina Scaglia's chart of derivations from Taccola and Francesco di Giorgio (Mariano di Iacopo 1984a, I, p. 162), the list of manuscripts and printed works directly inspired by drawings of machines by Sienese engineers in Galluzzi ed., 1991, pp. 208–271, and the checklist of manuscripts in Scaglia 1992. See also Lamberini 1991, pp. 135–146.

226. Francesco di Giorgio, *Opusculum de architectura* (Ms. 197.b.21, British Museum), f. 1r. The text is an almost verbatim quotation from Book III of Taccola's *De ingeneis* (Mariano di Iacopo 1969, p. 144, f. 15v). See Scaglia 1991, pp. 78–79.

227. That Ubaldini assisted Francesco was supposed by Michelini Tocci (Francesco di Giorgio 1989, *Einführung,* pp. 13–18).

228. For a list of the manuscripts containing drafts of Francesco's *Trattato* as well as an overview of the different opinions on their chronological sequence of the scholars who, over the last forty years, have tackled these delicate issues, see Mussini 1993, pp. 358–379.

229. The earliest version of the *Trattato* is documented by two manuscripts: Ms. Ashburnham 361, Biblioteca Medicea Laurenziana, Florence (edited, with facsimile reproduction, by Pietro Marani: Francesco di

Giorgio 1979), and Ms. Saluzziano 148, Biblioteca Reale, Turin (edited, with facsimile reproduction, by Corrado Maltese and Livia Maltese Degrassi: Francesco di Giorgio 1969, vol. I). A substantially different later version of Francesco's *Trattato* is found in Ms. Magliabechiano II.I.141, Biblioteca Nazionale Centrale, Florence (edited, with facsimile reproduction, by Corrado Maltese and Livia Maltese Degrassi: Francesco di Giorgio 1969, vol. II). In keeping with the tradition started by Corrado Maltese (Francesco di Giorgio 1969), we shall henceforth use *Trattato I* to denote the drafts contained in Ms. Saluzziano 148 and Ms. Ashb. 361, and *Trattato II* to refer to the text preserved in Ms. Magliabechiano II.I.141.

230. *Trattato I* (Ms. Ashb. 361), ff. 6v–8v. On the Florentine manuscript of *Trattato I,* in addition to Francesco di Giorgio 1979, see Mussini 1991, pp. 81–92.

231. *Trattato I* (Ms. Ashb. 361), ff. 26r–32v.

232. *Trattato I* (Ms. Saluzziano 148), ff. 66r–67r.

233. The section on the art of war is not currently present in Ms. Ashb. 361 of the Biblioteca Medicea Laurenziana but was originally included in it, as Mussini demonstrated. See *Trattato I* (Ms. Ashb. 361), ff. 55v–64r, and Mussini 1991, pp. 81–92.

234. *Trattato I* (Ms. Ashb. 361), f. 51v.

235. Ibid., ff. 47v–49r.

236. *Trattato I* (Ms. Ashb. 361), f. 42v.

237. Ms. Magliabechiano II.I.141, Biblioteca Nazionale Centrale, Florence (Francesco di Giorgio 1967, vol. II). On the second version of Francesco's *Trattato,* see Scaglia 1991, pp. 57–80 and Mussini 1993, pp. 366–368.

238. Francesco di Giorgio 1967, II, p. 499 (f. 94r).

239. Ibid., p. 505 (f. 98v).

240. *Trattato I* (Ms. Ashb. 361), f. 45v.

241. Valturius 1472 and 1483.

242. Vegetius 1473.

243. Vitruvius 1511.

244. Francesco di Giorgio, *Opusculum de architectura* (Ms. 197.b.21, British Museum), f. 75r; on Francesco di Giorgio's method for depicting machines, see Kemp 1991, pp. 105–112.

245. Ibid., f. 74v.

246. Francesco di Giorgio 1967, II, p. 489 (Ms. Magliabechiano II.I.141, f. 88r).

247. Ibid., II, p. 295 (Ms. Magliabechiano II.I.141, f. 1r).

248. On Francesco's translation of sections of Vitruvius's *De architectura* contained in Ms. Magliabechiano II, I, 141, see Scaglia 1985, Fiore 1985, Biffi 2002, and Mussini 2003.

249. Francesco di Giorgio 1967, II, p. 489 (Ms. Magliabechiano, II, I, 141, f. 88r).

250. Papini 1946, I, p. 178.

251. On Francesco's role in the Bruna river dam project, see Adams 1984, especially pp. 778–784.

252. *Trattato I* (Ms. Ashb. 361), ff. 6v–8v.

253. Ibid., f. 27r (detail).

254. Ibid., f. 31v.

255. See Chironi 1991, p. 479 (document III, 135). In the previous letter to Francesco di Giorgio, of July 7 of the same year, the representatives of the Sienese Republic urged him to return home. They reminded him of his official duties as contractor for the maintenance of the underground aqueduct and stressed that "especially after [your] departure . . . all the fountains are short of more than half their water supply" (Weller 1943, pp. 382–383).

256. See Daniela Lamberini's entries in Galluzzi ed., 1991, pp. 224–228. See also Lamberini 1991, pp. 135–146.

257. See Galluzzi ed., 1991, p. 239.

258. Ibid., pp. 229–239 (Daniela Lamberini's entries).

259. Ibid., pp. 239–243 (Daniela Lamberini's entries); see also Reti 1963.

260. Ibid., pp. 218–223 (Daniela Lamberini's entries).

2. LEONARDO VERSUS THE "ANCIENT PHILOSOPHERS"

1. Leonardo da Vinci 1973–1980, f. 94r.

2. See Marani 1982 and 1987.

3. See, for instance, the pump operated by an oscillating arm in Leonardo da Vinci 1990, f. 54r.

4. See the drawing of a particularly complex system, probably a study for the escapement of a mechanical clock (ibid., f. 33v), and the exploded view of a mechanism operated by a rack-and-pinion system (ibid., f. 72r).

5. Ibid., f. 80r.

6. Ibid., f. 89r.

7. For Leonardo's studies on flight, the monograph by Giacomelli, while dated, remains essential (Giacomelli 1936); see also Laurenza 2008.

8. Leonardo da Vinci 1973–1980, V, p. 340 (f. 434r).

9. "We shall therefore say that such an instrument made by man is lacking only the soul of the bird, which must be counterfeited by the soul of man" (ibid.).

10. However, this distinction is not always observed. On Madrid I, see Reti 1974b and Leonardo da Vinci 1974a, vol. III. See also Galluzzi 1987a, pp. 236–239, Moon 2007, Lohrmann, Alertz, and Hasters 2012, and Leonardo da Vinci 2018.

11. After Reti's death in 1973, the publication was completed by Augusto Marinoni (Leonardo da Vinci 1974a).

12. See Reti 1974b, pp. 272–273.

13. Galluzzi 1987a.

14. Ibid., pp. 237–238. Although Leonardo most probably drew inspiration from the title of Euclid's treatise, his choice of the word *elementi* was also suggested by the title of another work that he had carefully examined: the *Elementa Jordani super demonstrationem ponderis*.

15. Lohrmann, Alertz, and Hasters 2012. The three scholars published a new digital edition of the manuscript on the Web, accompanied by a commentary and computer graphics reconstructions of the devices illustrated by Leonardo. They also carefully tabulated the occurrences of both *Teorica* and *Elementi macchinali* in all his manuscripts. When my book was in press, Dietrich Lohrmann and Thomas Kreft published an impressive and long-awaited critical edition in four volumes of Codex Madrid I (Leonardo da Vinci 2018), which includes introduction, facsimile reproduction of the entire manuscript (in mirror inverted images and numbered blocks of texts for easy reference to transcriptions and commentary), plus transcriptions, German translation, and detailed indices. This precious resource represents a model that should be followed in future editions of Leonardo's notebooks. The German scholars have also made their work available on the Web (www.codex-madrid .rwth-aachen.de).

16. Leonardo da Vinci 1974, III, p. 198 (I, f. 82r).

17. Ibid., I f. 44v.

18. Ibid., f. 66v.

19. Ibid., f. 86v.

20. As in the case of the jack with antifriction bearings, ibid., f. 26r (Figure 69).

21. As in the drawing of a mechanical clock, ibid., f. 27v.

22. Ibid., f. 17r.

23. Ibid., f. 92v.

24. An eloquent example of Leonardo's mastery of shadowing is offered by the drawing of a circular endless screw turned by a pinion (Figure 72), in which the clever use of *chiaroscuro* produces a three-dimensional effect comparable to that of a physical model (ibid., f. 70r).

25. Vasari G. 1966–1987, I, pp. 169–170, Introduction to the section on *Painting.*

26. Leonardo da Vinci 1974, III, p. 310 (f. 119r).

27. Leonardo da Vinci 1973–1980, IX, p. 41 (f. 730r).

28. Leonardo da Vinci 1976, p. 63 (f. 14v).

29. On the mechanical foundations of Leonardo's human anatomy, see Keele 1983; see also Galluzzi 1987, Pedretti 2000, and Salvi 2013.

30. Leonardo da Vinci 1978–1980, II, p. 530 (K/P 143r: RL 19009r).

31. Ibid., p. 590 (K/P 153r: RL 19060r).

32. On this aspect of the evolution of Leonardo's thought, see Paola Salvi's contributions in Pedretti ed., 2015 (pp. 30–52) and in Pedretti 2000 (pp. XIII–XLIII); see also Nova and Laurenza eds., 2011.

33. Leonardo da Vinci 1976, p. 32 (f. 3r).

34. Leonardo da Vinci 1978–1980, I, p. 266 (K/P 80v: RL 19038v).

35. Ibid., II, p. 472 (K/P 134r: RL 19002r).

36. Ibid., I, p. 108 (K/P 43v: RL 19057v).

37. Leonardo da Vinci 1974, IV, f. 100v.

38. Leonardo da Vinci 1978–1980, I, p. 322 (K/P f. 102r: RL 19144r).

39. Ibid., K/P f. 179v (RL 19075v).

40. Ibid., p. 478 (K/P 135r: RL 19000r).

41. Ibid., II, p. 508 (K/P 140r: RL 19008r).

42. Ibid., III, K/P 42v (RL 19058v).

43. Ibid., K/P 148v (RL 19014v).

44. Ibid., K/P 149v (RL 19015v).

45. Ibid., I, p. 110 (K/P 44r: RL 19141r).

46. Leonardo da Vinci, "Weimar Sheet," Schlossmuseum, Weimar.

47. Leonardo da Vinci 1978–1980, III, K/P 143r (RL 19009r).

48. Ibid., K/P 149r (RL 19015r).

49. Ibid., II, p. 587 (K/P 152r: RL 12619r).

50. Ibid., p. 495 (K/P 137v: RL 19003v); see Keele 1983, pp. 267–268.

51. Ibid., p. 594 (K/P 154r: RL 19061r).

52. Ibid., III, K/P 152r (RL 12619r); see Keele 1983, pp. 274–275.

53. Leonardo da Vinci 1978–1980, II, p. 594 (K/P 154r: RL 19061r).

54. Ibid., p. 472 (K/P 134r: RL 19002r).

55. Ibid., I, p. 340 (K/P 107r: RL 19104v).

56. Leonardo da Vinci 1987b, p. 154 (f. 20r).

57. Leonardo da Vinci 1978–1980, I, p. 224 (K/P 71r: RL 19029r).

58. Ibid., II, p. 728 (K/P 179v: RL 19075v).

59. Ibid., p. 542 (K/P 144v: RL 19013v).

60. Ibid., p. 362 (K/P 113r: RL 19070v).

61. Ibid., I, p. 196 (K/P 62v: RL 19021v).

62. Leonardo da Vinci 2000, p. 146 (f. 102r).

63. Ibid., p. 185 (f. 134r).

64. Ibid., p. 179 (f. 130r).

65. Ibid., p. 144 (f. 101v).

66. Ibid., pp. 62–63 (ff. 57r–v).

67. Ibid., p. 62 (f. 56v); see Figure 48, p. 75.

68. Leonardo da Vinci 2000, p. 84 (f. 57v).

69. Ibid.

70. Leonardo da Vinci 1973–1980, VII, pp. 51–52 (f. 553r).

71. Leonardo da Vinci 1998, II, p. 188 (P 49r: f. 66r). It has been questioned (see, for instance, Maccagni 1971, p. 304) whether Leonardo had read Alberti's *Ludi matematici*, based on the argument that he quoted the Latin title *(Ex ludis rerum mathematicarum)*, which appears inappropriate for a work written in the vernacular. To dispel all doubts, suffice it to recall that the Latin title appears in many of the manuscripts of the *Ludi*. There is no need, therefore, to assume second-hand information, or to conjure up lost Latin versions dating from Alberti's or Leonardo's time.

72. Leonardo da Vinci 1973–1980, IV, p. 323 (f. 257r).

73. Leonardo da Vinci 2001b, p. 20 (f. 8v).

74. Leonardo da Vinci 1992, II2, pp. 73–74 (f. 86v): "different slopes make different degrees of resistance at their contact; and the reason is that if the weight that should be moved must be dragged along a level ground, undoubtedly this weight will be in the utmost degree of resistance, because it rests entirely on ground and nothing upon the cord that ought to drag it. But if you wish to draw it along a very steep road, all the weight that it gives to the cord that sustains it is subtracted from the friction that is produced by its contact with the ground. But it is necessary [he reminds himself] to provide a more convincing cause of this phenomenon. You know that if one were to draw it [the weight] upright, grazing and partly touching a wall, it weighs almost all upon the cord that draws it, and only a small part upon the wall where it rubs."

75. Leonardo da Vinci 1974, I, p. 492 (I, f. 176r).

76. Ibid.

77. Leonardo da Vinci 1973–1980, VI, p. 361 (f. 532v).

78. Ibid.

79. Leonardo da Vinci 1992, II2, f. 87r.

80. Leonardo da Vinci 1998, II, p. 210 (P 57v: f.187v).

81. Leonardo da Vinci 1989b, p. 157 (f. 78v).

82. Leonardo da Vinci 1973–1980, V, p. 146 (f. 393r).

83. Ibid., p. 351 (f. 438r).

84. Ibid.

85. Ibid., p. 263 (f. 417r).

86. Ibid., X, p. 220 (f. 922r).

87. Leonardo da Vinci 1989b, f. 58r.

88. Leonardo da Vinci 2002, p. 128 (f. 59r).

89. "as is seen of the extremities of the balance about its pivot with its oscillations—first up, then down—until its impetus is consumed. And this is produced solely by the inequality of these opposite parts about the center" (ibid., p. 125, f. 57v). In Ms. G, Leonardo sketches the diagram of a balance with a note emphasizing the need to distinguish between the mathematical center of the instrument and the material point of contact of the beam of the real balance with its support (Leonardo da Vinci 1989c, p. 114: f. 57v).

90. Leonardo specifies that his new rule is contained in the Sixth Book of his treatise on mechanical elements; see Leonardo da Vinci 2002, p. 138 (f. 79v), translation amended.

91. Leonardo da Vinci 1976, f. 1r.

92. Ibid., p. 27 (f. 1r).

93. Ibid., p. 33 (f. 3r).

94. Ibid., p. 28 (f. 1r).

95. Leonardo da Vinci 1992, II, p. 112 (f. 133r).

96. Leonardo da Vinci 2002, p. 104 (f. 63r): "I say force is a spiritual power, incorporeal and invisible, which is produced in those bodies that by accidental violence are removed from their natural place and from rest. I said *spiritual* because there is active life in this force."

97. Leonardo da Vinci 1973–1980, III, p. 219 (f. 220v).

98. Leonardo da Vinci 1974, IV, p. 509 (f. 183v).

99. Ibid., p. 523 (f. 189r).

100. See Galluzzi 2003.

101. Uccelli 1940.

102. On Leonardo's personal library and his reading of ancient and contemporary authors, see Vecce 2017 and Findlen 2019.

103. Leonardo da Vinci 2001a, p. 74 (f. 27v).

104. Leonardo da Vinci 1989a, p. 15 (f. 4v).

105. See Keele 1983, pp. 207–210.

106. On Leonardo's studies of optics and, in particular, his intensive research on burning mirrors, see Dupré 2005a, Marani 2014, and Fiorani and Nova (eds.) 2013.

107. In a note written ca. 1515 in Ms. G next to the drawing of a metal panel with a brace ("remember the soldering of the sphere of Santa Maria del Fiore"), Leonardo recalls Verrocchio's use of burning mirrors to assemble the sections of the gilt copper sphere crowning Brunelleschi's dome on Santa Maria del Fiore (Leonardo da Vinci 2002, p. 149: f. 84v).

108. Leonardo da Vinci 1973–1980, I, p. 204 (f. 87r).

109. In this folio (ibid., p. 31: f. 17v) he describes how to make "a concave sphere for setting fire."

110. On Leonardo's intensive work on the design and production of burning mirrors during his stay in Rome (1513–1516), see Pedretti 1977, II, pp. 303–306. On his other activities during those three years, see Laurenza 2004.

111. Leonardo da Vinci, I, P 64r–v (ff. 84v–88r). The most important evidence of Leonardo's 1503–1508 research on *ignie* is found in a group of sheets of the Codex Arundel (ibid., P 101–102: ff. 95r–v and 85r–v), and in many sheets of the Codex Atlanticus (see, for example, Leonardo da Vinci 1973–1980, III, pp. 237–241, f. 226r, and XII, pp. 207–208, f. 1103v).

112. Leonardo da Vinci 1998, I, P 65r–v (ff. 84v–88r).

113. Ibid., II, p. 229 (P 64v: f. 84v).

114. Ibid.

115. "This profiler has the curvature of a circumference of 400 *braccia*" (ibid.).

116. Leonardo da Vinci 1989c, p. XXI.

117. Leonardo da Vinci 1998, I, P 64v (f. 88r).

118. Ibid., II, p. 229.

119. Leonardo designed a compass for drawing parabolas (Leonardo da Vinci 1973–1980, XII, f. 1093r). As noted previously, in an early text, he also recommended using a parabolic profiler to grind a burning mirror for smelting metals.

120. Leonardo da Vinci 1998, II, p. 440 (P 145r: f. 279v).

121. Leonardo da Vinci 1973–1980, XII, p. 83 (f. 1036 a–v).

122. Leonardo da Vinci 1989c, p. 121 (f. 74v).

123. Leonardo da Vinci 1973–1980, VIII, p. 162 (f. 671r), and Pedretti 1987, pp. 4–5.

124. Leonardo da Vinci 1998, I, P 145v (f. 279r).

125. Leonardo da Vinci 1989c, pp. 40–41 (f. 85r).

126. Leonardo da Vinci 1998, II, pp. 440–441 (P 145v: f. 279r).

127. Leonardo da Vinci 2002, p. 150 (f. 85r).

128. A practically identical tabulation is found in folio P154r (f. 279r) of the Codex Arundel.

129. See, for example, Leonardo da Vinci 1973–1980, IX, pp. 81–84 (f. 750r).

130. Ibid., f. 751a–v; see also ff. 750r, 751a–v, and 751b–v.

131. It is worth highlighting the analogy between Leonardo's quasi-circular mirrors and the Archimedean method of exhaustion to square the circle by inscribing in it a regular polygon of a near-infinite number of sides. Leonardo was thoroughly familiar with the Archimedean method and used it in his studies on the squaring of a circle (see Marinoni 1982, pp. 145–174).

132. See Leonardo da Vinci 1973–1980, VII, p. 162 (f. 587r).

133. Leonardo da Vinci 2002, p. 69 (f. 44v).

134. Ibid., p. 72 (ff. 45v–46r); translation amended.

135. Leonardo da Vinci 1989c, f. 45r.

136. Leonardo da Vinci 1973–1980, IX, p. 255 (f. 823a–r); see also the variants of the mirror lathe on f. 1103v dating from the same period.

137. Leonardo da Vinci 1989c, f. 78r.

138. See the memorandum in the Codex Atlanticus: "soldered with the burning ray [razzo igneo]" (Leonardo da Vinci 1973–1980, XII, p. 88: f. 1036 b–v).

139. See, for example, his drawing of the rib for the thin metal blades in Leonardo da Vinci 1989c, f. 71v.

140. Ibid. See, in particular, the elegant drawings of metal-drawing machines on ff. 70v, 72r, 83r, and 84v.

141. Leonardo delineates the burning pyramid resulting from the curved brick wall (ibid., f. 74v).

142. Ibid., f. 45v.

143. Ibid., f. 47v.

144. Leonardo da Vinci 1973–1980, XII, p. 83 (f. 1036a–v).

3. IMMATERIAL MACHINES

1. See Alberti 1966, II, especially chapters VI–VIII (pp. 472–498).

2. "Quae penitus architecto necessaria ex artibus haec sunt: pictura et mathematica" (ibid., p. 861).

3. Alberti 1550.

4. Averlino 1972.

5. Ibid., II, pp. 475–476: Biblioteca Nazionale Centrale, Florence, Ms. Magliab. II.I.140, f. 127r.

6. Vitruvius Pollio 1486 [?]. On Sulpicius's edition, see the Introduction by Rowland in Vitruvius Pollio 2003, pp. 1–64.

7. It should also be stressed that Lorenzo Ghiberti inserted vernacular translations of some passages from Vitruvius's text in his *Commentarii* (Ghiberti 1998).

8. "rationis difficilis et artificibus laboriose" (ibid., *Epistola* to the reader).

9. "ut cum vel nostro vel aliorum studio edentur in lucem, suis locis possint affigi" (ibid.).

10. Ibid.

11. Vitruvius Pollio 1511.

12. On the life, personality, and activities of Fra Giocondo, see Fontana 1988 and Galluzzi 2005.

13. Fontana 1988, pp. 30–31.

14. "Indicavitque id primus nobis Romae Basilius Ampelinus, deinde Iocundus Veronensis sacerdos, architecti nobiles" (ibid., pp. 19–20).

15. Valturius 1472.

16. See Fontana 1988, pp. 47 and 76. For the graphic reconstruction of Julius Caesar's bridge on the Rhine, see Caesar 1513.

17. Alberti 1966, I, pp. 308–310.

18. *Libri de re rustica* 1514. See Fontana 1988, p. 76.

19. "Rebus in obscuris oritur lux clara figuris," ibid., p. 85.

20. Vitruvius Pollio 1511, dedication letter to Pope Julius II.

21. "Nobis vero in ea lectione contigit praeceptorem eximium nancisci, Iucundum sacerdotem, architectum tum Regium, hominem antiqui-

tatis peritissimum qui graphice quoque non modo verbis intelligendas res praebebat" (see Fontana 1988, p. 46).

22. Ibid., pp. 46–47. Budé's annotated copy is in the Bibliothèque Nationale in Paris (Rés. V 318). On Fra Giocondo's role in the initial circulation of the work of Vitruvius in France, see Juren 1974.

23. "Sed satis mihi fecisse videor aperuisse studiosis fores et ostendisse semitas quibus hic auctor intelligi valeret" (Vitruvius Pollio 1511, *Liber X*, p. 102v).

24. Ibid., p. 103v.

25. Ibid., p. 104v.

26. "Ex iisdem Graecis auctoribus quos Vitruvius citat" (ibid., p. 105v).

27. "Studiosis et ingeniosis qui forsan ibi perficere poterunt ubi ego defeci" (ibid.).

28. Ibid., p. 106v. Fra Giocondo specifies that the *balista* hurled stones, while the catapult launched arrows.

29. See Fontana 1988, p. 20.

30. On Fra Giocondo's stay in Naples, see ibid., pp. 16–36.

31. See Fontana and Morachiello 1975.

32. Ms. Corsini 50.F.1, Biblioteca dell'Accademia Nazionale dei Lincei e Corsiniana. The Accademia dei Lincei published a facsimile of the incunabulum (Vitruvius Pollio 2003).

33. Vitruvius Pollio 1521 and Vitruvius Pollio 1981.

34. See Vitruvius Pollio 1981, pp. XV–XVI.

35. For example, they claimed that "the figure showing this machine is placed here below, but another rope should go directly and immediately from the wheel to the hoist. But the Master who depicted it [i.e., Cesariano] placed a pulley in the middle and did not follow the description given by the author [i.e., Vitruvius]" (ibid., c. CLXIVr).

36. Ibid., c. IIIv.

37. Ibid., c. XVIIIr.

38. Ibid.

39. Ibid.

40. Biringucci 1540, c. 137r.

41. See Cataneo and Barozzi da Vignola 1985, pp. 31–50.

42. Ibid., pp. 51–61.

43. Philandrier 1545.

44. Cataneo and Barozzi da Vignola 1985, p. 53.

45. Ibid.

46. Ibid., p. 59.

47. Ibid.

48. Ibid., p. 60.

49. Ibid., p. 38 note 1.

50. Ibid., p. 39.

51. Vitruvius Pollio 1556.

52. Vitruvius Pollio 1567.

53. Ibid., p. 4.

54. Ibid., p. 5.

55. Ibid., p. 4.

56. Ibid., p. 13.

57. Barbaro 1557, p. 7; see Manno 1987, p. 229.

58. Vitruvius Pollio 1567, p. 442.

59. Ibid., p. 463.

60. Ibid., p. 464.

61. Ibid., p. 463.

62. Ibid., p. 471.

63. Ibid., p. 473.

64. Ibid.

65. In her doctoral dissertation, Luisa Dolza offered a systematic review of the *Theaters of machines* of the sixteenth and early seventeenth centuries (Dolza 1997–1998). See also her introductory essay (with H. Vérin) to the edition of Jacques Besson's *Theatrum* (Besson 2001, pp. 1–49).

66. Such as the hoist to lift a bell in Ramelli 1588 (plate 177).

67. On Ramelli see Dolza 1997–1998 and Ramelli 1991.

68. See Fontana 1984, p. 137 (f. 63v.).

69. Ibid., p. 131 (f. 51r.). However, Fontana took care to stress that these effects were produced not through magic but by the ingenious combination of a series of mechanical devices.

70. See the preface by P. Galluzzi and the editors' essay in Gorman and Wilding 2000.

71. See Lo Sardo ed., 1999.

72. On the prolific Jesuit and his successful *Technica curiosa* (Schott 1664), see Gorman and Wilding 2000, pp. 3–62.

73. Or like the sundial *(Horoscopium botanicum)* that exploited the heliotropic motion of sunflowers (Kircher 1654, p. 508).

74. *Iconismus XXIV* in Schott 1657–1659.

75. On the subtle frontier that divided the most advanced technical solutions from natural magic in those decades, see Anthony Grafton's penetrating essay (Grafton 2005).

76. Such as those illustrated in his *Mechanica Hydraulico-Pneumatica,* starting with the image (Figure 102) that adorned its frontispiece (Schott 1657).

77. It should be stressed that the representatives of the new mathematical science of mechanics systematically ignored the authors of the Renaissance notebooks as well as those of the *Theaters of machines.*

78. On the classical models followed by the restorers of ancient mechanics, and on their vast literary output, see Rose 1975.

79. Dal Monte 1581 (italics mine): dedication by Filippo Pigafetta to Giulio Savorgnan, unnumbered page.

80. Piccolomini 1565.

81. Piccolomini 1582, p. 5. Piccolomini's *Paraphrasis* was translated into the vernacular by Oreste Vannocci Biringucci.

82. Ibid., p. 10.

83. Dal Monte 1581: Filippo Pigafetta's letter "to readers."

84. Ibid., p. 8.

85. Dal Monte 1588.

86. Commandino 1565. The young Galileo also compiled a concise text on the center of gravity of solids (see Galilei 1890–1909, I, pp. 179–208).

87. Dal Monte 1577; see Renn and Damerow 2010.

88. Dal Monte 1581.

89. Dal Monte 1588, pp. 14–16.

90. "[Archimedes] aperte supponit plana ac superficies graves existere, rem sane immaginariam prorsus, ipsiusque rei naturae nullatenus respondentem, ita ut Archimedes circa ea quae omnino rei naturae adversantur negotium sumpsisse videatur" (ibid., p. 15).

91. "quamvis re ipsa, actuque plana seorsum a corporibus reperiri nequeant, in ipsis tamen haec ipsorum circa centra gravitatis aequeponderatio ad actum facile redigi poterit" (ibid.).

92. On this aspect, see especially Micheli 1995, and 1992, pp. 100–104.

93. See Guidobaldo's letter to Pigafetta in Micheli 1995, pp. 163–167.

94. Included in Dal Monte 1581, p. 28.

95. Quoted by Micheli 1995, p. 167.

96. See Dal Monte 1588, p. 2.

97. Guidobaldo stated that mechanics both emulates nature and competes with it (ibid., p. 1).

98. On the genesis and development of Galileo's treatise on mechanics, see Romano Gatto's essay (Galilei 2002).

99. Galilei 1890–1909, II, p. 155.

100. Ibid.

101. Machines appear to move weights—Galileo explains—by "a force lesser than the weight [the 'miraculous' operation claimed by those mechanics who are his target]; but in actual fact that force will travel a much longer distance than that covered by the weight" (ibid., p. 156).

102. Ibid.

103. Ibid., pp. 157–158.

104. In his recent monograph, in which he emphasizes Galileo's abiding interest in technical matters and the design and/or improvement of instruments and machines, Matteo Valleriani defines him as an "Aristotelian engineer" (Valleriani 2010, pp. XX and 203–205). While this

label seems hardly suitable for Galileo's intellectual experience, Valle-
riani's study is valuable for its detailed analysis of Galileo's statements
on technical issues often neglected by scholars.

105. On Galileo's *Bilancetta,* see Mottana 2017.

106. On Galileo's thermoscope, see Valleriani 2010, pp. 155-168, and Gal-
luzzi 2011, pp. 49-54.

107. See Galilei 1890-1909, II, pp. 335-424, and Camerota 2004.

108. See Strano ed., 2008 and Galluzzi 2017, pp. 1-24.

109. For the documents on Galileo's December 1593 application to the
Venice Town Council [Provveditori di Comun di Venezia] for a patent
for his invention of a "machine to raise water . . . which, with the power
of a single horse, will provide a continuous flow of water . . . from
twenty spouts," see Galilei 1890-1909, pp. 126-129; see also Valleriani
2010, p. 68.

110. Galilei 1890-1909, VI, p. 232; Drake and O'Malley eds., 1960, pp. 183-185.

111. See Valleriani 2010, pp. 147-153; see also Renn and Valleriani 2000.

112. Galilei 1974. The title of the original edition was *Discorsi e dimostrazioni
matematiche intorno a due nuove scienze,* Leiden 1638 (Galilei 1890-1909,
VIII, pp. 41-313).

113. Galilei 1974, pp. 43ff (Galilei 1890-1909, VIII, pp. 50ff).

114. Ibid., VIII, pp. 632-633.

115. Ibid., VIII, p. 632.

116. Viviani owned the autograph of this document, now unfortunately lost.
Galileo's last disciple also recorded the names of the artisans (Miglio-
rini and Landini) refuted by Galileo. See ibid., p. 633, note 1.

117. See, for example, the recirculation mill illustrated in Francesco di
Giorgio 1979, II, f. 6r. Francesco defines this type of structure as a mill
"in dead water."

118. Ms. 197.b.21, British Library, London, f. 6r.

119. Galileo 1890-1909, VIII, pp. 570-584. See A. Favaro's *Avvertimento,* ibid.,
pp. 559-561. A note by Vincenzo Viviani tells us that the device had
been offered to the Grand Duke by a "Sicilian engineer" (ibid., p. 560,
note 2). One of the three drafts is in the form of a dialogue between
Salviati and Sagredo (ibid., pp. 581-584); see Valleriani 2010,
pp. 67-68.

120. Galilei 1890–1909, VIII, p. 572.

121. Ibid., p. 573.

122. Ibid.

123. Ibid.

124. Ibid.

125. Ibid., p. 575.

126. Ibid., pp. 585–587. On Galileo's assessment, see A. Favaro's *Avvertimento* (ibid., p. 561), and Valleriani 2010, pp. 66–67.

127. Galilei 1890–1909, VIII, p. 585.

128. Ibid.

129. Ibid., p. 586.

130. Ibid.

131. Ibid., p. 587.

132. See, for example, the multi-piston mill in Ms. 2723, Biblioteca Statale, Lucca (f. 262), by Benedetto Saminiati, an engineer from Lucca who flourished in the mid-sixteenth century. The manuscript displays abundant borrowings from Francesco di Giorgio (see Lamberini in Galluzzi ed., 1991, p. 232).

133. Zonca 1607, pp. 85–87: "machine for pounding gunpowder for bombards."

134. Lorini 1609, p. 237.

135. Galilei 1890–1909, XVI, p. 222.

136. See above, note 112.

137. In his letter of March 3, 1635, de Ville told Galileo that he had been able to read the manuscript draft of the first two *Days* of the *Two New Sciences* thanks to the courtesy of Andrea Argoli, who had received it from Fulgenzio Micanzio. De Ville states that Argoli had lent him the text for "only one day" (ibid., XVI, p. 221). For a complete English translation of this important document, see Valleriani 2010, pp. 277–283.

138. On the scant biographical information on Antoine de Ville, see Vérin 2002, pp. 309–310.

139. See de Ville's letter to Galileo from Venice, January 4, 1633: "I have avidly read all of your treatises that I have been able to find, and this latest

one [the *Dialogue*] captured my enthusiasm and wonderment; in it you examine the system of Copernicus, which . . . I found to be very true" (Galilei 1890–1909, XV, p. 12).

140. "after wasting three years studying philosophy under the Jesuits and other teachers, I found myself to be as ignorant as before, and even more confused; and, as my judgment matured over the years, I understood that all those philosophies of Friars and Jesuits and various others are just a jargon of invented words" (ibid.).

141. In the same letter to Galileo of January 4, 1633, de Ville wrote: "I shall not tire you with so many other propositions whose truth I considerably doubt; indeed, I shall say that I find little certainty in all those [propositions] that are not based on mathematical demonstrations or that are not acquired through the senses" (ibid., p. 12).

142. Ibid., XVI, p. 222.

143. Ibid.

144. Ibid.

145. Ibid.

146. Ibid., pp. 223–224. Valleriani 2010, pp. 279–282 and Vérin 2002, pp. 316–320.

147. Galilei 1890–1909, XVI, pp. 224–228. See Palmerino 2000; see also Galluzzi 1980, pp. 350–360, and 2011, p. 110 (note 53).

148. Letter to de Ville from Arcetri, March 1635 (Galilei 1890–1909, XVI, pp. 242–244).

149. Ibid., p. 243.

150. Ibid.

151. Ibid.

152. Ibid., p. 244.

153. Ibid., VIII, p. 159.

154. Ibid., p. 157.

155. In the introduction to his influential treatise, *Mécanique analytique*, Joseph-Louis Lagrange, one of the key figures in the analytical revolution of mechanics, emphatically stressed the novelty of this approach: "No figures will be found in this work. The methods I describe here require neither constructions nor geometrical or mechanical reasoning, but only algebraic operations" (Lagrange 1788, *Avertissement*).

Bibliography

Adams, N., 1984. "Architecture for fish. The Sienese dam on the Bruna river. Structures and design, 1468-ca. 1530," *Technology and Culture,* XXV, 4, pp. 768-797.

Alberti, L. B., 1485. *De re aedificatoria,* Florentiae [Florence], impression Nicolai Laurentii.

Alberti, L. B., 1550. *L'architettura di Leon Battista Alberti [. . .] tradotta in lingua fiorentina da Cosimo Bartoli [. . .]. Con l'aggiunta de disegni,* in Firenze [Florence], appresso Lorenzo Torrentino.

Alberti, L. B., 1966. *L'architettura. De re aedificatoria.* Latin text edited and translated into Italian by G. Orlandi. Introduction and notes by P. Portoghesi, 2 vols., Milan.

Anonymous, 1989. A. Giardina (ed.), *Le cose della guerra,* Milan.

Averlino, A., known as Il Filarete, 1972. A. M. Finoli and L. Grassi (eds.), *Trattato di architettura,* 2 vols., Milan.

Barbaro, D., 1557. *Della eloquenza. Dialogo [. . .] nuovamente mandato in luce da Girolamo Ruscelli,* in Venetia [Venice], appresso Vincenzo Valgrisio.

Bargagli Petrucci, F., 1902. "Francesco di Giorgio Martini Operaio dei bottini," *Bullettino Senese di Storia Patria,* IX, pp. 227-236.

Bargagli Petrucci, F., 1906. *Le fonti di Siena e i loro acquedotti. Note storiche dalle origini fino al MDLV,* 2 vols., Siena.

Bargagli Petrucci, F., 1929. *Come i Senesi antichi ricercando la Diana trovarono l'acqua per la loro città,* Siena.

Barome, J. (ed.), 2019. *Leonardo da Vinci. A mind in motion* (catalogue of the exhibition, British Library, London, June–September 2019), London.

Barsanti, R. (ed.), 2015. *Leonardo e l'Arno,* Pisa.

Bartoli, L., 1994. *Il disegno della Cupola del Brunelleschi,* Florence.

Battisti, E., 1975. *Filippo Brunelleschi,* Rome.

Beck, J. H., 1968. "The historical Taccola and the Emperor Sigismund in Siena," *The Art Bulletin*, L, pp. 309–320.

Beck, T., 1899. *Beiträge zur Geschichte des Machinenbaues*, Berlin, Julius Springer.

Bellone, E. and Rossi, P. (eds.), 1982. *Leonardo e l'età della ragione*, Milan.

Bellosi, L., 1993. *Francesco di Giorgio e il Rinascimento a Siena 1400–1500*, Milan.

Beltrami, L., 1912. *Vita di Aristotile da Bologna*, Bologna.

Benigni, P. and Ruschi, P., 1977. "Il contributo di Filippo Brunelleschi all'assedio di Lucca," in *Filippo Brunelleschi. La sua opera e il suo tempo*. Atti del convegno Internazionale (proceedings of international conference), Florence, October 16–22, 1977, Florence.

Benigni, P. and Ruschi, P., 2015. "Brunelleschi e Leonardo. L'acqua e l'assedio," in R. Barsanti (ed.), *Leonardo e l'Arno*, Pisa, pp. 99–129.

Bernini Pezzini, G., 1985. *Il fregio dell'Arte della guerra nel Palazzo Ducale di Urbino. Catalogo dei rilievi*, Rome.

Berthelot, M., 1891. "Pour l'histoire des arts mécaniques et de l'artillerie vers la fin du Moyen Âge," *Annales de Chimie et de Physique*, s. VI, vol. XXIV, pp. 433–521.

Berthelot, M., 1900. "Histoire des machines de guerre et des arts mécaniques au Moyen Âge. Le livre d'un ingénieur militaire à la fin du XVI^ème siècle," *Annales de Chimie et de Physique*, s. VII, vol. XIX, pp. 289–420.

Besson, J., 2001. *Theatrum instrumentorum et machinarum* (Lyon, 1578). Introductory essay by L. Dolza and H. Vérin; with a linguistic study and annotated translation from Latin by M. Sonnino. Preface by P. Rossi, Rome.

Biffi, M. (ed.), 2002. Francesco di Giorgio Martini, *La traduzione del* De architectura di Vitruvio dal ms. II.I.141 della Biblioteca Nazionale Centrale di Firenze, Pisa.

Biringucci, V., 1540. *De la pirotechnia*, in Venezia (Venice), per Venturino Roffinello.

Borroni Salvadori, F., 1977. "Deianira, San Sebastiano e il guerriero contro il Marzocco. Disegni inediti provenienti da Volterra," *Mitteilungen des Kunsthistorisches Institut in Florenz*, XXI, pp. 307–314.

Bottini, 1993. *I bottini medievali di Siena*. Essays by D. Balestracci, D. Lamberini, and M. Civai. Preface by P. Galluzzi, Siena.

Brusatin, M., 1980. "La macchina come soggetto d'arte," in G. Micheli (ed.), *Storia d'Italia. Annali III (Scienza e tecnica nella cultura e nella società dal Rinascimento a oggi)*, Turin, pp. 29–81.

Bruschi, A., Maltese, C., Tafuri, M., and Bonelli, R. (eds.), 1969. *Scritti rinascimentali di architettura*, Milan.

Caesar, C. J., 1513. *Commentarii*, Venetiis (Venice), in aedibus Aldi.

Calvi, G., 1925. *I manoscritti di Leonardo da Vinci dal punto di vista cronologico, storico e biografico,* Bologna (new ed. by A. Marinoni, Busto Arsizio, 1982).

Camerota, F., 2004. *Il compasso geometrico e militare di Galileo Galilei* (with cardboard replica of the instrument, CD-ROM, and English translation by S. Drake), Florence.

Cataneo, P. and Barozzi da Vignola, G., 1985. E. Bassi, S. Benedetti, R. Bonelli, L. Magagnato, P. Marini, T. Scalesse, C. Semenzato, and M. Walcher Casotti (eds.), *Trattati con l'aggiunta degli scritti d'architettura di Alvise Cornaro, Claudio Tolomei, Giorgio Trissino, Giorgio Vasari,* Milan.

Catoni, G., 1973. "Genesi e ordinamento della Sapienza di Siena," *Studi Senesi,* LXXXV, pp. 155-198.

Cavalcanti, G., 1838. *Istorie fiorentine,* 2 vols., Florence, Tipografia all'insegna di Dante.

Chironi, G., 1991. *Repertorio dei documenti riguardanti Mariano di Iacopo detto il Taccola e Francesco di Giorgio,* in P. Galluzzi (ed.), pp. 471-482.

Ciapponi, L. A., 1960. "Il 'De Architettura' di Vitruvio nel primo Umanesimo," *Italia medievale e umanistica,* III, pp. 59-99.

Ciapponi, L. A., 1984. "Fra Giocondo da Verona and his edition of Vitruvius," *Journal of the Warburg and Courtauld Institutes,* XLVII, pp. 72-90.

Clagett, M., 1976. "The life and the works of Giovanni Fontana," *Annali dell'Istituto e Museo di Storia della Scienza di Firenze,* I, 1, pp. 5-28.

Coccia, M., 2015. *Cesare Cesariano. Ricomposizione di un problema critico,* Rome.

Commandino, F., 1565. *Liber de centro gravitatis solidorum,* Pisauri [Pesaro], ex officina Alexandri Benacii.

Cultura, scienze e tecniche, 1987. *Cultura, scienze e tecniche nella Venezia del Cinquecento* (Proceedings of the conference on *Giovanni Benedetti e il suo tempo* [Giovanni Benedetti and his times]), Venice.

Dal Monte, G., 1577. *Mechanicorum liber,* Pisauri [Pesaro], apud Hyeronimum Concordiam.

Dal Monte, G., 1581. *Le mechaniche dell'Illustriss. Guido Ubaldo del Monte, tradotte in volgare dal Sig. Filippo Pigafetta,* in Venetia [Venice], appresso Francesco de Franceschi.

Dal Monte, G., 1588. *In duos Archimedis aequeponderantium libros Paraphrasis,* Pisauri [Pesaro], apud Hyeronimum Concordiam.

Degenhart, B. and Schmitt, A., 1982. *Corpus der italienischen Zeichnungen 1300–1450, Teil II, 4 Bde. (Venedig, Addenda zu Süd und Mittelitalien): Katalog,* pp. 717-719. *Mariano Taccola,* Berlin.

Di Pasquale, G., 2019. *Le macchine nel mondo antico,* Rome.

Dolza, L., 1998. *A gloria di Dio, a beneficio degli studiosi e servizio di Vostra Altezza: i primi Teatri di macchine,* doctoral dissertation in history of science, University of Florence, academic year 1997-1998.

Drachmann, A. G., 1963. *The Mechanical Technology of Greek and Roman Antiquity,* Munksgaard.

Drake, S. and O'Malley, C. D. (eds.), 1960. *The Controversy on the Comets of 1618. Galileo Galilei, Orazio Grassi, Mario Guiducci, Johannes Kepler.* Translated by S. Drake and C. D. O'Malley, Philadelphia.

Dupré, S., 2005a. "Optics, picture and evidence: Leonardo's drawings of mirrors and machinery," *Early Science and Medicine,* X, 2, pp. 211-236.

Dupré, S., 2005b. "Ausonio's mirrors and Galileo's lenses: The telescope and sixteenth-century practical optical knowledge", *Galilaeana,* II, pp. 145-180.

Fane, L., 2003. "The invented world of Mariano Taccola: Revisiting a once famous artist-engineer of 15th century Italy," *Leonardo,* XXXVI, 2, pp. 135-143.

Festa, E. and Gatto, R. (eds.), 2000. *Atomismo e continuo nel XVII secolo,* Naples.

Findlen, P. (ed.), 2019. *Leonardo's library. The world of a Renaissance reader,* Stanford, Ca.

Fiorani, F. and Nova, A. (eds.), 2013. *Leonardo da Vinci and Optics,* Venice.

Fiore, F. P., 1978. *Città e macchine del '400 nei disegni di Francesco di Giorgio Martini,* Florence.

Fiore, F. P., 1985. "La traduzione da Vitruvio di Francesco di Giorgio. Note a una parziale trascrizione," *Architettura, storia e documenti,* no. 1, pp. 128-131.

Fiore, F. P. and Tafuri, M. (eds.) 1993. *Francesco di Giorgio Architetto,* Milan.

Fontana, G., 1984. E. Battisti and G. Saccaro del Buffa Battisti (eds.), *Le macchine cifrate di Giovanni Fontana: con la riproduzione del Cod. icon. 242 della Bayerische Staatsbibliothek di Monaco di Baviera e la decrittazione di esso e del Cod. lat. nouv. acq. 635 della Bibliothèque Nationale di Parigi,* Milan.

Fontana, V., 1988. *Fra Giovanni Giocondo architetto 1433c.–1515,* Venice.

Fontana, V. and Morachiello, P., 1975. *Vitruvio e Raffaello. Il "De architectura" di Vitruvio nella traduzione inedita di Fabio Calvo Ravennate,* Rome.

Francesco di Giorgio, 1841. *Trattato di architettura civile e militare di Francesco di Giorgio Martini [. . . .], Per la prima volta pubblicato per cura del Cavaliere Cesare Saluzzo, con dissertazione e note per servire alla storia militare italiana a cura di C. Promis,* 3 vols., Turin, Tipografia Chirio e Mina.

Francesco di Giorgio, 1967. C. Maltese (ed.), *Trattati di architettura, ingegneria e arte militare.* Transcribed by L. Maltese Degrassi, 2 vols., Milan.

Francesco di Giorgio, 1979. *Il Codice Ashburnham 361 della Biblioteca Medicea Laurenziana di Firenze. Trattato di architettura di Francesco di Giorgio Martini.* Presentation by L. Firpo; introduction, transcriptions, and notes by P. C. Marani, 2 vols. (I: Text; II: Facsimile), Florence.

Francesco di Giorgio, 1989. *Das Skizzenbuch des Francesco di Giorgio Martini.* Cod. Vat. Urb. Lat. 1757. Introduction by L. Michelini Tocci, 2 vols. (I: Introduction; II: Facsimile), Zurich.

Frosini, F. and Nova, A., 2015. *Leonardo da Vinci on Nature: Knowledge and Representation,* Venice.

Galilei, G., 1890–1909. *Le opere di Galileo Galilei,* Edizione Nazionale, 20 vols., Florence, Tipografia di G. Barbera.

Galilei, G., 1974. *Two New Sciences, including Centers of Gravity and Force of Percussion.* A new translation with introduction and notes by S. Drake, Madison (Wisconsin).

Galilei, G., 2002. *Le Mecaniche.* Critical ed. and introductory essay by R. Gatto, Florence.

Galluzzi, P. (ed.), 1974. *Leonardo letto e commentato,* Florence.

Galluzzi, P., 1980. *Momento. Studi Galileiani,* Rome.

Galluzzi, P., 1987a. "Leonardo da Vinci: From the 'Elementi machinali' to the man-machine," *History and Technology,* IV, 1–4, pp. 235–265.

Galluzzi, P. (ed.), 1987b. *Leonardo da Vinci Engineer and Architect* (Catalogue of exhibition at Musée des Beaux Arts, Montreal, May 22–November 8, 1987), Florence.

Galluzzi, P., 1988. "Leonardo e i proporzionanti," XXVIII Lettura Vinciana (April 16, 1988), Florence.

Galluzzi, P. (ed.), 1991. *Prima di Leonardo. Cultura delle macchine a Siena nel Rinascimento* (Catalogue of exhibition at Magazzini del Sale, Siena, June 9–September 30, 1991), Milan.

Galluzzi, P., 1991. "Le macchine senesi. Ricerca antiquaria, spirito di innovazione e cultura del territorio," in P. Galluzzi (ed.), pp. 15–44.

Galluzzi, P., 1996a. *Renaissance Engineers. From Brunelleschi to Leonardo da Vinci* (Catalogue of exhibition at Palazzo Strozzi, Florence, June 22, 1996–February 2, 1997), Florence.

Galluzzi, P., 1996b. "Ritratti di macchine dal Quattrocento" (Keynote address at inauguration of 1995–1996 Academic Year, University of Florence), pp. 37–66, Florence.

Galluzzi, P., 2003. "I 'sostentaculi' nel f. 238r," in *Leonardo da Vinci 1452–1519. Disegni di Leonardo da Vinci e della sua cerchia nel Gabinetto dei Disegni e Stampe delle Gallerie dell'Accademia di Venezia*, pp. 186–201, Florence.

Galluzzi, P., 2005. "Machinae pictae. Immagine e idea della macchina negli artisti-ingegneri del Rinascimento," *Machina*, pp. 243–272.

Galluzzi, P. (ed.), 2006. *The Mind of Leonardo. The Universal Genius at Work* (Catalogue of exhibition at Uffizi Gallery, Florence, March 28, 2006–January 7, 2007), Florence.

Galluzzi, P., 2011. *Tra atomi e indivisibili. La materia ambigua di Galileo,* Florence.

Galluzzi, P., 2015. "Contro gli 'altori che hanno sol colla immaginazione voluto farsi interprete 'n fra la natura e l'omo," in P. C. Marani and M. T. Florio (eds.), pp. 261–270.

Galluzzi, P., 2017. *The Lynx and the Telescope. The Parallel Worlds of Federico Cesi and Galileo Galilei,* Leiden (Netherlands) and Boston.

Galluzzi, P. (ed.), 2018. *Water as microscope of nature. Leonardo da Vinci's Codex Leicester* (catalogue of the exhibition, Uffizi Gallery, Florence, October 30, 2018–January 20, 2019), Florence.

Galluzzi, P., 2019. *The common centre of the Elements "soul and guide" of motion,* in J. Barone (ed.), pp. 184–191.

Gaye, G., 1839. *Carteggio inedito d'artisti dei secoli XIV, XV, XVI, pubblicato ed illustrato con documenti pure inediti,* Florence, Giuseppe Molini.

Ghiberti, L., 1998. *I Commentarii.* Introduzione e cura di Lorenzo Bartoli, Firenze.

Giacomelli, R., 1936. *Gli scritti di Leonardo da Vinci sul volo,* Rome.

Gille, B., 1964. *Les ingénieurs de la Renaissance,* Paris.

Gorman, M. J. and Wilding, N., 2000. *La Technica Curiosa di Kaspar Schott.* Introductory essay by M. J. Gorman and N. Wilding, with a linguistic study and annotated translations from Latin by M. Sonnino. Preface by P. Galluzzi, Rome.

Grafton, A., 2005. *Magic and Technology in Early Modern Europe* (Dibner Library Lecture, October 15, 2002), Washington, D.C.

Guido da Vigevano, 1993. *Le macchine del Re. Il* Texaurus Regis Francie. Transcription and translation of, and commentary on, Cod. Lat. 11015, Bibliothèque Nationale de France, Paris, by G. Ostuni, Vigevano.

Guillaume, J. (ed.), 1988. *Les Traités d'architecture de la Renaissance,* Paris.

Hall, B. S., 1979. *The Technological Illustrations of the So Called "Anonymous of the Hussite Wars,"* Codex Lat. Monacensis 197. I, Wiesbaden.

Hall, B. S. and West, D. C. (eds.), 1976. *On Premodern Technology and Science: A Volume of Studies in Honor of Lynn White Jr.,* Malibu.

Hall, R. A., 1976. "Guido's *Texaurus* 1335," in Hall and West, pp. 11–52.

Innocenzi, P., 2019. *The Innovators behind Leonardo. The True Story of the Scientific and Technological Renaissance,* Springer.

Juren, V., 1974. "Fra Giovanni Giocondo et le début des études vitruviennes en France," *Rinascimento,* s. II, XIV, pp. 101–105.

Keele, K., 1983. *Leonardo da Vinci's Elements of the Science of Man,* London and New York.

Kemp, M., 1977. "From 'Mimesis' to 'Fantasia': The Quattrocento vocabulary of creation, inspiration and genius," *Art History,* I, 2, pp. 134–161.

Kemp, M., 1991. "La 'diminutione di ciascun piano'. La rappresentazione delle forme nello spazio di Francesco di Giorgio," in P. Galluzzi (ed.), pp. 105–112.

Kircher, A., 1654. *Magnes, sive de Arte magnetica opus tripartitum quo universa magnetis natura eiusque in omnibus scientiis et artibus usus nova methodo explicatur,* Romae, sumptibus Blasii Derversini et Zanobii Masotti bibliopolarum, typis Vitalis Mascardi.

Kucher, M. P., 2005. *The Water Supply System of Siena, Italy. The Medieval Roots of the Modern Networked City,* New York and London.

Kyeser, K., 1967. *Bellifortis. Hrsg. der Georg-Agricola-Gesellschaft zur Förderung der Geschichte der Naturwissenschaften und der Technik. Umschrift und Übersetzung von Götz Quarg,* 2 vols., Düsseldorf.

Lagrange, J.-L., 1788. *Mécanique analytique,* Paris, chez la veuve Desaint.

Lamberini, D., 1991. "La fortuna delle macchine senesi nel cinquecento," in P. Galluzzi (ed.), pp. 134–146.

Lamberini, D., 2001. "Disegno tecnico e rappresentazione prospettica nel Rinascimento," *Bollettino degli Ingegneri,* VII, pp. 3–10.

Lamberini, D., 2003. "Machines in perspective: Technical drawings in unpublished treatises and notebooks of the Italian Renaissance," in L. Massey (ed.), pp. 213–233.

La Regina, A. (ed.), 1999. *L'arte dell'assedio di Apollodoro di Damasco.* Contributions by A. La Regina, G. Commare, L. Nista, G. Martines, A. M. Liberati, and M. A. Tomei, Milan.

La science, 1960. *La science au XVIᵉ siècle* (proceedings of the International Conference, Royaumont, July 1–4, Paris), Paris.

Laurenza, D., 2004. "Leonardo nella Roma di Leone X, c. 1513–16: gli studi ana-tomici, la vita, l'arte," XLII Lettura Vinciana (April 12, 2003), Florence.

Laurenza, D., 2008. *Leonardo. Il volo,* Florence.

Lefèvre, W. (ed.), 2004. *Picturing Machines 1400–1700,* Cambridge, Mass. and London.

Leonardo da Vinci, 1973–1980. *Il Codice Atlantico.* Diplomatic and critical tran-scriptions by A. Marinoni, 24 vols. (12 of facsimile and 12 of transcrip-tions), Florence.

Leonardo da Vinci, 1974. L. Reti (ed.), *The Madrid Codices,* 5 vols. (I–II: Transcrip-tions and translations; III: Introduction; IV–V: Facsimiles), New York and London.

Leonardo da Vinci, 1976. *Codice sul volo degli uccelli.* Diplomatic and critical tran-scriptions by A. Marinoni, Florence.

Leonardo da Vinci, 1978–1980. K. D. Keele and C. Pedretti (eds.), *Corpus of the Anatomical Studies in the Collection of Her Majesty the Queen at Windsor Castle,* 3 vols. (I–II: Transcriptions; III: Facsimile), London.

Leonardo da Vinci, 1986. *Il Manoscritto C.* Diplomatic and critical transcriptions by A. Marinoni, Florence.

Leonardo da Vinci, 1987a. *Il Manoscritto I.* Diplomatic and critical transcriptions by A. Marinoni, Florence.

Leonardo da Vinci, 1987b. *The Codex Hammer (Leicester).* Translated into English and annotated by C. Pedretti, Florence.

Leonardo da Vinci, 1989a. *Il Manoscritto D.* Diplomatic and critical transcriptions by A. Marinoni, Florence.

Leonardo da Vinci, 1989b. *Il Manoscritto E.* Diplomatic and critical transcriptions by A. Marinoni, Florence.

Leonardo da Vinci, 1989c. *Il Manoscritto G.* Diplomatic and critical transcriptions by A. Marinoni, Florence.

Leonardo da Vinci, 1990. *Il Manoscritto B.* Diplomatic and critical transcriptions by A. Marinoni, Florence.

Leonardo da Vinci, 1992. *I codici Forster I–III.* Diplomatic and critical transcrip-tions by A. Marinoni, 3 vols., Florence.

Leonardo da Vinci, 1998. C. Pedretti (ed.), *Il codice Arundel 263 nella British Library.* Transcription and critical notes by C. Vecce, 2 vols. (I: Facsimile; II: Tran-scriptions), Florence.

Leonardo da Vinci, 2000. *The Manuscripts of Leonardo da Vinci in the Institut de France. Manuscript I.* Translated and annotated by J. Venerella, Ente Raccolta Vinciana, Milan.

Leonardo da Vinci, 2001a. *The Manuscripts of Leonardo da Vinci in the Institut de France. Manuscript C.* Translated and annotated by J. Venerella, Ente Raccolta Vinciana, Milan.

Leonardo da Vinci, 2001b. *The Manuscripts of Leonardo da Vinci in the Institut de France. Manuscript E.* Translated and annotated by J. Venerella, Ente Raccolta Vinciana, Milan.

Leonardo da Vinci, 2002. *The Manuscripts of Leonardo da Vinci in the Institut de France. Manuscript G.* Translated and annotated by J. Venerella, Ente Raccolta Vinciana, Milan.

Leonardo da Vinci, 2003. *The Manuscripts of Leonardo da Vinci in the Institut de France. Manuscript B.* Translated and annotated by J. Venerella, Ente Raccolta Vinciana, Milan.

Leonardo da Vinci, 2018. *Codex Madrid I, Kommentierte Edition,* herausgegeben und bearbeiten von D. Lohrmann und Th. Kreft, unter Mitarbeit von V. Alertz und F. Hasters, Wien.

Libri de re rustica, 1514. *Libri de re rustica,* Venetiis [Venice], in aed. Aldi et Andreae soceri.

Lisini, A., 1935. "Notizie delle miniere della Maremma toscana e leggi per l'estrazione dei metalli nel Medioevo," *Bullettino di Storia Patria,* n.s., VI, pp. 185–256.

Lohrmann, D., 2012. "Leonardo da Vinci zwei deutsche Handwerker und eine Beschwerdebrief an Giuliano de' Medici (1515)," *Quellen und Forschungen aus italienischen Archiven und Bibliotheken,* XCVII, pp. 270–307.

Lohrmann, D., Alertz, U., and Hasters, F., 2012. "*Teorica* and *Elementi Macchinali:* two lost treatises of Leonardo da Vinci on Mechanics," *Archives Internationales d'Histoire des Sciences,* LXII, pp. 55–84.

Long, P., 1991. "Invention, authorship, intellectual property and the origin of patents: notes toward a conceptual history," *Technology and Culture,* vol. 32, pp. 846–884.

Long, P., 1997. "Power, patronage and the authorship of arts: From mechanical know-how to mechanical knowledge in the last scribal age," *Isis,* LXXXVIII, pp. 1–41.

Long, P., 2001. *Openness, Secrecy, Authorship: Technical Arts and the Culture of Knowledge from Antiquity to the Renaissance,* Baltimore.

Long, P., 2004. "Picturing the machine: Francesco di Giorgio and Leonardo da Vinci in the 1490s," in W. Lefèvre (ed.), pp. 116–141.

Lorini, B., 1609. *Le fortificazioni nuovamente ristampate,* in Venetia [Venice], presso Francesco Rampazzetto.

Lo Sardo, E. (ed.), 1999. *Iconismi e mirabilia da Athanasius Kircher.* Edited and with an essay by E. Lo Sardo; note by R. Vlad; introduction by U. Eco, Rome.

Maccagni, C., 1974. "Ricercando il problema delle fonti di Leonardo. L'elenco dei libri ai fogli 2v–3r del Codice 8936 della Biblioteca Nacional di Madrid," X Lettura Vinciana (April 15, 1970), in P. Galluzzi (ed.), pp. 273–307.

Machiavelli, N., 1532. *Historie fiorentine di Niccolò Machiavelli cittadino et segretario fiorentino,* in Firenze [Florence], per Bernardo di Giunta.

Machina, 2005. M. Veneziani (ed.), *Machina. XI Colloquio Internazionale del Lessico Intellettuale Europeo* (Rome, January 8–10, 2004), Rome.

Manno, A., 1987. "Giulio Savorgnan. *Machinatio* e *Ars fortificatoria* a Venezia," in *Cultura, Scienze e Tecniche,* pp. 227–245.

Marani, P. C., 1982. "Leonardo, Francesco di Giorgio e il tiburio del Duomo di Milano," *Arte Lombarda,* n.s. LXII, pp. 81–92.

Marani, P. C., 1987. "'I vari lochi richiegan variare le forteze secondo la lor natura.' Leonardo e Francesco di Giorgio: architettura militare e territorio," *Raccolta Vinciana,* XXII, pp. 71–73.

Marani, P. C., 2014. *L'occhio di Leonardo. Studi di ottica e di prospettiva. Disegni di Leonardo dal Codice Atlantico,* Novara.

Marani, P. C. and Florio, M. T. (eds.), 2015. *Leonardo da Vinci 1452–1519. Il disegno del mondo* (Catalogue of exhibition held in Milan, April 16–July 19, 2015), Milan.

Mariano di Iacopo known as Taccola, 1969. J. Bech (ed.), *Liber tertius de ingeneis et edifitiis non usitatis,* Milan.

Mariano di Iacopo known as Taccola, 1971. G. Scaglia (ed.), De machinis. *The Engineering Treatise of 1449,* 2 vols. (I: Introduction and transcriptions; II: Facsimile), Wiesbaden.

Mariano di Iacopo known as Taccola, 1984a. De ingeneis. Liber primus leonis, liber secundus draconis; *addenda Book I and II, on engines, and addenda (the Notebook),* by G. Scaglia, F. Prager, and U. Montag, 2 vols. (I: Text; II: Facsimile), Wiesbaden.

Mariano di Iacopo known as Taccola, 1984b. De rebus militaribus *(De machinis, 1449) mit dem vollständigen Faksimile der Pariser Handschrift.* Introduction by E. Knobloch, Baden Baden.

Marinoni, A., 1982. *La matematica di Leonardo da Vinci. Una nuova immagine dell'artista scienziato,* Milan.

Massey, L. (ed.), 2003. *The Treatises on Perspective: Published and Unpublished,* Washington, D.C.

McGee, D., 2004. "The origin of early modern machine design," in W. Lefèvre (ed.), pp. 53–84.

Micheli, G., 1992. "Guidobaldo del Monte e la meccanica," in *Matematizzazione dell'Universo,* Assisi, pp. 87–104.

Micheli, G., 1995. *Le origini del concetto di macchina,* Florence.

Michelini Tocci, L., 1962. "Disegni e appunti di Francesco di Giorgio in un codice di Taccola," in *Scritti di storia dell'arte,* pp. 203–212.

Michelini Tocci, L., 1986. "Federico da Montefeltro e Ottaviano Ubaldini della Corda," in *Federico da Montefeltro. Lo Stato, le Arti, la Cultura,* Rome, pp. 297–284.

Montesinos, J. and Solis, C. (eds.), 2001. *Largo campo di filosofare. Eurosymposium Galileo 2001,* La Orotava.

Moon, F. C., 2007. *The Machines of Leonardo da Vinci and Franz Reuleaux: Kinematics of Machines from the Renaissance to the 20th Century,* Dordrecht.

Mottana, A., 2017. *La Bilancetta di Galileo. Un momento fondamentale nella storia dell'idrostatica e del peso specifico,* Florence.

Mussini, M., 1991. "Un frammento del Trattato di Francesco di Giorgio Martini nell'archivio di G. B. Venturi alla Biblioteca Municipale di Reggio Emilia," in P. Galluzzi (ed.), pp. 81–92.

Mussini, M., 1993. "La trattatistica di Francesco di Giorgio: un problema critico aperto," in F. P. Fiore and M. Tafuri (eds.), pp. 358–379.

Mussini, M., 2003. *Francesco di Giorgio e le traduzioni del* De architectura *nei codici Zichy, Spencer 129 e Magliabechiano II.I.141,* Florence.

Nanni, R., 2011. "Il 'badalone' di Filippo Brunelleschi e l'iconografia del 'navigium' tra Guido da Vigevano e Leonardo," *Annali di Storia di Firenze,* VII, pp. 66–119.

Nanni, R., 2013. *Leonardo e le arti meccaniche.* With contributions by M. Biffi, F. Giusberti, A. Neuwahl, and D. Russo, Milan.

Napoleon III and Favé, I., 1846–1862. *Étude sur le passé et l'avenir de l'artillerie,* 3 vols., Paris.

Nova, A. and Laurenza, D. (eds.), 2011. *Leonardo da Vinci's Anatomical World. Language, Context and "Disegno,"* Venice.

Oechslin, W., 1976. "La fama di Aristotele Fioravanti ingegnere e architetto," in *Arte Lombarda,* n.s., XLIV–XLV, pp. 102–120.

Palmerino, C. R., 2000. "Una nuova scienza della materia per la Scienza Nova del moto. La discussione dei paradossi dell'infinito nella prima giornata dei *Discorsi* galileiani," in E. Festa and R. Gatto (eds.), pp. 275–319.

Papini, R., 1946. *Francesco di Giorgio architetto,* 3 vols., Florence.

Parson, W. B., 1939. *Engineers and Engineering in the Renaissance,* Baltimore.

Pedretti, C., 1977. *The Literary Works of Leonardo da Vinci. A Commentary to Jean Paul Richter's Edition,* 2 vols., Oxford.

Pedretti, C., 1987. *Introduction,* in P. Galluzzi (ed.), pp. 1–21.

Pedretti, C., 2000. *L'anatomia di Leonardo da Vinci fra Mondino e Berengario.* With an introductory essay by P. Salvi, Prato.

Pedretti, C. (ed.), 2015. *Leonardo da Vinci. I cento disegni più belli delle raccolte di tutto il mondo. Anatomia e studi di natura.* Selected and classified by C. Pedretti with the assistance of S. Taglialagamba and an essay by P. Salvi, Florence.

Philandrier, G., 1545. *In decem libros M. Vitruvii Pollionis de Architectura adnotationes,* Parisiis [Paris], apud Iacobum Kerver.

Piccolomini, A., 1565. *In Mechanicas Quaestiones Aristotelis Paraphrasis paulo quidem plenior,* Venetiis [Venice], apud Traianum Curtium.

Piccolomini, A., 1582. *Parafrasi [. . .] sopra le Mecaniche d'Aristotele, tradotta da Oreste Vannocci Biringucci,* in Roma [Rome], per Francesco Zanetti.

Popplow, M., 2002. *Models of Machines: A Missing Link between Early Modern Engineering and Mechanics?,* Berlin.

Popplow, M., 2004. "Why draw pictures of machines? The social context of early modern machine drawings," in W. Lefèvre (ed.), pp. 17–48.

Prager, F. D., 1946. "Brunelleschi's Patent," in *Journal of the Patent Office Society,* XXVIII, pp. 109–135.

Prager, F. D., 1968a. "A manuscript of Taccola quoting Brunelleschi on problems of inventors and builders," *Proceedings of the American Philosophical Society,* CXII, 3, pp. 131–149.

Prager, F. D., 1968b. "Fontana on fountains," in *Physis,* XIII, 3–4, pp. 341–360.

Prager, F. D. and Scaglia, G., 1970. *Brunelleschi. Studies of his technology and inventions,* Cambridge, Mass. and London.

Prager, F. D. and Scaglia, G., 1972. *Mariano Taccola and His Book* De ingeneis, Cambridge, Mass. and London.

Ramelli, A., 1588. *Le diverse et artificiose machine, composte in lingua italiana e francese,* Parigi [Paris], in casa dell'autore.

Ramelli, A., 1991. G. Scaglia, A. Carugo, and E. S. Ferguson (eds.), *Le diverse et artificiose machine, composte in lingua italiana e francese,* Milan (facsimile reprint of Ramelli, A., 1588).

Renn, J. and Damerow, P., 2010. *Guidobaldo del Monte's* Mechanicorum liber, Berlin.

Renn, J. and Valleriani, M., 2000. "Galileo and the challenge of the Arsenal," Letture Galileiane, *Nuncius,* XVI, pp. 505–510.

Reti, L., 1963. "Francesco di Giorgio Martini's Treatise on engineering and his plagiarists," *Technology and Culture,* IV, 3, pp. 287–298.

Reti, L., 1964. "Tracce dei progetti perduti di Filippo Brunelleschi nel Codice Atlantico," IV Lettura Vinciana (April 15, 1964), Florence (reprinted in P. Galluzzi, ed., 1974, pp. 83–130).

Reti, L., 1965. "A postscript to the Filarete discussion: On horizontal waterwheels and smelter blowers in the writings of Leonardo da Vinci and Juanelo Turriano," *Technology and culture,* 6, pp. 428–441.

Reti, L. (ed.), 1974a. *Leonardo,* Milan.

Reti, L., 1974b. "Elementi di macchine," in L. Reti (ed.), pp. 264–287.

Ricci, M., 2014. *Il genio di Filippo Brunelleschi e la costruzione della cupola di Santa Maria del Fiore,* Florence.

Rose, P. L., 1968. "The Taccola manuscripts," *Physis,* X, 4, pp. 337–346.

Rose, P. L., 1975. *The Italian Renaissance of Mathematics: Studies on Humanists and Mathematicians from Petrarch to Galileo,* Geneva.

Saalman, H., 1980. *Filippo Brunelleschi: The Cupola of Santa Maria del Fiore,* London.

Sabbadini, R., 1931. *Il carteggio di Giovanni Aurispa,* Rome.

Salvi, P., 2013. *L'anatomia di Leonardo: figurare e descrivere. Contesti e metodi di visualizzazione anatomica in Leonardo da Vinci.* Introduction by C. Pedretti, Poggio a Caiano.

Scaglia, G., 1960–1961. "Drawings of Brunelleschi's mechanical inventions from the construction of the Cupola," *Marsyas,* X, pp. 45–68.

Scaglia, G., 1966. "Drawings of machines for architecture from the early Quattrocento in Italy," *Journal of the Society for Architectural Historians,* XXV, 2, pp. 90–114.

Scaglia, G., 1968. "The allegorical portrait of Emperor Sigismond by Mariano Taccola of Siena," *Journal of the Warburg and Courtauld Institutes,* XXXI, pp. 428–434.

Scaglia, G., 1981. "Alle origini degli studi tecnologici di Leonardo da Vinci," XX Lettura Vinciana (April 20, 1980), Florence.

Scaglia, G., 1982. "Leonardo e Francesco di Giorgio a Milano nel 1490," in E. Bellone and P. Rossi (eds.), pp. 225–253.

Scaglia, G., 1985. Il "Vitruvio" Magliabechiano di Francesco di Giorgio Martini, Florence.

Scaglia, G., 1988. "The development of Francesco di Giorgio's Treatises in Siena," in J. Guillaume (ed.), pp. 91–97.

Scaglia, G., 1991. "Francesco di Giorgio, autore," in P. Galluzzi (ed.), 1991, Milan, pp. 57–80.

Scaglia, G., 1992. Francesco di Giorgio: Checklist and History of Manuscripts and Drawings in Autographs and Copies from ca. 1470 to 1687 and Renewed Copies 1764–1839, Bethlehem.

Schelby, L. R., 1975. "Mariano Taccola and his books on engines and machines," Technology and Culture, XVI, 3, pp. 466–475.

Schott, K., 1657. Mechanica Hydraulica-Pneumatica, Francofurti [Frankfurt], excudebat Henricus Pigrin.

Schott, K., 1657-1659. Magia universalis naturae et artis, sive recondita naturalium et artificialium rerum scientia, 4 vols., Herbipoli [Würzburg], sumptibus haeredum Johannes Godefridi Schönwetteri.

Schott, K., 1664. Technica curiosa, sive mirabilia artis, Herbipoli [Würzburg], sumptibus Johannis Andreae Endteri, excudebat Jobus Hertz.

Scolari, M., 2005. Il disegno obliquo: una storia dell'antiprospettiva, Venice.

Scolari, M., 2012. Oblique Drawing. A History of Anti-perspective, Cambridge, Mass.

Scritti di storia dell'arte, 1962. Scritti di storia dell'arte in onore di Mario Salmi, Rome.

Spencer, J. R., 1963. "Filarete's description of a fifteenth century Italian iron smelter," Technology and Culture, IV, 2, pp. 201–206.

Strano, G., 2008. Galileo's telescope. The instrument that changed the world (Catalogue of exhibition at Museo Galileo, Florence, March 4, 2008-January 31, 2009), Florence.

Taccola: see Mariano di Iacopo.

Tafuri, M., 1969. "Cesare Cesariano e gli studi vitruviani nel Quattrocento," in A. Bruschi, C. Maltese, M. Tafuri, and R. Bonelli (eds.), pp. 387–437.

Tafuri, M., 1987. "Daniele Barbaro e la cultura scientifica veneziana del '500," in Cultura, scienze e tecniche, pp. 55–81.

Thorndike, L., 1955. "Marianus Jacobus Taccola," *Archives Internationales d'Histoire des Sciences,* n.s., VIII, 30, pp. 7–26.

Tugnoli Pattaro, S., 1976. "Le opere bolognesi di Aristotele Fioravanti architetto e ingegnere del secolo quindicesimo," *Arte Lombarda,* n.s., XLIV–XLV, pp. 35–70.

Uccelli, A., 1940. *Leonardo da Vinci. I libri di meccanica,* Milan.

Uzielli, G., 1904. *Le deviazioni dei fiumi negli assedi di Lucca, Pisa ecc. e in altre imprese guerresche, ossia difesa di Filippo Brunelleschi, Niccolò Machiavelli e Leonardo da Vinci contro i loro accusatori* (press clipping), in *La navigazione interna in Toscana,* Florence.

Valleriani, M., 2010. *Galileo engineer,* New York.

Valturius, R., 1472. *Elenchus et index rerum militarium,* [Verona], Johannes ex Verona oriundus.

Valturius, R., 1483. *Opera de facti e precepti militari di [. . .] Robertus Valturius [. . .] traducto in vulgar da Paolo Ramusio,* in la magnifica città di Verona [Verona], impressa cum industria di Bonin de Boninis da Ragusa.

Vasari, G., 1966–1987. R. Bettarini (ed.), *Le vite de' più eccellenti pittori, scultori e architettori nelle redazioni del 1550 e 1568,* with a compilation of earlier commentaries by P. Barocchi, 9 vols., Florence.

Vecce, C., 2017. *La biblioteca perduta. I libri di Leonardo,* Roma.

Vegetius, R., 1473. *Epitoma rei militaris,* Utrecht [Ketelaer et de Leempt].

Venturi, G., 1815. *Dell'origine e dei primi progressi delle odierne artiglierie,* Reggio Emilia, Stamperia Torreggiani.

Vérin, H., 2002. "Galilée et Antoine de Ville. Un courrier sur l'idée de matière," in J. Montesinos and C. Solis (eds.), pp. 307–321.

Vestri, V., 2001. "Il privilegio del *Badalone.* Trascrizione e note storico-archivistiche," in R. Nanni, pp. 82–85.

Villard de Honnecourt, 2009. *The Portfolio of Villard de Honnecourt (Paris, Bibliothèque nationale de France, Ms. Fr. 19093).* A new critical edition and color facsimile edited by C. F. Barnes; glossary prepared by S. L. Hahn, Farnham and Burlington.

Vitruvius Pollio, M., 1486 [?]. *De architectura,* Rome [G. Herolt].

Vitruvius Pollio, M., 1511. *M. Vitruvius per Jocundum solito castigatior factus cum figuris et tabula [. . .],* Venetiis [Venice], sumptu miraque diligentia Joannis de Tridino.

Vitruvius Pollio, M., 1521. *Vitruvio traslato, commentato et raffigurato da Cesare Caesariano,* Como, Gotardus de Ponte.

Vitruvius Pollio, M., 1556. *I dieci libri dell'Architettura tradutti e commentati da Monsignor Barbaro, eletto Patriarca d'Aquileggia,* in Vinegia [Venice], appresso Francesco Marcolini.

Vitruvius Pollio, M., 1567. *I dieci libri dell'Architettura di Marco Vitruvio tradotti e commentati da Mons. Daniele Barbaro [. . .] da lui riveduti e ampliati,* in Venetia [Venice], appresso Francesco de Franceschi senese.

Vitruvius Pollio, M., 1981. A. Bruschi, A. Carugo, and F. P. Fiore (eds.), *De architectura. Traslato commentato et affigurato da Caesare Caesariano,* Milan, 1981 (facsimile reprint of Vitruvius Pollio, M., 1521).

Vitruvius Pollio, M., 1987. *I dieci libri dell'Architettura di Vitruvio tradotti e commentati da Daniele Barbaro.* With an essay by M. Tafuri and a study by M. Morresi, Milan (facsimile reprint of Vitruvius Pollio, M., 1556).

Vitruvius Pollio, M., 2003. *Vitruvius Ten Books on Architecture: The Corsini Incunabulum with the Annotations and Autograph Drawings of Giovanni Battista da Sangallo.* Edited with an introductory essay by I. D. Rowland, Rome.

Weller, A. S., 1993. *Francesco di Giorgio, 1439–1501,* Chicago.

White, L., Jr, 1969. "Kyeser's *Bellifortis:* The first technological treatise of the fifteenth century," *Technology and Culture,* X, pp. 436–441.

Zanetti, C. (ed.), 2016. *Janello Torriani. Genio del Rinascimento* (catalogue of the exhibition at Cremona Sept. 10, 2016–Jan. 29, 2017), Cremona.

Zonca, V., 1607. *Novo teatro di machine et edificii per varie et sicure operationi con le loro figure tagliate in rame et la dichiaratione et dimostratione di ciascuna,* in Padova [Padua], appresso Pietro Bertelli (facsimile reproduction ed. by C. Poni, Milan, 1985).

Zoubov, V. P., 1960. "Vitruve et ses commentateurs du XVI^e siècle," in *La science,* pp. 67–90.

Illustration Credits

Fig. 1 Konrad Kyeser: Philo's bath.
K. Kyeser, *Bellifortis,* Ms. Philos. 63, f. 114v, Niedersächsischen Staats- und Universitätsbibliothek Göttingen, Germany.

Fig. 2 Giovanni Fontana's siege ladder: overview and individual parts.
G. Fontana, *Bellicorum instrumentorum liber,* Cod. icon. 242, f. 63v, Bayerische Staatsbibliothek, Munich, Germany.

Fig. 3 Taccola: portrait of Emperor Sigismund.
Taccola, *De ingeneis III–IV,* Ms. Palatino 766, f. 1v, Biblioteca Nazionale Centrale, Florence, Italy.

Fig. 4 Taccola: ideal portrait of St. Dorothy.
Taccola, *De ingeneis III–IV,* Ms. Palatino 766, f. 42r, Biblioteca Nazionale Centrale, Florence, Italy.

Fig. 5 Taccola: Saint George slaying the dragon.
Taccola, *De ingeneis III–IV,* Ms. Palatino 766, f. 48r, Biblioteca Nazionale Centrale, Florence, Italy.

Fig. 6 Sheet from *De ingeneis* III–IV with Taccola's dedication to Sigismund.
Taccola, *De ingeneis III–IV,* Ms. Palatino 766, f. 1r, Biblioteca Nazionale Centrale, Florence, Italy.

Fig. 7 Taccola's dedication blacked out in the Paris copy of *De machinis*.
Ms. Lat. 7239, Bibliothèque Nationale de France, Paris, France.

Fig. 8 Taccola: man as microcosm.
Taccola, *De ingeneis I–II,* Clm 197, II, f. 36v, Bayerische Staatsbibliothek, Munich, Germany.

Fig. 9 First page of Taccola's interview with Brunelleschi.
Taccola, *De ingeneis I–II,* Clm 197, II, f. 107v, Bayerische Staatsbibliothek, Munich, Germany.

Fig. 10 Allusive portrait of Brunelleschi with "sewn" mouth (detail).
Taccola, *De ingeneis I–II,* Clm 197, II, f. 108v, Bayerische Staatsbibliothek, Munich, Germany.

Fig. 11 Taccola: symbolic image of the virtue of discretion.
Taccola, *De ingeneis I–II*, Clm 197, II, f. 30r, Bayerische Staatsbibliothek, Munich, Germany.

Fig. 12 Taccola: symbolic image of the inventor "mute as a fish."
Taccola, *De ingeneis I–II*, Clm 197, II, f. 31r, Bayerische Staatsbibliothek, Munich, Germany.

Fig. 13 Taccola: interpretation of Brunelleschi's three-speed hoist.
Taccola, *De ingeneis III–IV*, Ms. Palatino 766, f. 10r, Biblioteca Nazionale Centrale, Florence, Italy.

Fig. 14 Leonardo da Vinci: drawing of Brunelleschi's three-speed hoist.
Leonardo da Vinci, *Codex Atlanticus*, f. 1083v, Biblioteca Ambrosiana, Milan, Italy.

Fig. 15 Taccola: excavation and transportation by land and sea of a marble column.
Taccola, *De ingeneis III–IV*, Ms. Palatino 766, ff. 14v–15r, Biblioteca Nazionale Centrale, Florence, Italy.

Fig. 16 After Taccola: damming a river by means of stone-laden boats.
P. Santini (after Taccola), *De machinis*, Ms. Lat. 7239, f. 8v, Bibliothèque Nationale de France, Paris, France.

Fig. 17 Taccola: miller dozing on floating flour mill.
Taccola, *De ingeneis III–IV*, Ms. Palatino 766, f. 39r, Biblioteca Nazionale Centrale, Florence, Italy.

Fig. 18 Taccola: boatman relaxing on boat moving upstream.
Taccola, *De ingeneis III–IV*, Ms. Palatino 766, ff. 44v–45r, Biblioteca Nazionale Centrale, Florence, Italy.

Fig. 19 Taccola: lady operating a suction pump.
P. Santini (after Taccola), *De machinis*, Ms. Lat. 7239, f. 42v, Bibliothèque Nationale de France, Paris, France.

Fig. 20 Taccola: a diver helps to raise a column from the seabed.
Taccola, *De ingeneis III–IV*, Ms. Palatino 766, f. 18r, Biblioteca Nazionale Centrale, Florence, Italy.

Fig. 21 Taccola: *eques scopetarius*.
Taccola, *De machinis*, Clm 28800, f. 75v, Bayerische Staatsbibliothek, Munich, Germany.

Fig. 22 Taccola: weaponry carried by *eques scopetarius*.
Taccola, *De ingeneis I–II*, Clm 197, II, f. 21r, Bayerische Staatsbibliothek, Munich, Germany.

Fig. 23 Guido da Vigevano: assault tower with its wheels tilted.
Guido da Vigevano, *Texaurus,* Ms. Lat. 11015, f. 52v, Bibliothèque Nationale de
France, Paris, France.

Fig. 24 Taccola: floating mill.
Taccola, *De ingeneis III–IV,* Ms. Palatino 766, f. 29r, Biblioteca Nazionale Centrale,
Florence, Italy.

**Fig. 25 Taccola: boat armored for protection from boulders launched by ene-
mies barricaded in tree houses.**
Taccola, *De machinis,* Clm 28800, f. 81v, Bayerische Staatsbibliothek, Munich,
Germany.

Fig. 26 Taccola: hydraulic fulling mill.
Taccola, *De ingeneis I–II,* Clm 197, II, f. 40r, Bayerische Staatsbibliothek, Munich,
Germany.

Fig. 27 Taccola: tide flour mill.
Taccola, *De ingeneis III–IV,* Ms. Palatino 766, ff. 8v–9r, Biblioteca Nazionale Cen-
trale, Florence, Italy.

Fig. 28 Taccola: weary workman operating a winch (detail).
Taccola, *De ingeneis III–IV,* Ms. Palatino 766, f. 24r, Biblioteca Nazionale Centrale,
Florence, Italy.

Fig. 29 Taccola: trees bent by the wind on a riverbank.
Taccola, *De machinis,* Clm 28800, f. 88v, Bayerische Staatsbibliothek, Munich,
Germany.

Fig. 30 Taccola: archer and man launching incendiary projectiles.
Taccola, *De ingeneis I–II,* Clm 197, II, f. 49r, Bayerische Staatsbibliothek, Munich,
Germany.

Fig. 31 Taccola: armored fire-carrying water buffalo.
Taccola, *De machinis,* Clm 28800, f. 76v, Bayerische Staatsbibliothek, Munich,
Germany.

Fig. 32 Taccola: fish farm with canal linking it to the sea.
Taccola, *De ingeneis I–II,* Clm 197, II, f. 99r, Bayerische Staatsbibliothek, Munich,
Germany.

Fig. 33 Fox holding captured bird, used by Taccola as bookmark (detail).
Taccola, *De ingeneis III–IV,* Ms. Palatino 766, f. 37v, Biblioteca Nazionale Centrale,
Florence, Italy.

Fig. 34 Taccola: ostrich chasing away enemy cavalry (detail).
Taccola, *De ingeneis I–II,* Clm 197, II, f. 38v, Bayerische Staatsbibliothek, Munich,
Germany.

Fig. 35 Taccola: stenographic sketch of scythed chariot in action (detail).
Taccola, *De ingeneis I–II*, Clm 197, II, f. 54v, Bayerische Staatsbibliothek, Munich, Germany.

Fig. 36 Taccola: floating house made of wooden beams and canes.
Taccola, *De machinis*, Clm 28800, f. 61v, Bayerische Staatsbibliothek, Munich, Germany.

Fig. 37 Taccola: method for excavating tunnels with a constant gradient.
Taccola, *De ingeneis III–IV*, Ms. Palatino 766, f. 33r, Biblioteca Nazionale Centrale, Florence, Italy.

Fig. 38 Taccola: amphibious carriage with sail mast drawn by a water buffalo.
Taccola, *De ingeneis III–IV*, Ms. Palatino 766, ff. 27v–28r, Biblioteca Nazionale Centrale, Florence, Italy.

Fig. 39 Taccola: high-tech fisherman.
Taccola, *De machinis*, Clm 28800, f. 84r, Bayerische Staatsbibliothek, Munich, Germany.

Fig. 40 Taccola: night fishing with lamps.
Taccola, *De ingeneis I–II*, Clm 197, II, f. 119v, Bayerische Staatsbibliothek, Munich, Germany.

Fig. 41 Taccola: retrieving valuables by means of an underwater bell with candle.
Taccola, *De ingeneis I–II*, Clm 197, II, f. 119v, Bayerische Staatsbibliothek, Munich, Germany.

Fig. 42 Taccola: waterproof lamp with a sponge inside (detail).
Taccola, *De ingeneis I–II*, Clm 197, II, f. 73v, Bayerische Staatsbibliothek, Munich, Germany.

Fig. 43 Anonymous: diver with bellows for breathing and lantern with sponge and lit candle.
Ms. Palatino 767, p. 9, Biblioteca Nazionale Centrale, Florence, Italy.

Fig. 44 Taccola: incendiary cats and mice destroy a fortress.
Taccola, *De machinis*, Clm 28800, f. 77r, Bayerische Staatsbibliothek, Munich, Germany.

Fig. 45 Taccola: stratagem for sinking an enemy ship.
Taccola, *De ingeneis I–II*, Clm 197, II, f. 10v, Bayerische Staatsbibliothek, Munich, Germany.

Fig. 46 Taccola: enogastronomic stratagem for trapping the enemy.
Taccola, *De ingeneis I–II*, Clm 197, II, f. 21v, Bayerische Staatsbibliothek, Munich, Germany.

Fig. 47 Taccola: stratagem with horses hoofed back to front.
P. Santini (after Taccola, *De machinis*), Ms. Lat. 7239, f. 10r, Bibliothèque Nationale de France, Paris, France.

Fig. 48 Taccola: stratagem with a dog ringing a bell.
P. Santini (after Taccola, *De machinis*), Ms. Lat. 7239, f. 7r, Bibliothèque Nationale de France, Paris, France.

Fig. 49 Taccola: armored fire-bearing great danes exhibiting their male "attributes."
Taccola, *De machinis,* Clm 28800, f. 57r, Bayerische Staatsbibliothek, Munich, Germany.

Fig. 50 Notes and sketches by Francesco di Giorgio in Taccola's *De ingeneis I–II*.
Taccola, *De ingeneis I–II,* Clm 197, II, f. 130v, Bayerische Staatsbibliothek, Munich, Germany.

Fig. 51 Francesco di Giorgio: column-raising machine.
Francesco di Giorgio, *Codicetto,* Ms. Lat. Urb. 1757, f. 118r, Biblioteca Apostolica Vaticana, Vatican City.

Fig. 52 Francesco di Giorgio: wagons with complex gears propelled by manpower.
Francesco di Giorgio, *Codicetto,* Ms. Lat. Urb. 1757, f. 116v, Biblioteca Apostolica Vaticana, Vatican City.

Fig. 53 Francesco di Giorgio: method for moving a tower without damaging it.
Francesco di Giorgio, *Opusculum de architectura,* Ms. 197.b.21, f. 26r, British Museum, London, UK.

Fig. 54 Anonymous Sienese Engineer: flying man.
Ms. Add. 34113, f. 189v, British Library, London, UK.

Fig. 55 Anonymous Sienese Engineer: man with parachute.
Ms. Add. 34113, f. 200v, British Library, London, UK.

Fig. 56 Francesco di Giorgio: protection and aiming systems for bombards.
Francesco di Giorgio, *Trattato I,* Ms. Ashburnham 361, f. 51v, Biblioteca Medicea Laurenziana, Florence, Italy.

Fig. 57 Francesco di Giorgio: five types of pumps.
Francesco di Giorgio, *Trattato I,* Ms. Ashburnham 361, f. 42v, Biblioteca Medicea Laurenziana, Florence, Italy.

Fig. 58 Direct dialogue between text and images on a sheet of "tirari e alzari" (hauling and lifting devices) of Francesco di Giorgio's *Trattato I*.
Francesco di Giorgio, *Trattato I,* Ms. Ashburnham 361, f. 45v, Biblioteca Medicea Laurenziana, Florence, Italy.

Fig. 59 Francesco di Giorgio: flour mill whose parts are distributed in box-like structures.
Francesco di Giorgio, *Opusculum de architectura,* Ms. 197.b.21, f. 75r, British Museum, London, UK.

Fig. 60 Francesco di Giorgio: horse-driven treadwheel powering a mill grindstone.
Francesco di Giorgio, *Opusculum de architectura,* Ms. 197.b.21, f. 74v, British Museum, London, UK.

Fig. 61 Francesco di Giorgio: sand and gravel filters to trap water impurities.
Francesco di Giorgio, *Opusculum de architectura,* Ms. 197.b.21, f. 27r, British Museum, London, UK.

Fig. 62 Leonardo da Vinci: drawing of cart for carrying a bombard (detail).
Leonardo da Vinci, *Codex Atlanticus,* f. 94r, Biblioteca Ambrosiana, Milan, Italy.

Fig. 63 Leonardo da Vinci: pump operated by means of an oscillating arm.
Leonardo da Vinci, *Ms. B,* f. 54r, Institut de France, Paris, France.

Fig. 64 Leonardo da Vinci: man operates flying machine using even the force of his head.
Leonardo da Vinci, *Ms. B,* f. 80r, Institut de France, Paris, France.

Fig. 65 Leonardo da Vinci: the imposing structure of the flying machine.
Leonardo da Vinci, *Ms. B,* f. 89r, Institut de France, Paris, France.

Fig. 66 Leonardo da Vinci: overhead and ground-level views of a *tirare* (hauling device).
Leonardo da Vinci, *Ms. Madrid I,* f. 44v, Biblioteca Nacional, Madrid, Spain.

Fig. 67 Leonardo da Vinci: study of a crank system with exploded view of mechanism.
Leonardo da Vinci, *Ms. Madrid I,* f. 66v, Biblioteca Nacional, Madrid, Spain.

Fig. 68 Leonardo da Vinci: reduction of screw to continuous inclined plane.
Leonardo da Vinci, *Ms. Madrid I,* f. 86v, Biblioteca Nacional, Madrid, Spain.

Fig. 69 Leonardo da Vinci: detail of pad to reduce friction on ratchet jack.
Leonardo da Vinci, *Ms. Madrid I,* f. 26r, Biblioteca Nacional, Madrid, Spain.

Fig. 70 Leonardo da Vinci: detailed analysis of mechanism to generate alternating movement.
Leonardo da Vinci, *Ms. Madrid I,* f. 17r, Biblioteca Nacional, Madrid, Spain.

Fig. 71 Leonardo da Vinci: hammers striking gear-wheel pins in sequence.
Leonardo da Vinci, *Ms. Madrid I,* f. 92v, Biblioteca Nacional, Madrid, Spain.

Fig. 72 Leonardo da Vinci: endless screw.
Leonardo da Vinci, *Ms. Madrid I,* f. 70r, Biblioteca Nacional, Madrid, Spain.

Fig. 73 Leonardo da Vinci: axle worn down by friction (detail).
Leonardo da Vinci, *Ms. Madrid I,* c. 119r, Biblioteca Nacional, Madrid, Spain.

Fig. 74 Leonardo da Vinci: mechanical interpretation of the structure supporting the head.
Leonardo da Vinci, *Anatomical Mss.,* K/P 179v (RL 19075v), Royal Library, Windsor, UK.

Fig. 75 Leonardo da Vinci: geometric schematization of human breathing mechanism (detail).
Leonardo da Vinci, *Anatomical Mss.,* K/P 149v (RL 19015v), Royal Library, Windsor, UK.

Fig. 76 Leonardo da Vinci: exploded view of cranial box.
Leonardo da Vinci, "Weimar Sheet," Schlossmuseum, Weimar, Germany.

Fig. 77 Leonardo da Vinci: drawings of the hand at different depths.
Leonardo da Vinci, *Anatomical Mss.,* K/P 143r (RL 19009r), Royal Library, Windsor, UK.

Fig. 78 Leonardo da Vinci: drawings of the structure of the torso at different depths.
Leonardo da Vinci, *Anatomical Mss.,* K/P 149r (RL 19015r), Royal Library, Windsor, UK.

Fig. 79 Leonardo da Vinci: model of human leg.
Leonardo da Vinci, *Anatomical Mss.,* K/P 152r (RL 12619r), Royal Library, Windsor, UK.

Fig. 80 Leonardo da Vinci: the devices supporting the human head.
Leonardo da Vinci, *Anatomical Mss.,* K/P 62v (RL 19121v), Royal Library, Windsor, UK.

Fig. 81 Leonardo da Vinci: experiment to measure the incidence of attrition (detail).
Leonardo da Vinci, *Codex Forster II²,* f. 87r, Victoria & Albert Museum, London, UK.

Fig. 82 Leonardo da Vinci: studies on the mathematical center and the center of revolution of balances.
Leonardo da Vinci, *Codex on the flight of birds,* f. 1r, Biblioteca Reale, Turin, Italy.

Fig. 83 Leonardo da Vinci: mirror-grinding machine.
Leonardo da Vinci, *Codex Atlanticus,* f. 17v, Biblioteca Ambrosiana, Milan, Italy.

Fig. 84 Leonardo da Vinci: reflection of solar rays on a hemispheric mirror and a polygonal mirror.
Leonardo da Vinci, *Codex Arundel,* ff. 84v and 88r (P64r–v), British Library, London, UK.

Fig. 85 Leonardo da Vinci: reflection of solar rays on a polygonal mirror.
Leonardo da Vinci, *Codex Arundel,* f. 88r (P64v), British Library, London, UK.

Fig. 86 Leonardo da Vinci: method to establish the desired focal length of burning mirrors.
Leonardo da Vinci, *Codex Atlanticus,* f. 751a–v, Biblioteca Ambrosiana, Milan, Italy.

Fig. 87 Leonardo da Vinci: method for drawing arcs of circles with very large diameters.
Leonardo da Vinci, *Ms. G,* f. 45r, Institut de France, Paris, France.

Fig. 88 Leonardo da Vinci: mirror lathe with sophisticated drive system.
Leonardo da Vinci, *Codex Atlanticus,* f. 823a–r, Biblioteca Ambrosiana, Milan, Italy.

Fig. 89 Leonardo da Vinci: brick profiler for burning mirrors.
Leonardo da Vinci, *Ms. G,* f. 74v, Institut de France, Paris, France.

Fig. 90 Leonardo da Vinci: sliding template for grinding mirrors.
Leonardo da Vinci, *Ms. G,* f. 47v, Institut de France, Paris, France.

Fig. 91 Filarete: Grottaferrata iron foundry.
A. Averlino, known as Il Filarete, *Trattato di architettura,* II, pp. 475–76, Biblioteca Nazionale Centrale, Florence, f. 127r, Museo Galileo Library, Florence, Italy.

Fig. 92 Ctesibius's pump in Fra Giocondo's edition of Vitruvius.
Fra Giocondo da Verona, *Vitruvii de architectura,* Venezia 1511, Pal. D.1.2.5, *Liber X,* p. 102v, Biblioteca Nazionale Centrale, Florence, Italy.

Fig. 93 Hydraulic organ in Fra Giocondo's edition of Vitruvius.
Fra Giocondo da Verona, *Vitruvii de architectura,* Venezia 1511, Pal. D.1.2.5, *Liber X,* p. 103v, Biblioteca Nazionale Centrale, Florence, Italy.

Fig. 94 Vitruvius's ship speedometer as interpreted by Fra Giocondo.
Fra Giocondo da Verona, *Vitruvii de architectura,* Venezia 1511, Pal. D.1.2.5, *Liber X,* p. 104v, Biblioteca Nazionale Centrale, Florence, Italy.

Fig. 95 Catapult in Fra Giocondo's edition of Vitruvius.
Fra Giocondo da Verona, *Vitruvii de architectura,* Venezia 1511, Pal. D.1.2.5, *Liber X,* p. 105v, Biblioteca Nazionale Centrale, Florence, Italy.

Fig. 96 Worm screw (lower right) in Daniele Barbaro's edition of Vitruvius.
Vitruvius Pollio, M., *I dieci libri dell'Architettura di Marco Vitruvio tradotti e commentati da Mons. Daniele Barbaro [. . .] da lui riveduti e ampliati,* in Venetia [Venice], appresso Francesco de Franceschi senese, 1567, p. 442, Museo Galileo Library, Florence, Italy

Fig. 97 Hydraulic organ in Daniele Barbaro's edition of Vitruvius.

Vitruvius Pollio, M., *I dieci libri dell'Architettura di Marco Vitruvio tradotti e commentati da Mons. Daniele Barbaro [. . .] da lui riveduti e ampliati,* in Venetia [Venice], appresso Francesco de Franceschi senese, 1567, p. 471, Museo Galileo Library, Florence, Italy.

Fig. 98 Agostino Ramelli: intricate pump mechanisms.

Ramelli, A., *Le diverse et artificiose machine, composte in lingua italiana e francese,* Parigi [Paris], in casa dell'autore, 1588, pl. 177, Museo Galileo Library, Florence, Italy.

Fig. 99 Giovanni Fontana: mechanical witch.

Fontana, G., *Bellicorum instrumentorum liber,* Cod. icon. 242, f. 63v, Bayerische Staatsbibliothek, Munich, Germany.

Fig. 100 Giovanni Fontana: skeleton rising from the tomb.

Fontana, G., *Bellicorum instrumentorum liber,* Cod. icon. 242, f. 51r, Bayerische Staatsbibliothek, Munich, Germany.

Fig. 101 Kaspar Schott: mechanical-organic organ.

Schott, K., *Magia universalis naturae et artis, sive recondita naturalium et artificialium rerum scientia,* Iconismus XXIV, Museo Galileo Library, Florence, Italy.

Fig. 102 Hydraulic devices in frontispiece of Father Schott's treatise.

Schott, K., *Mechanica Hydraulica-Pneumatica,* Francofurti [Frankfurt], excudebat Henricus Pigrin, 1657, frontispiece, Museo Galileo Library, Florence, Italy.

Fig. 103 Galileo Galilei: geometrical diagram of functioning of pendulum-driven lifting device.

Galilei, G., *Le opere di Galileo Galilei,* VIII, p. 575, Museo Galileo Library, Florence, Italy.

Fig. 104 Vittorio Zonca: gunpowder mill.

Zonca, V., *Novo teatro di machine et edificii per varie et sicure operationi con le loro figure tagliate in rame et la dichiaratione et dimostratione di ciascuna,* in Padova [Padua], appresso Pietro Bertelli, 1607 [facsimile reproduction ed. by C. Poni, Milano, 1985], pp. 85–87, Museo Galileo Library, Florence, Italy.

Fig. 105 Bonaiuto Lorini: gunpowder mill.

Lorini, B., *Le fortificazioni nuovamente ristampate,* in Venetia [Venice], presso Francesco Rampazzetto, 1609, p. 237, Museo Galileo Library, Florence, Italy.

Fig. 106 Galileo Galilei: resistance of a beam supported by a wall.

Galilei, G., *Le opere di Galileo Galilei,* vol. VIII, p. 159, Museo Galileo Library, Florence, Italy.

Fig. 107 Galileo Galilei: resistance of a beam supported by a wall and carrying a load at the free end.

Galilei, G., *Le opere di Galileo Galilei,* Edizione Nazionale, vol. VIII, p. 157, Museo Galileo Library, Florence, Italy.

Index